If You Shoot the Breeze, Are You Murdering the Weather?

If You Shoot the Breeze, Are You Murdering the Weather?
100 Musings on Art and Science
by Alan Dean Foster

Collection © 2022

All rights reserved. Printed in the United States of America. No part of this publication may be reproduced, stored in a retrieval system, or transmitted in any form or by any means, digital, electronic, mechanical, photocopying, recording, or otherwise, or conveyed via the internet or a website without prior written permission of the publisher, except in the case of brief quotations embodied in critical articles and reviews.

Fantastic Books
1380 East 17 Street, Suite 2233
Brooklyn, New York 11230
www.FantasticBooks.biz

ISBN: 978-1-5154-4785-6

First Edition

Table of Contents

Introduction. 9
How to Make Millions in the Art Market
 Without Leaving Your Home. 11
You Ain't Healthy Until You Throw Up. 13
The Perniciousness of Dogs and Bugs. 15
The Tech we *Don't* Need. 18
The Meaning of Life. 20
Those Who Live in Plastic Houses. 22
Weather it Makes a Difference or Not. 24
The Instantaneousness of Bad. 27
The Immateriality of the Original. 30
Touchdown! (Batteries Not Included). 33
I, for One, Welcome Our (Insert Programming Here). 36
Comic Art: an Oxymoron?. 39
We Are All Art. 41
We're all Furrys at Heart (Even the Bald Guys). 44
Getting a Buzz from Woody. 47
Fallacies of Advertising #8C (Eight Cylinders). 49
Pastafauteuils, with Fruits. 52
Artistic Obsession. 54
The Art and/or Science of Travel. 57
Of Diseases and Wheezes. 62
Jihadi MTV. 65
How to Create a Successful New TV Series (In One Column). 68
In the Eye of the Froot Loop. 71
Don't Bach Down. 73
Meeting Our Holidays Coming. 75
The Art of Calling a Parade. 78
Weather or Not. 81
Leash or Lease?. 84
The Tao of Mix-ins. 86
Escape. 89
Chains. 91
Charge!. 93
The Reading of Pictures. 95
The Science of (Selling) Sleep. 97

Rise of the Pod People... 100
Planet of the Coywolves. ... 103
Do Android Cats Dream of Electric Mice?.. ... 105
Get Wood. ... 108
Is it Art or Is it Digital?. ... 110
A Few Mild Shocks... 112
An Uber Simpsons Couch Gag (Sort Of). ... 115
Pixels and Doodles. ... 118
Science... or Industry?.. ... 121
The Singularity May be Squishy. ... 123
Set in Stone... 125
Enter: Backwards. ... 128
When Sometimes it's Better Not to Leave Well Enough Alone. ... 130
The Distancing has Begun... 133
Planetary Appropriation... 135
Everythings' Hometown. ... 137
Glassy-eyed... 139
Disney Versus the Death Channels.. ... 141
Stravinsky: Dinosaurs Optional: Part I... 144
Stravinsky: Dinosaurs Optional: Part II. ... 147
Inka-dinka-do-You... and Me. ... 150
Everybody Was Here.. ... 152
The Aesthetics of Gurgle... 154
Nostalgia or Art?... 157
The Tao of Pussyfoot.. ... 160
The Blue Raspberry of Forgetfulness. ... 162
The Robots are Coming, and They Have Broccoli!.. ... 165
Who Steals Unsellable Art?.. ... 168
Your Science Conspiracies Nay Be Charged at a Higher Rate. ... 170
Have Your Cake and Shoot it Up, Too... 173
Excavating a Drink of Water. ... 175
(He)art Beats and Flowers. ... 178
Science and Silence.. ... 180
Adrenaline Low.. ... 183
Go Pound Rocks. ... 186
Depth Perception.. ... 189
Does History Anoint Your Taste?. ... 192

The Taste of Nothing. 195
The Death of Western Civilization. 198
Faster Processor, Same Hard Drive. 201
Get a Horse (If You Want to Drive). 204
The Death of Film. 206
Your Dealer and Mine. 209
Farewell to the 17th Century: Class is in Session. 212
Architecture for Hoomans. 215
Rise of the YGPs. 217
Mona Lisa Simpson. 220
Symphony + Metal = Symphonic Metal. 223
How Microsoft Got Started, and Other Adult Fairy Tales. 225
Art Theft, Thieves Bereft. 228
That Sinking Feeling. 230
Critical Mess. 233
CV Baby, You're Driving Me Crazy. 236
Planet of the Unrepurposers. 239
Of Note. 241
Science?. 244
When Pigs Fly. 246
The Decepticons. 249
The Buzz. 252
The Mouse and Me. 255
Metal Can be Funny. 258
Refrigeration Relativity. 261
Algorithim for the Deceased.. 264
Wither Weather?. 267

Introduction

Not all that many years ago, a young local entrepreneur thought to start a regional magazine/newspaper focusing on art and science, thereby offering reviews, articles, essays, and news different from the usual media recitative of car crashes, lost pets, dubious political moves, distant wars, and why everyone in the country is either anorexic or obese (there is seemingly no middle ground).

Aware of my interests in art, science, and pretty much everything else that occurs in this dimension and on this particular planet, he inquired if I would be open to writing a monthly column focused on—but not restricted to—the primary thrust of his proposed publication. I did not exactly demur, but I was extremely busy at the time and told him as much.

"It's only monthly," he reiterated. I pondered.

"How many words?"

"There are no exact length requirements, but around eight hundred would be good."

Eight hundred words a month. I could manage that.

"What about specific subject matter?"

"Anything you want. If you can relate it to the overall thrust of the paper that would be good."

That sounded good. "What about payment?" He told me.

Not so good. But—more or less complete freedom to write anything I wished. To express my thoughts regarding subjects on which I might have an opinion.

Okay, I have an opinion on everything. Not an issue. I agreed to participate as much to help the new enterprise get off the ground as for any other reason. I figured that after a dozen or so columns it would be established or have disappeared.

One hundred essays later the publication, *5enses*, is still established, expanding its reach, and helping to entertain and educate the general population. I hope I'm contributing to all of that.

The writing contained herein represents my thoughts and feelings on many subjects. I expect you'll treat them like a candy sampler. You'll like

one, blanch at the next, find yourself ambivalent regarding those containing nuts or unfamiliar fillings. Feel free to sample at your leisure.

You'll laugh, you'll cry, and occasionally, hopefully, wonder why.

—Prescott, Arizona

[Editor's note: these essays first appeared in 5enses *starting in 2013. The last of them appeared in early 2022. For a few of them which may seem dated, keep those dates in mind.]*

How to Make Millions in the Art Market Without Leaving Your Home

I've finally got it figured out. Contemporary art, that is. And I have Jeff Koons to thank for it.

It wasn't his "balloon flower", which sold at auction for more than 25 million (yes, that's "million") bucks. It was his balloon dog. See, Bozo the Clown on TV used to make balloon dogs. I used to make balloon dogs. But nobody would give me twenty-five cents for one, much less millions. Maybe Bozo did better—I hope so. It got me to thinking: what's the difference between a Koons balloon dog (methinks the alliteration is worth more than the art) and a Foster balloon dog?

It's... size. In modern art, size really does matter. In fact, size is everything.

In my innocence, I used to believe that a requirement for committing art was that one possess at least a minimal command of the skill of drawing. How quickly modern art disabused me of this antediluvian notion. To be a success in the contemporary art market, all one has to do is scale up ordinary objects to ridiculous sizes. That's it.

This qualification isn't unique to Koons, who by all accounts laughs himself silly all the way to the banks. Nor is it a new phenomenon. Take Jasper Johns who made (I hesitate to say "painted") reproductions, in various forms, of American flags. But they're all *big* American flags. Or his "painting" of a bulls-eye. I bet your ten-year-old can paint a bulls-eye. You want bulls-eye art, all you got to do is head for the nearest sporting goods department and buy dozens, hundreds, for less than a cheap print of a Jasper Johns.

Then there's Robert Rauschenberg. He did collages. You know what collages are: you did them in school and your children do them now. But the ones you did and that your offspring do were small. Classroom-sized. Rauschenberg did *big* collages. And lots of paint smears. But they were *big* paint smears.

See how easy this is? Koons isn't trying to fool anybody. Roy Lichtenstein was equally up front about his own work. "I think my

paintings are critically transformed, but it would be difficult to prove it by any rational line of argument."

No disagreement there. Lichtenstein didn't even try to be original. He just appropriated the work of great comic artists like Jack Kirby and enlarged individual panels to humongous size. Oh, sometimes he might alter a few colors. You want to own that art? Have it in your own house? Go buy a Kirby comic and you'll own dozens of such panels. It won't cost you millions, and you can cut out the panels you like and paste them on the wall.

Andy Warhol did the same, but sometimes he'd get bored. So in addition to enlarging his common objects, he'd reproduce them multiple times. And change the color overlay (see: Marilyn, Soup Can, etc.). Any kid with a computer can do the same. Just be sure to make everything... big.

I could go on (I am going on), but let's conclude with "artist" Michael Heizer's Levitated Mass. That's the huge boulder that was trucked, at great expense, through the streets of Los Angeles to its final (unless one day it becomes Sunken Mass) resting place atop a concrete slot at the L.A. County Museum of Art. It's a big (there's that adjective again) rock you can... walk under. I found far more art in the transportation of the rock than the final "installation."

I'm sorry: an installation is something a plumber does in your bathroom. It is not art.

Heck, we live in Arizona. We got all kindsa such installations just outside of town. Sometimes within town. Sometimes inside our yards. And none of them cost multiple thousands of dollars. So that's the secret to modern art. Make it big. Nobody'd pay to stroll beneath a baseball-sized dirt clod... small doesn't cut it.

But a really *big* dirt clod.... We could call it "Earth Abides," except that would be stealing the title of a well-known science-fiction novel.

Check your trash. Exhume your recyclables. Somewhere entombed deep within lies the key to your aesthetic future and financial success. Take that old soda bottle and make it big (bronze is good)! Extract that chewed-up dog toy and balloon it to Koonsian proportions (do it in stainless steel)!

Just be sure to credit your kids.

You Ain't Healthy Until You Throw Up

Modern medical science is a never-ending wonder. There are medicines for malaria, shots for flu prevention, pills to reduce fever, vaccines to pnip pneumonia in the bud. X-rays, MRIs, and CAT scans let us see deep inside the living human body. I'm old enough to remember when a CAT scan meant that your favorite tabby was fixing you with an unbroken feline stare. There are surgical techniques that permit the repair of nearly every part of the *corpus humanus* except the back (ask anyone with back problems). Artificial knees and hips are readily available for installation, just like you'd replace the worn-out springs on an antique auto. Even the brain is known in detail and can be operated on with a reasonable degree of safety (except in Washington D.C., where brains are apparently immune to manipulation, as well as being in short supply).

It seems there's a pill, prosthetic, or pre-op for anything and everything.

Maybe that's part of the problem.

When is there such a thing as scientific overkill? Take cholesterol. My wife's parents were good country folk from west-central Texas. Had a small farm, raised much of their own food. Their diet, like those of their friends and neighbors, would give a modern heart doctor palpitations. Real ham with eggs and toast with butter for breakfast. Everything else was fried. There were fried potatoes, fried okra, chicken fried steak, chicken fried chicken. About the only thing that wasn't fried was the squirrel gravy (you haven't experienced authentic American cuisine until you've bent over a pot of simmering gravy only to see a small white skull grinning up at you). And the baked goods... home-made cookies, pies, cakes, all made with... lard.

Yet my father-in-law lived to be 81 and my mother-in-law to 76, and they enjoyed every meal they ever ate in their lives, without worrying about it.

Today they'd be prescribed Lipitor or Crestor or Zocor or some other 'Or' and have to deal with the drug's side effects, and to be careful not to miss a dose, and have to find a way to pay the cost until the day they died.

Me, I think I'd rather enjoy fifty years with bacon than an extra one or two without.

Nowadays it seems as if commercial television is dominated and supported by advertisements for two products: cars, and drugs. All General Motors has to do to return to its glory days is find some way to prove that seeing the USA in your Chevrolet also prevents osteoporosis, or cures hemorrhoids. As for the medication ads, government regulation has made them among the most amusing segments on TV. You get two or three minutes of homey images of healthy loving couples or individuals whose lives have been enhanced by a specific drug, underneath which video a soothing voice proceeds to quietly list the four hundred and twenty-six side effects taking said medication might induce. My favorite, which seems to be common to many drugs, is, "Women who are pregnant or might become pregnant should not take Getafixadrine," or whatever.

Might become pregnant?

What one takes away from ads for contemporary medicines is that in certain instances, they can kill, or incapacitate, or blind, or make you sterile. Speaking of the latter, and concerning modern drugs about which there is too much information, have you ever tried to explain what "male erectile dysfunction" is to a ten-year-old?

I'm not suggesting that we go back to the days of witch doctors (when I was a kid, I thought a witch doctor was a doctor who tended to sick witches) or snake oil salesmen. But we could do without the constant barrage of commercials pushing medications, recommendations to take medications, medications for everything from sore and aching muscles (an endemic condition that used to be known as "work") to poor bowel movements (eat better).

Medical science is a wonderful thing, and I look forward to each new advance. But that doesn't mean each new discovery should be pushed on an already drug-exhausted public. The resultant worry about medication leads to stress, and any doctor will tell you that stress kills more people than just about anything.

Say you take that new medication. Then you need a pill to counteract the side effects of the new medication. Soon you need a pill to deal with the side effects of the counteracting pill. Then you throw up.

And suddenly you feel better.

Until those commercials start hammering you again.

The Perniciousness of Dogs and Bugs

In my previous columns I've written about art and about science. This one's about what can sometimes happen when science meets art. Or to put it in simple rhyme:

Not everything that can be done is good
And just because you can
Doesn't mean you should.

TV manufacturers like to boast about the size of their "viewable area." What no one seems to note is that while the devices have increased in size, the actual viewable area for many, many programs is continually being reduced. This is the fault of a technology called digital on-screen graphics, usually abbreviated as DOGs. More colloquially, they're referred to as bugs. They are a true plague that has spread to television in every country. Unfortunately, as with any technological development that can be short-handed to "$," the US is the leader in this ongoing aesthetic regression.

What is a TV "bug"?

They started out innocently enough. That little channel identifier in the lower right-hand corner of your screen? That's a bug. Originally just a number, the channel ID bug now usually includes the name of the communications company that owns the channel, or some other additional identifier. They're irritating and distracting, like most bugs. Alas, the channel ID bug was but the forerunner of the visual catastrophe that was to come.

If you think your channel ID bug is irksome, consider our poor neighbors to the north. Canadian stations that import U.S. channels will often have two such bugs: one identifying original U.S. station and a second their own, rebroadcasting channel that will usually appear in the upper right corner of the TV screen. Lower and upper right—doubly distracting.

What began as a comparatively innocent way to "watermark" TV stations soon got worse. Much, much worse.

To the dismay of viewers everywhere, stations and companies quickly discovered that bugs can be used for *advertising*.

I am (or was) a big fan of nature shows on TV. The National Geographic channels, the Discovery Network channels, and a host of others. As far as DOG bugs go, your local PBS broadcasts in this vein, such as *Nature*, *Nova*, and the like, are relatively benign offenders. Their ads are normal; thrown up full-screen at the beginning and end of the broadcast, with usually only the channel ID bug allowed in the lower right-hand corner of the screen.

But the commercial channels....

Recently Discovery ran a BBC nature series on Africa. Bugs rendered it virtually unwatchable. There was the Discovery Channel bug in the lower right-corner of the screen. Okay, fair enough. But behind, around, or above the logo was an ad for some upcoming show I had no interest whatsoever in seeing. Usually these ads had the word "gold" in the title. As in "Bering Sea Gold," "Black Gold," "Gold Rush," etc. I await with dread the debut of the Discovery Networks' GOLD channel, wherein every show will have the apparently inescapable mnemonic "gold" in the title.

Not only do these channel ID-backing ads continue to grow larger and larger, eating up more and more of your precious viewable image, but instead of appearing on screen for a bit and then going away, they remain *throughout the entire program*. Plus, now they're *animated*. Moving clouds, roiling seas... I shudder to think what the Comedy Channel is working on. What could be more aggravating to someone trying to engage in enthralled contemplation of elephants in a bai, or a surfing hippo, or a herd of a million wildebeest, than animated junk ads flashing continuously from one corner of the screen?

Well, they've figured it out.

In addition to occupying increasing real estate in the lower right corner of your TV set, animated DOGs are now increasingly spread across the remaining bottom sixth of your viewing territory. Not only does the lower right corner remain *permanently* occupied by advertising, additional ads splash completely across the lower portion of the screen. Performing actors. Dancing cartoons. At least with Discovery you have some idea of what you're going to get... whatever unrelated show they're promoting, it's gonna have "gold" in the title.

That's exactly what I'm eager to see promoted and to learn about while I'm watching a high-class nature documentary on Africa: some

If You Shoot the Breeze, Are You Murdering the Weather?

reality show about a bunch of unshaven dorks trying to get rich quick in Alaska, or Ghana, or Guyana instead of getting a real job. These bugs don't take you out of the moment; they shatter it, obliterate it, and are an insult to the hard-working camerafolk and scientists and in-house production teams who spend years making those moments available to you, the viewer, at home. They constitute an unapologetic assault on every creative talent behind whatever show you happen to be watching, be it a BBC Nature documentary that took years to film or a Hollywood half-hour comedy. DOGs have created advert anarchy.

I can see where this is going, if the advertisers think they can get away with it: soon the adverts will expand until they occupy the major portion of your screen while the actual show shrinks to take the place of the channel ID bug in the lower-right hand corner.

The FCC regulates the volume of commercials. But as far as advertising bugs are concerned, it appears that this one increasingly uninterested government regulatory agency has surrendered completely to the DOGs.

The Tech We *Don't* Need

We're all gadget geeks now. Manufacturers know it, advertisers know it, and those who live by selling us all the myriad technological developments we don't need surely know it.

I was put in mind of this when, for the umpteenth time, I found myself turning into the Willow Creek Road post office in the wake of a 4x4 SUV that, if its wheels were removed, might possibly fit into the cargo compartment of a 747. It wasn't the size of this gas-guzzling behemoth that forced contemplation upon me. It was the speed with which it took the driveway; a velocity only slightly greater than that of a desert tortoise anxious to commence mating.

Every monster 4x4 that enters the post office parking lot, each looking as if it possessed the ability to climb the steep side of Thumb Butte, was taking the driveway as if its undercarriage and suspension were no tougher than a chocolate soufflé just out of the oven. Hence the inevitable question that echoes in my mind every time I am witness to this vehicular farce.

Why?

Why pay all that money for engineering and technical advances if you don't need them and are never going to use them, short of puttering up and down the hill in front of the Elks' Opera House a couple of times on the rare occasions when a few inches of snow actually sticks to Gurley St. Who needs a semi-military class machine to fetch kids from school and groceries from the market?

My 4x4 commuters: you've been had. But then, we all have.

Take telephones. Or what used to be called telephones. Now they're personal communication devices. Deviant as it may seem, I use my telephone to call people. That's all. I don't need a phone to tell me the best way to get to San Jose, how to bake corn bread, what's happening this week in Ouagadougou, or why I should give a damn about anybody named Kardashian. My phone is so inexpensive I don't worry about losing it, so retro I don't have to worry about being mugged for it, and the monthly service cost is minimal.

If You Shoot the Breeze, Are You Murdering the Weather?

The tech pushers insist I *need* that $500 phone. And $100/month service, so I can have access to my email and the web anywhere, anytime. Except I don't want access to my email and the web anywhere, anytime. I want that access, you bet, but on *my* terms, when and where I'm in the mood for it. And I sure as Babel don't want everyone else to have instant access to *me*.

But, I am told, there are hundreds of thousands of apps available for these new (meaning out-of-date in six months) smartphones! And each app costs so little! Don't you really, deep down, want to know *right now* what the weather is in Moose Jaw, Saskatchewan?

Sorry. I'm using that time to enjoy a cheeseburger and fries. Very low-tech, but ultimately more satisfying. There's no app for grilled onions.

If I had to come up with an ultimate example of overpriced, over-engineered, absolutely unnecessary tech for sale, I reckon I'd nominate smart refrigerators. I mean, *really* smart refrigerators. The kind with video screens embedded in one of the front doors. The most "advanced" models can tell you more than you want to know about how your refrigerator and its contents are doing. In my ignorance, I thought all you had to do was open the fridge door and look inside. I don't need a two hundred-dollar color screen accessory to tell me that if there's water pooling up in the bottom of the freezer compartment, the fridge is likely not in good shape.

As if that wasn't sufficient, some models allow you (via an app, natch) to monitor the condition of your refrigerator and its contents remotely. Now the high-tech add-on finally makes sense. I mean, how could I enjoy lying on a beach somewhere in the South Pacific without the ability to instantly ascertain how the celery back home is feeling? In contrast, it's almost impossible to buy a refrigerator with a bottom freezer that, like our late, lamented, prehistoric GE, has a foot pedal that allows you to open it without risking rugby-class back injury? I suspect that's because a foot pedal might cost a few dollars, its profit margin being considerably less than that to be derived from an integrated color smart screen.

Lastly, I was going to talk about the computer-controlled smart toilets that are all the rage in Japan, but the ghost of my father-in-law, who was born in rural Texas in 1900, is already laughing so hard over my shoulder that I can't get started.

It's a wonderful thing, advanced technology. But sometimes, like that chocolate soufflé, it's something best taken in small doses.

The Meaning of Life

Some years ago I wrote a novel called *Glory Lane* (Ace Books). Three teens—a punk, a nerd, and a Valley Girl—find themselves engaged in an assortment of often outrageous adventures involving multiple species of aliens, alien worlds, and inter-alien conflicts. Eventually they find themselves on an advanced, highly developed planet that features a world-spanning computer network. Supposedly it can answer *any* question.

The punk isn't interested and the Valley Girl just wants to go shopping. The nerd is aghast. Here they have the opportunity to find the answers to all the great questions that have bedeviled mankind since the dawn of time, and they aren't interested? So he takes it upon himself to ask the vast system, "What is the meaning of existence?" This query is so profound that even the immense computational power of the alien network requires time to reply. When it finally does, its answer is:

Shopping.

"See?" the Valley Girl huffs, not in the least surprised.

I reference the excerpt from my own book because I have just returned from a week in a land where the alien computer's response appears to be wholly accurate. Dubai is one of the United Arab Emirates. A week there is sufficient to convince one that the name might accurately be read as "Youbuy."

I mention this because in the language of contemporary diplomacy, "soft power" has many meanings. While it is usually used to refer to art, or music (it is often alleged that MTV brought down the Soviet Union, not Ronald Reagan), it can also mean anything that one culture employs, intentionally or indifferently, to infiltrate and influence another. Based on my world travels, of which Dubai is the most recent, I reckon the Chinese haven't got a chance.

Why? Because American culture, like America itself, is blissfully content to adapt and absorb elements from other cultures. As we are fond of saying: whatever works. Where the French squabble to find French words for popular American English sayings like le Weekend, we are quite happy to be chauffeured to a pied-a-terre in the city.

But back to the Meaning of Life, and what people elsewhere are willing to happily embrace.

Malls in Dubai are as much tourist attractions as they are for actual shopping. The mall next to my hotel featured "only" 551 shops. The Mall of the Emirates boasts an indoor ski slope. Claiming to be the world's largest with 1200+ stores and vendors, the Dubai Mall encloses a four-story high artificial waterfall plus a huge aquarium (the ice-skating rink seems like an afterthought).

I won't try to go through the stores, but just to give an idea of the penetration of American shopping culture into this part of the world, if you want to eat while in the mall (perhaps after picking up a few non-traditional underthings at Victoria's Secret), here are a few of your options:

McDonald's, Burger King, Cinnabon, Pizza Hut, Red Lobster, the Hershey's chocolate store (never seen one before), Johnny Rockets, KFC, Fatburger, Subway, Texas Chicken (!), Baja Fresh, California Pizza Kitchen, Chili's, Cantina Mariachi, iHop, Macaroni Grill, P.F. Chang's, Rainforest Café, TGI Fridays, Texas Roadhouse, The Cheesecake Factory, Uno Chicago Grill, Pinkberry, Great American Cookies, Baskin-Robbins, Cold Stone Creamery, Caribou Coffee, Seattle's Best Coffee, Gloria Jean's Coffee, and of course, Starbucks. Not to mention Outback Steakhouse.

If the secret to world domination is having an American-concocted Australian-themed restaurant that has virtually nothing Australian on the menu, I want our franchise back in Prescott.

I'm not worried about North Korea. Not when an Islamic emirate halfway around the world openly embraces Fatburger. Don't think these restaurants and shops are just for tourists; they're always full of Emiratis. On Thursday and Friday nights (their weekend) you can hardly move for all the young people busily sluicing through American-owned or -themed stores. Our food and shopping is changing the world far faster and more effectively than any military intervention ever could. It's the real soft power, and for better or worse, it's inescapable anywhere on the planet. Fortunately, we here have grown up submerged in interminable advertising and are therefore aware of and immune to the enticing blandishments of our own consumer culture.

Now if you'll excuse me, I have to go pick up a few things at the store.

Those Who Live in Plastic Houses....

So if USArmor LLC can provide approximately one inch thick glass that will stop multiple 7.62 rounds from an AK-47, why can't I get my Kraft Real Mayonnaise in a glass jar anymore?

Plastic. That's the world we're careening toward, where everything in addition to our politicians is made out of one kind or another of plastic. With the advent of the Boeing 787 we're already there with airplanes. Oh, alright: technically it's carbon fiber. I suppose that shouldn't bother me. We humans are mostly oxygen (65%) and carbon (18%) anyway. But people are still calling it the plastic airplane.

Folks worry about peak oil, the end of recoverable oil. When that happens, we won't miss it in our cars because we'll have found other means of propelling ourselves from one place to another. I can quite easily imagine a world without gasoline or diesel. But a world without plastics? Can't visualize it.

That doesn't mean I have to like it, and I especially don't like it when it comes to food storage. Which brings me back to mayonnaise. I know it's the same product I've been slathering on bread for years and that my opinion is entirely subjective, but doggone it, everything seems to taste better to me when it comes out of a glass container as opposed to one that's fashioned from plastic.

The big corporate food conglomerates say that plastic costs less to ship and is less prone to breakage, but insofar as mayonnaise is concerned (and ketchup, and mustard) we know that the *real* reason for the changeover from glass to plastic containers is because you can't make a squeeze bottle out of glass.

Ah, but squeeze bottles are so much more convenient, goes the manufacturers' argument. Persiflage. We know that "convenience" has nothing to do with it. Manufacturers of mayo, etc., love squeeze bottles because there is no way, short of inveigling a squadron of trained beetles to assist on your behalf, to actually get the last ten percent out of such containers. Which means, after subjecting yourself to contortions sufficient to qualify you for a tryout with Cirque du Soleil but which still

prove insufficient to get those last gobs of mayo on the end of a butter knife, you have to buy... another new container.

Returning to matters of taste, my drink of choice is iced tea. You used to be able to buy excellent glass bottles of Tetley Iced Tea, but the big American producers chased Tetley all the way back to the British Isles. Lipton employed similar bottles for years, switched to plastic, went *back* to glass (after a deluge of customer complaints, one wonders?) and has, lamentably, succumbed once more to the lure of extruded petroleum byproducts. Nestea has used plastic for years.

There are a few smaller, specialty drink companies, some owned by conglomerates loath to surrender even a fractional segment of such a substantial market, who still use glass. Honest Tea, Sweet Leaf, and others do their best to keep up the fight on behalf of glass. I try to patronize them when I can. That they strive to emphasize their exclusivity by selling only single bottles at a time (no convenient four- or six-packs) makes it difficult for someone who consumes their product daily.

Even in restaurants that serve iced tea in plastic tumblers, I try to have it served in a glass. Note that finer restaurants always serve it in glass.

A number of years ago it was possible to buy Promised Land chocolate milk in a couple of Prescott supermarkets. Shipped over from Texas, Promised Land milk came in a *glass bottle*. I am not succumbing to nostalgia when I say that the taste was so different from what is presently available in plastic jugs or cardboard cartons as to be a different product entirely. I am even allowing for the fact that Promised Land was made with whole milk. Not two percent milk, not one percent milk: actual milk. The kind one still finds in markets all across Europe, where milk products are still regarded as nutritional food and not an excuse to indulge in liquefied soy and globules of carrageen.

Imagine. Real, whole chocolate milk in glass bottles. All without having to fire up the Wayback machine and return to the 1950's.

I don't *hate* plastic. I think it's a wonder of the modern age, eminently suitable for use in everything from planes to trains to the keyboard on which I'm typing this screed. I just don't want it in my food.

Or my food in it.

Weather it Makes a Difference or Not

For thousands of years, humans have been working hard at trying to predict the weather. From gazing out to sea in search of incoming storms, to studying various cloud formations, to monitoring the temperature from month to month and season to season, it has been a primary and important component of the rise of civilization. Today we have access to techniques and devices for forecasting the weather that are beyond our ancestors' wildest imaginings.

Every day, GOES satellites send back multiple images of the Earth. Computers analyze the pictures and compare them with data from thousands of individual land-based monitoring stations. Sensors can count the number of microparticles in the air and issue health warnings based on carefully developed charts. Pilots have access to wind speeds and direction at different altitudes. We can instantly call up the air pressure at multiple elevations. Tornadoes and other dangerous weather phenomena can not only be monitored, but in many instances can be predicted with remarkable accuracy.

So with all this impressive technology, with all these immense scientific and human resources at their disposal, why the hell can't different weather-predicting organizations ever concur on what the high or low will be on any given day in Prescott, Arizona?

I'm writing this at 8:40 AM on Thursday morning, May 30th. Here are the predicted highs and lows for tomorrow from select major weather sources.

National Weather Service (NOAA): 85 – 52
Weather Underground: 84 – 54
Accuweather: 86 – 54
The Weather Channel: 81 – 52
The Weather Channel app: 82 – 54

Notice that out of the five sites, no two concur on the predicted high for the day? And this is a *mild* example of the kind of differences that exist in the forecasting for Prescott. The further in advance one goes, the greater the disparity in the forecasting. I mean, if The Weather Channel

If You Shoot the Breeze, Are You Murdering the Weather?

can't even get two of its *own* components to agree on a forecast (and they never do), what is the anxious citizen squinting over their morning coffee supposed to believe?

Sure, there are different weather reporting stations scattered around Prescott. But is it too much to ask that the major forecasting services agree on a single mutual site, at least for their main forecast? The airport, perhaps, or downtown. Anyone with a computer or tablet who is sufficiently curious can go to different sites and obtain different readings. But for someone getting up in the morning to go to work, or trying to prep the kids for school, they don't need to know how much the temperature is going to vary between Safeway Willow Creek Road and Safeway Montezuma Street. What people want is an agreed-upon general forecast for City of Prescott. That's what the multiple sources I've sited previously each claim to provide.

Would someone dress differently if they thought the high for the day was going to be 82 versus 85? Maybe, maybe not, but for those who would, it would be nice if they weren't forced to choose. Such disparities are at once worse and more important in the winter, when nationally predicted daily lows for Prescott can vary even more than in the summer. And if one site says the low is going to be 30 and another says it will only drop to 34, that's of obvious significance, not only to the general populace but especially to farmers.

Among the major weather sites I've seen differences in daily forecasts for Prescott of as much as seven degrees. It's immensely frustrating when you're trying to plan your day. Don't any of these services compare their data? Why don't they all simply utilize the NOAA forecast? Or would that compromise their individuality (i.e., the ability to sell commercial space)?

What is particularly striking about Prescott's situation in this respect is that it seems to be somewhat unique, and not because of our town's unusual topography. As an example, here are the relevant predictions from the same weather sites for tomorrow for Phoenix.

National Weather Service: 100 – 79
Weather Underground: 100 –79
AccuWeather: 102 – 81
The Weather Channel: 102 - 81

A lot more consistency there, and over a much wider area. You'll never see a seven, or even a four degree spread, for Phoenix. Or for nearly

any other city in the U.S. Yet the forecasts for Prescott are consistently all over the (weather) map.

At least we don't have to rely on the major services for tornado warnings. If a twister is roaring toward you, it's too late to complain to your preferred weather service that their forecast called for moderate breezes throughout the day.

The Instantaneousness of Bad

We live in an age where some folks desperately seek to *avoid* knowledge. Indeed, they actively work to escape from its very presence. They're not hermits. They enjoy the company of others, are perfectly sociable, work normal jobs and have relatively ordinary daily lives. But they can't stand, or can't cope with, or just desperately desire to avoid the flood, the tsunami, of information with which our contemporary society is inundated 24/7. There's even a name for it.

Epistemophobia.

Fear of knowledge. Foremost among these poor souls are the many who refuse to watch television news, or read any news-related media such as newspapers (you remember those... an ancient means of communication that utilized ink sprayed on fragments of bleached dead trees), magazines, or worst of all, the internet. These folks refuse to allow daily news into their daily lives because it's all so damn depressing, downbeat, and demoralizing. To those suffering from epistemophobia, the world is going to hell in a handbasket and as far as they are concerned, they want to encounter as little about it as possible.

But you know what? Overall, the world is actually in much better shape than it has ever been. There are no major wars raging between blocks of nations, famine is an occasional instead of daily fact of life in increasingly isolated parts of the world, a great many debilitating diseases have not only been brought under control but have been completely wiped out, people in formerly isolated countries can talk to relatives in the most developed cities, and much more. Popular entertainment is cheap and ubiquitous, we are well on our way to brokering the existence of a common language (English—if only for purposes of doing business), and cultural and economic isolation is for most of the planetary population a thing of the past.

So then, why all the angst? Why all the depression, the bemoaning, the constant letters to the editors decrying the current state of morality in the world?

Blame the knowledge revolution.

C'mon, y'all. Take a good, careful look around you. Things aren't worse than they were in "the good old days." The difference now is that in the good old days, if somebody in Milan went on a rampage and stabbed half a dozen fellow citizens, nobody in Chicago ever heard about it. If Count Whackapeon of Upper Depravia arbitrarily decided to slaughter a village or two, folks in Philadelphia remained ignorant of the outcome. And if there were a couple of murders and rapes and a bit of arson on the Barbary Coast in San Francisco, it all passed unnoticed in New York.

The difference now is, every one of those incidents would be fodder for the evening news, sandwiched in between what the Kardashians intend to call their next offspring (I believe South is still available) and why the local professional baseball team's third-string catcher's batting average has fallen off. Beyond such piffle you get only the bad news, leavened occasionally by a single feel-good human interest story drawn from one of the other five inhabited continents.

And that's just television. On top of that you have the daily ration of radical ratiocination that strives to persuade you that the apocalypse, in one form or another, is just around the corner, and here today by golly is proof positive of it. If a bus goes off a cliff in Peru, killing everyone on board, then clearly one should never ride aboard a Peruvian bus. If a village is burned in the Congo, then Africa is plainly off-limits.

On the evening news, Fox News' "World Minute" has to be my exemplar of this obsession with global morbidity. In sixty seconds you learn, basically, that *everything is bad*. The world is overwhelmed with death, destruction, and devastation. There is no hope, no chance for improvement, and you might as well pack it all in because life tomorrow will never be as good as it was yesterday.

Then they try to sell you a Disney World vacation. Or hemorrhoid medicine.

I feel for the epistemophobiacs. I really do. But it's a treatable phobia. The same technology that enables a farmer in the Punjab to learn that there's a drought in Iowa also allows him to adjust the price of his harvest accordingly. Whoever wins their local talent contest becomes an instant feel-good story. There's ample good news out there and it's just as readily available as the bad news. The difference is that in contemporary media, good news doesn't sell as many sleep aids, or cars, or carpets.

If You Shoot the Breeze, Are You Murdering the Weather?

Don't become an epistemophobiac. There's wheat among the chaff, even if media prefers to bombard you with the chaff. Knowledge empowers, it shouldn't inhibit.

I assure you that there's no need to hide from a world that's actually better in nearly every way than it used to be, if only for the existence of indoor plumbing and aspirin. You just have to be your own filter, technology-wise.

Don't be afraid to research your own news. There's actually far more good stuff than bad out there.

The Immateriality of the Original

In a stove in a small village in Romania likely rest the ashes of at least three of seven paintings stolen last year from the Kunsthal Museum in Rotterdam. When confronted, the mother of one of the alleged thieves said that she burned them (i.e., the evidence) to try and protect her son. She has now changed her story and says that she didn't burn them. Three of the stolen works were on paper, but the others were on canvas. Traces of paint pigment, canvas, nails, and more were found in the stove's ashes.

The works were by Pablo Picasso, Claude Monet, Lucian Freud, Henri Matisse, Paul Gauguin and Meijer de Haan. Some of these names you certainly recognize: others you may not. That's not important. Nor is their collective monetary value, estimated to be in the tens of millions of dollars, important. Nor do I wish to discuss the profound ignorance of the thieves, who plainly knew so little about art and the art market that they for one moment believed they could actually sell any such immediately recognized masterpieces on the open market. Or for that matter, on the black market.

What I want to talk about is the fact that the pictures are gone and, does it really matter?

Every moderately known painting by an artist of record has been photographed, digitized, and placed in thousands of books and on thousands of websites. Picasso exists in a cloud he did not paint and that Gauguin could never have envisioned. Printing technology exists that can reproduce any painting, on canvas if you wish, down to the finest original brushstrokes. In the gift shop of the National Gallery in London is a machine that can, in a short while, not only reproduce the museum's resident masterpieces in brilliant color, but can do so in the original size and dimensions for all but the largest pieces.

I've been fortunate enough to have spent time in most of the world's great art museums. I've squinted at thousands of famous and not so famous originals. There's nothing to compare to sitting by yourself in a small room in the Kunstacademie in Vienna where the only painting is

Hieronymus Bosch's *The Last Judgment* and being able to study it detail by detail, figure by figure, in complete silence and without interruption.

But—is it necessary to have the original to enjoy the art?

Once an artist's technique and style have been determined, is it critical that one see the original? Or is a copy that is virtually indistinguishable from the original just as valid to view? The picture is the same: the images, the colors, the figures. We know who did it. Would the Mona Lisa be just as famous, just as adored, if a copy hung in the Louvre that no one in the crowd could tell was a copy? Or if the original had been silently spirited away? Would there be fewer oohs and aahs?

Sculpture is no different. In 1504 Michelangelo's *David* was placed in the Piazza della Signoria in Florence. In the intervening centuries, kids climbed on it and pigeons expressed their own artistic opinions. Today the original is sequestered in a museum, while a fine copy occupies the original space. I don't doubt that there are numerous visitors to Florence who see only the copy and are confident they have seen the true expression of Michelangelo's genius. And so they have: they just did not see the original.

Children and adults who visit natural history museums throughout the world marvel at the skeletons of dinosaurs without realizing that a great many of them, especially of the rarer species, are casts. The casts are made from the original bone. Not only are casts far cheaper than original fossils, they're much easier to transport, set up, clean, and move. Only an expert can tell a professionally fashioned cast from the original bone. Does seeing a cast invalidate the viewing experience? If not, then where lies the difference between looking at an original Gauguin versus a perfect copy, or perfect print? The art is there even if actual touch of the artist is not.

Depending on the artist copies, prints, or etchings can be as valuable as "original" art. Rembrandt's etchings bring tens of thousands of dollars, yet they are nothing but copies. Dürer made his reputation and his fortune by cranking out hundreds of etchings and woodcuts, not by selling originals. If such geniuses were alive today, would they be using the high-end version of Insty-Prints instead of copper plate and wood block? If the artist feels a copy is as valid an expression of his or her art as an original, like Ansel Adams with his photographs, who are we, the audience, to argue?

It's wonderful to view the original of something, but I'm not so sure that in an age of increasingly perfect reproduction it is the great artistic crisis that it was a hundred or even fifty years ago, when the originals and bad copies were all we had. If that were the case, no one would buy Warhol or Hirst.

Maybe not such a bad thing.

Touchdown! (Batteries Not Included)

You could say that it all started (as so many things these days seem to) with a science-fiction story. Specifically, Richard Matheson's terse opus "Steel," that most recently served as the basis for the film *Real Steel*, about boxing robots. Certainly more than a few folks must have found the concept amusing when Matheson's tale first appeared in the May 1956 issue of that serious harbinger of advanced technological change, *The Magazine of Fantasy and Science-Fiction*. Keep 'em amused, I say.

Except…

Nostalgic toys like Rock'em Sock'em Robots aside, the battling robot concept has resulted in several television series. Teams of predominantly youthful engineers, mechanics, metallurgists, and programmers construct innovative mobile melanges of metal, plastic, and whatever else they can scrounge and then send them into battle against each another. What ensues is a great deal of flame, flashing sparks, screaming metal being ripped to shreds, unexpected explosions, and general high-energy mayhem accompanied by the shrieks of semi-hysterical fans. Not unlike your typical NASCAR race.

Is it therefore so very absurd to envision such contests taking place without the presence of human drivers? We already are in the first stages of development of commercially viable self-driving cars. Why not self-driving race cars? Higher speeds possible, the same rush of wreck-fueled adrenaline, but without the risk of human casualties. Would anyone watch, you ask? As mentioned, people gleefully cheer robots bashing each other to bits. Why not the same enthusiasm for watching robot cars bash each other to bits?

That's just one sport, for starters. If people will watch robot combat (MMA meaning Mixed Metal Assault) and accept the reality of self-driving cars and self-flying planes, I don't see why the notion can't be extended to all sports.

Retired professional football players just reached a settlement with the NFL regarding serious injuries, especially those involving cranial contact. Why not solve the problem and permanently eliminate the danger by

replacing live players with their metallic counterparts? Imagine the possibilities: one-ton mechanical lineman smashing into each other with all the power and acceleration of small trucks. High-speed receivers able to outrun cheetahs and out-jump gazelles. Running backs quick and sharp enough not only to turn on a dime, but to cut dimes. Quarterbacks with *actual* rifle arms.

I'd pay to see that. And no broken bones, no concussions.

Would the game lose its "spontaneity"? Heck, coaches "program" the plays and their players from the sideline as it is. Even today's relatively simplistic video sports games allow for the on-screen "players" to improvise moves and reactions. Just add a hundred tons of metal and plastic, and you've got robot football. When the players are synthetic, you don't even need synthetic grass.

I'm not sure it would work as well with baseball. No matter how fast the pitcher throws, a batter equipped with stereoscopic normal, infrared, and UV vision would probably hit everything thrown in its direction—with a solid aluminum, or maybe titanium, bat. True, the games would be high-scoring, but they'd get boring pretty quickly. Same thing with soccer, where every player would be as quick, agile, and adept as every other one, and the goalie would block every kick.

Oh, wait—soccer's mechanical enough already.

Probably the optimum competition for advanced mechanicals would be something akin to team paintball. Give a whole new twist to the old game "kick the can." Only with robots, the game could be a tad more lethal than paintball. Explosives could be permitted and a whole host of individually designed battle machines ranged against one another, with the winners receiving custom lube jobs. Or maybe send them to Disney World, where they would be greeted and feted by the resident audioanimatronics.

This would be an easy league to implement. We already have robot bomb disposal machines, smart bombs, and all manner of borderline cybernetic warriors. They just need to be anthropomorphized a bit to enhance their Q score (Wikipedia: The Q Score is a measurement of the familiarity and appeal of a brand, company, celebrity, or television show used in the United States).

Today's kids would take to such innovations immediately. There'd be very little difference between the games they play on their electronic

If You Shoot the Breeze, Are You Murdering the Weather?

devices and seeing them made real. Interactive combat/gaming exercises like fantasy football, fantasy baseball, or Afghanistan already exist. The first two simply need to be metalized.

Then... what's left for humans, you wonder? If we turn all our big-name sports over to our machines, what's left for us to actually participate in on the professional level? I suppose there'll always be golf.

I don't think we could persuade even the robots to participate in that.

I, for One, Welcome Our (Insert Programming Here)

A running joke among those who have studied literature is to begin a story, usually faux, by quoting from the novel *Paul Clifford* by the English author Edward Bulwer-Lytton by saying, "It was a dark and stormy night." Fans of science-fiction have a similar favorite trope, which they enjoying modifying to suit whatever literary or cinematic threat happens to be manifesting itself in the relevant tale. To wit; "I, for one, welcome our new alien overlords." Or, "I, for one, welcome our new insect overlords." And so on. A particular favorite, since the plot device is featured in so many stories, is, "I, for one, welcome our new robot overlords."

Which brings me to Congress.

Not physically, thank your favorite deity, because if I happened to find myself there at the present time I don't think I could restrain myself. Or my vocabulary. However, this column is supposed to be about science and/or art. Not politics. So let's talk science.

Many years ago I wrote a novel called *The I Inside* (which has nothing to do with the movie of the same name whose producers were futilely called to account for swiping my title and who, in the time-honored fashion of filmic production ethics, choose to pretend neither I nor the book actually existed, presumably thus salving the fragmentary portion of whatever consciences they might once have possessed, though I am not at all certain their immortal souls remain safe).

The story involves a man who is more than he seems who catches a single glimpse of a woman in a passing vehicle and becomes helplessly, unutterably smitten with finding her. Among the background actors in the novel is a device called the Colligatarch (from "colligate," to connect or unite, and "autarch," a ruler who has absolute power). The Colligatarch has been provided with so much input (essentially every bit of information on Earth) and so much processing power that it can pretty much govern by suggestion. In other words, it doesn't need to force anyone anywhere

If You Shoot the Breeze, Are You Murdering the Weather? 37

to do anything, but since its suggestions are customarily the correct ones, to go against them is invariably to fail.

Back to Congress (apologies in advance).

Obviously we're not sufficiently mature as a species to hand over decision-making to a kind of semi-conscious world wide web. We still prefer rendering our own irrational decisions even when they lead to such appalling consequences as war, famine, the spread of diseases we could easily stamp out, and twerking. But imagine for a moment if such a device as the Colligatarch *was* available.

Forget for a moment your personal opinion of the Affordable Healthcare Act. Instead of trying to defund something that was legally passed into law, suppose all the elements of the AHA, pro and con, large and minuscule, could be entered into and processed by a machine that all sides agree beforehand is smarter and more even-handed in its decision making than any politician from your local dog catcher on up to the President himself. Suppose both sides agreed, beforehand, to abide by whatever result, advice, or instructions such a machine could provide.

Imagine how much faster Congress would run (right now it has two speeds: dead slow and slower than dead). Imagine how much more efficiently the country would run. A machine belongs to no political party.

What about the programmers, you ask? It would be an easy enough matter to check, cross-check, and re-cross-check any programming to ensure that it is non-partisan. The key, of course, is that any decision handed down by such a system would not be a directive, or an order. Only a *recommendation*. But if time after time the system's recommendation turned out to be correct, before long it would be a foolish member of Congress indeed who opted to vote against it.

Airlines already use such a system (to their benefit, not ours) to set routes, determine flight times, and decide which aircraft to put on what flight path. Farmers in nearly every country collate information from NOAA and other sources to determine what to plant, how much to plant, when to plant it, and when and where to bring it to market. If comparatively primitive linked computers can decide when we fly and what we eat, why not have a similar system make suggestions about which Federal program deserves to be funded, how much it should receive, and so forth? Exempt from the need to appeal to special interests

or get re-elected, an impartial computer network could be expected to deliver programs based purely on information.

None of it becomes law, of course, until humans vote on it. Once again: if the machine network proves to be right the great majority of the time, then such voting should proceed in much more orderly and expeditious manner, saving us the need to endure endless bloviation and meaningless platitudes from overheated Congressfolk. Such speech can be reserved for human pundits and particular media outlets, where they will do less harm.

Can such a system be any more dysfunctional than the one we have now? Given the option, I'd wager Ben Franklin would be the first to vote to put it to use.

Now if you'll excuse me, my toaster is calling.

Comic Art: an Oxymoron?

I learned how to read from comic books. Back when (enlightened) parents used to buy their kids subscriptions to comic titles, you could get them delivered directly to your house via the mail. This had the dual benefit of ensuring that junior had access to approved titles while preventing him or her from hanging out in disreputable locales like the corner drugstore.

My literary mentors were Herman Melville and Carl Barks. If queried, most folks would avow that they'd heard of Melville and that he had something to do with a whale. Barks would elicit considerably less recognition. Carl Barks, or Unca Carl as fans came to know him, created Uncle Scrooge, Duckburg, and a host of other characters, locations, and plot devices from which Disney has reaped millions. As all Disney artists labored anonymously, his work was singled out by his avid readers (including George Lucas and Steven Spielberg, among others) as being by "the good artist."

Interesting that he was recognized first for his art and to a lesser extent for his writing.

A master draftsman, Barks could get more emotion into his drawings of anthropomorphized ducks than most "fine" artists could from high-priced formal portraits. This is true of all great comic artists because they are required to tell a story with their work and not simply petrify a scene. Comic art, or if one wishes to be high-falutin', "graphic novels," are not unlike still frames lifted from movies. Or if you prefer, from a cinematic storyboard. The requirement that they tell a story in no way invalidates the artistic skill of those behind the pen, brush, or computer.

But is it "art"?

Here we again find ourselves back at the old Eye of the Beholder argument. To me, great art, regardless of the medium, consists of an image that provokes an emotional response in the viewer. If it's Kandinsky that does it for you, then it's art. Myself, I'd rather see Scrooge and his nephews battling the Beagle Boys than a giant canvas featuring a black dot on a white background, or slashes of red, blue, and green paint a la the noted contemporary artist Gerhard Richter

Just because drawings or paintings tell a sequential story should not automatically preclude that work from being considered art. If that were the case we would have to begin by invaliding, or denigrating, the work of William Hogarth, arguably one of the precursors of the graphic novel. Taken individually, his twelve paintings for *The Rake's Progress* are considered fine art. Looked at collectively, they comprise an early comic—and a richly detailed one at that.

(Side note for travelers: Hogarth's *Rake's Progress* paintings are in the remarkable and little-known Sir John Soane's Museum in London, not in the National Gallery. All the more reason to visit Soane's place. The chair from Hogarth's studio is there, too, along with a couple of nice Turners and much else.)

Comic art can be at least semi-abstract as well, if that is the critical criterion for modern art. Have a look at any Krazy Kat collection. Want surrealism the equal of Dali or Magritte? Drown yourself in the glorious aesthetic wanderings of *Little Nemo in Slumberland* by Winsor McKay. Art as contemporary commentary? These days there's Banksy, but no one could top the underground comic art of the '60's. Critical essays by the yard dissect the work of Robert Crumb (though I prefer Gilbert Shelton's *The Fabulous Furry Freak Brothers*) and Robert Williams. Original art by both "comic" artists go for many thousands.

On the other hand, we have the waste of paint by such acclaimed contemporary artists as Jasper Johns and Frank Stella, which sell for millions. My favorite example in this genre is the "work" of Roy Lichtenstein, who simply appropriated the efforts of numerous comic artists and blew them up to enormous size (recall my earlier column here about the same thing happening with sculpture). So while Lichtenstein's panels sell for zillions, the artists who originally generated the actual art, such as Irv Novick—whose panel Lichtenstein copied over and scaled up for his celebrated canvas *Whaam*—received neither credit nor royalties.

If that's art, then give me *Blacksad* by the Spanish comic artist Juanjo Guarnido (with writer Juan Diaz Canales). Better use of watercolor would be difficult to find anywhere. Is it "art" according to the current anointers of "fine" art? Probably not.

But I know which I'd rather hang in my house.

We Are All Art

While Perceivings is nominally a column about art or science, I do try once in a while to speak to a subject that manages to combine the two. LED art, for example, or the optics of color perception. Every once in a while, though, something so universal, so widely accepted, something that combines both art and science throughout the world, strikes me as so blatantly obvious that it's a wonder to me that I hadn't thought of it before.

I am referring, naturally, to T-shirts.

The internet, cell phones, television—as a means of communication and art they have nothing on the humble T-shirt. Plain cotton short-sleeved shirts existed before they were turned into works of art, of course, but it took the advance of science to turn one of the simplest articles of clothing ever invented into a means for mass communication and the world-wide distribution of art.

The US Navy first issued the undergarment we have come to know as the T-shirt in 1913, but it didn't fulfill its destiny as a means of artistic expression until the 1960s. In the decade prior, they initially became a venue for advertising, starting with a company called Tropix Togs and its far-seeing founder Sam Kantor. As a licensee for numerous Walt Disney Studio characters, Kantor discovered that printing Mickey Mouse, Donald Duck, et al on plain cotton shirts was a means of printing money that would not draw the attention of the Treasury Department.

The advent of rock 'n' roll saw the appearance of not just band members on T-shirts, but an explosion of psychedelic artwork that culminated in the procedure called tie-dying, wherein the shirt became the art and vice versa. Tie-dying owes a great deal to the Southeast Asian art form known as batik. In a wondrous twist of irony this is a development that has come full-circle, as any traveler to the region is likely to return home with a T-shirt that has been transformed with batik. That's world commerce for you.

Contemporary T-shirts feature appliqués as often as printing. The result is that today, anyone can put anything on a shirt. You can wear anything from the Grateful Dead to Goya, Rammstein to Rembrandt. Via

your clothing you can proclaim your interest in everything from fine art to low art, from a favorite beer to a favorite gear (if cars are your thing). While innumerable T-shirts flaunt little more than words, those that feature not just art for art's sake but advertising and individualized art are required to go through a printing or heat application process that until recently did not even exist.

Take a step back in time. Contemplate clothing, be it elaborate or workmanlike, and what it looked like prior to the introduction of the printed T-shirt. Shirt or jacket decoration was for the wealthy who could afford elegant stitching, lace trim, gold thread, and detailed embroidery. Yet even those kings and nobles who could pay to have jewels and medals strung from their waistcoats had no way to say much about anything other than themselves. "I am well-off" was about the extent of what a shirt could proclaim. Today, for a few bucks, anyone can wear any design that can be imagined, on a T-shirt. Elizabeth the Great wore pearls, but she couldn't easily say on her gown, "I am a pearl"… much less "King Philip II sucks" or "The Armada is going *down*". Accompanied by appropriate artwork, of course.

Here we see that not only is the T-shirt a venue for art, it has morphed yet farther into a delivery vehicle for political art.

I'm not talking about shirts that shout political slogans. I'm not even referring to those that combine art with politics, like the famous image of Che Guevara that adorned so many shirts back in the '60s. Forget smart bombs. Abjure cruise missiles. The T-shirt has been one of the most formidable weapons ever wielded by the US of A.

Because even in places where American television is banned, where expressing certain political opinions can get you thrown in jail or worse, the American T-Shirt is omnipresent and omnipotent. It may not feature an image of Uncle Sam, or the Declaration of Independence, but in China you'll find an astonishing number of T-shirts that feature art declaring them "Chicago Office, FBI" or "US Army Ranger" or "Property of the Chicago Bears."

How many T-shirts do you see, anywhere in the world, that say "People's Army Rules!"? Or "I love Karl Marx" (Groucho, on the other hand…). Exactly.

In poor countries, the printed T-shirt is perhaps the most ubiquitous article of clothing, and the vast majority of these arrive as second or third

or fourth hand-me-downs from the United States, purchased in huge quantities by sharp middle-men. Via the T-shirt, we have been flooding the Third World with our art for the past half century without even the KGB cottoning to what was going on. Call it stealth clothing.

So there you have it. The science of T-shirt printing allows the universal distribution of art which in turns leads to the triumph of democracy. Not even Ben Franklin saw that one coming.

We're All Furrys at Heart
(Even the Bald Guys)

Some of us wear fur. Thanks to changing mores (as opposed to charging more, which has always influenced who wears fur), even more of us wear fake fur.

Then there is the case of Stalking Cat.

Stalking Cat's real name was Dennis Avner. I meet Dennis a couple of times at "furry" conventions. Dennis held the world record for "most permanent transformations to look like an animal." Specifically, a tiger. Fourteen surgical procedures plus makeup gave him prominent canines, bulging cheeks, broad stripes, flattened nostrils, and much more. While he tended to alternately amaze and freak out non-furries, representatives of primitive societies would have understood immediately what he was all about. Namely, trying to partake of animal, non-human characteristics that we admire and can ourselves aspire to possess only in our imagination. That's why we dress up as animals for Halloween and office parties and costume balls.

Dennis died a little over a year ago. There was a melancholy about him that only manifested itself in quiet, private conversation. He was honestly sorry he wasn't born a tiger. While he was not alone in wishing this (as others might prefer to be an eagle, or a lion, or a gazelle), he went further than nearly anyone I know in striving to meet his goal. But no amount of plastic surgery could transform the human inside him.

Why do we do it?

Why are animal prints and patterns and accessories so popular in the world of fashion? It isn't as if there are no aesthetic alternatives. But we always see, regardless of how they are manipulated, animal spots and stripes, butterfly wings and fish scales, feathers and leathers adorning wasp-waisted models as they prance down the fashion runway. Every year, in endless permutations. It has been so since the beginning of time. Nor is this an affectation that's restricted to women. Zulu chieftains in South Africa still adorn themselves in leopard pelts (now trending,

thankfully, to faux ones) on ceremonial occasions. Senior chiefs and warriors in South America proudly put on their best feather necklaces and headdresses when attending formal political functions. In the Sepik River region of Papua New Guinea, young men continue to endure the ritual of having their backs scarred with sharp blades into which are rubbed fireplace ashes, resulting in lines of raised skin that closely resemble the scutes of the locally revered crocodile.

Why do we do it?

Such adornments are "pretty," to be sure. In primordial societies, it is often done in the hopes that the wearing of an animal's skin, or imitation thereof, will imbue the wearer with that particular creature's beauty, or powers. Wear eagle feathers and perhaps, in some way, you might fly. Put on a lion's mane to assume some of his strength. Wear a leopard coat (even a fake one) on Fifth Avenue and you'll not only be warm, maybe passers-by will find you sleek and strong and a little big dangerous.

What's going on here has nothing to do with what we see but what we think, and it's something that is true of both the wearer and the watcher. In that respect, from an anthropological standpoint we've changed very little from our ancestors who busied themselves finger-painting mastodons and horses in caves in France and elsewhere.

Humans dominate the Earth. We overpopulate and control and flick other species aside whenever it suits our needs of the moment. But we still, after hundreds of thousands of years of evolution, envy our biological brethren. Yes, we're smarter than the cat—but we'd love to run and hunt as fast and gracefully as they do. So we (pace, Dennis) dress up as cats. In our nakedness we envy the fox. So we wear fox. The wolf is stronger than we are, so (where legal), winter coat hoods are made of wolf (or again, imitation). You don't see men wearing winter coats boasting hoods rimmed with chinchilla.

No man wears a necklace to the beach that sports pig teeth. But tusks, or feline canines, or alligator teeth, or even a fossilized theropod dinosaur tooth: you see those all the time. Because even in this modern day and age, we still strive for a simulated connection with powerful or beautiful species through the wearing of their body parts.

We may be the ascendant species, but after tens of thousands of years we continue to partake of those primeval characteristics we like to believe we have left behind. Tell a friend your wallet is leather and you'll be

rewarded with a shrug, or a blank stare. Tell him it's sharkskin and you get an immediate reaction. Not because said wallet may wear longer than one made of leather, but because in his eyes you have suddenly taken unto yourself, however infinitesimally, the qualities of that ferocious creature.

It's all in the mind, not in the eye.

No matter how many centuries have passed.

Getting a Buzz from Woody

While for the beholder art is primarily visual, for the artist it's often as much about what is touched as what is seen. Tactility. A painter needs physical contact with brushes, or pens, or chalk, or a keyboard. A sculptor feels as much as moulds the material, be it stone, clay, metal, or Silly Putty. But there is something special about wood that goes back to the beginning of human artistic consciousness.

Maybe it's because unlike welding steel or chiseling marble or coagulating collages, wood is like us in that it is also an organic material. Wood carving makes art out of something that was once alive, just like us. Unlike other organic materials that are frequently fashioned into art like ivory or bone, wood is common. The woodcarver's material lies all around us, even in the depths of big cities. We grow up with it. We live with it and, often, within it. It's a material that is a part of our lives from the very beginning, lying in a wooden cradle or crib, to the end, when we are returned to the Earth encased in a wooden coffin (which, as it slowly decomposes, helps to refertilize the ground and… give birth to more wood).

Hand the average youth a hammer and chisel and point them toward a pile of rock and the first thing they're likely to do is put down the hammer and chisel, pull out their cell phone, and start texting. Brush and paint are usually ignored or result in, at best, unidentifiable splotches of color. Welding torches and tin snips we have to leave to the more mature. But hand a youngster a nice solid chunk of wood, give them a sharp knife, and sit back and watch. Unlike any other aesthetic medium with the possible exception of cave painting, woodcarving is even older than human civilization.

They feel natural in our hands, this combination of wood and a sharp-edged tool. Doesn't matter if the latter is made of steel, flint, or laboriously flaked obsidian. The urge to reduce, to transform, to bring something once alive but now dead back to life in a new form, has been with us since the beginning. I can't help but imagine that one of humankind's earliest words, now lost to us, was the Neanderthal term for "whittlin'."

And what other universally available art form is employed not just to create art, but to pass the time? Nobody paints just to pass the time. People don't chisel down and polish a hunk of soapstone or porphyry or marble to pass the time. Only whittling satisfies both desires: to mark the passage of time while simultaneously creating art, with neither objective necessarily taking precedence over the other.

In Hancock, Maine, dwells Ray Murphy. Ray is a bit like… well, picture a cross between Michelangelo and Leatherface from *The Texas Chainsaw Massacre*. Ray is a chainsaw artist who works, thankfully, exclusively in wood. He's in a lot of record books, not least for once chainsawing the alphabet on the side of a number two pencil. Once chainsawed his name onto the head of a match without lighting it. The artistic equivalent of performing surgery with a bazooka.

But at heart, Ray's just a whittler. The only difference between him and the old guys sitting on a porch in their rocking chairs carving away with their pocket knives is that Ray employs a somewhat larger and considerably noisier sharp-edged tool.

Then there was Tilman Riemenschneider, whose wood carvings astonished viewers in 16th-century Europe. Viewing his spectacular *Holy Blood Altar* in the town of Rothenburg ob der Tauber (Germany's Christmas city, for Prescott residents interested in another country's designation of a town as such) completely transforms the viewer's notion of what can be defined as "woodcarving." Seeing Riemenschneider's work is like viewing the drawings of Dürer rendered in wood.

It doesn't matter where the whittling hails from. Whether medieval European woodcarving, or modern Makonde art from East Africa, or blackwood from the Solomons delicately inlaid with bits of mother-of-pearl shell, or exquisite duck replicas fashioned in Virginia and intended for use as decoys, woodcarvers everywhere have that same love for their medium in common. That same essential tactility permeates their work just as it did for Paleolithic whittlers chipping away at their primitive masks while huddled together for protection against the predators roaming outside their cave. With no other medium does the artist feel as organic a connection. No other medium will get a child to try their hand at art with the same enthusiasm as will woodcarving.

I guess deep down and at heart, we are all whittlers. It's a connection not just to art, but to Mother Earth herself.

Fallacies of Advertising #8C (Eight Cylinders)

By my admittedly imperfect but likely adequate calculations, I reckon that in the course of my lifetime I've seen (been exposed to? been infected by?) something like 20,000 TV car commercials. They first began to impinge on my slowly coagulating consciousness while I was watching *Rocky Jones, Space Ranger*; *Howdy Doody*; and *The Kate Smith Show* ("When the moooon, comes over, the mouuuntain!") on our black-and-white blonde console Emerson TV back in the Bronx, New York. Though no more than between three and five at the time, one advertisement I distinctly remember was for the Oldsmobile Rocket 88. Not only did this mighty paragon of Detroit steel feature more chrome than typical kitchenette furniture of the '50s, the hood ornament was an actual rocket! What could be more appealing to a kid than a rocket except—a rocket coated in *chrome*. Pretty smart, those Detroit ad guys. Except…

They were wrong. It didn't work.

At least, in my case they were wrong. Setting aside the fact that, given the way our bureaucracy malfunctions, my dad could probably have obtained a legitimate driver's license for his gabby four-year old, all the Olds 88 advertisements I saw never propagated in me the slightest desire to actually *own* an Olds 88. But that neat hood ornament, now…

A lot of science is supposedly put into studying what persuades people to buy specific products. Whole battalions of psychology majors who are otherwise unable to secure actual gainful employment are vacuumed up by the advertising business with the sole agenda of trying to learn what makes folks buy this and ignore that. We've identified the regions of the brain that respond to pleasure, and to disappointment, to satisfaction and to pain. But we still haven't isolated that special, still sought-after corner of the amygdala that contains the specific network of "Buy!" neurons. It is entirely possible that this Holy Grail of Madison Avenue doesn't actually exist.

By way of proof, I offer those 20,000 car commercials. Most I ignored, notwithstanding the often exquisite locations ("See the USA, in your Chevrolet!"); the music that ran the gamut from Hendrix to Hermann, hip-hop to Holst; and increasingly, the elaborate digital special effects.

Oh, I *remember* the advertisements. That's self-evident. A few I even enjoyed, for their own sake. Among so many efforts directed toward any goal, a few must perforce prove memorable. So many that I sometimes wonder why the big car manufacturers just don't buy one of the major networks. Why place thousands of expensive Ford ads on CBS when you could just buy CBS, rename it the Ford channel, and deny access to all your competitors?

But not one, not a single one, of those thousands and thousands of ads ever persuaded me to even look at a certain car—much less buy one.

I doubt I'm alone in this. In fact, I suspect that I'm in the majority. We buy our cars based on research that we conduct ourselves, on recommendations from friends, on whatever dealer or individual gives us good value for our hard-earned cash, and on personal or family need. Not because of the dozens of flashy, incredibly expensive advertisements that afflict the airwaves during the commercial breaks for some of our favorite shows. We don't buy new cars because of heavy-handed product placement (*Transformers*, I'm looking at you) or because our home-town quarterback drives one (we know he's only driving it because the manufacturer gave it to him), or because it goes eight thousand miles per hour ("professional driver, closed track: do not attempt"), or because it's somehow favored by giant dancing hamsters.

Do you hear me, Detroit? *It doesn't work!* Television and movie advertising *don't sell cars*. I don't care what your "audience research" says. Researchers have their own agenda. Reliability ratings sell cars. Social media (person-to-person chat) sells cars. The recommendations of friends and neighbors sell cars. Not fast music. Not driving cars on beaches. Not helicoptering them to the top of buttes in Monument Valley or Canyon de Chelly. Not draping the impossibly handsome driver with even more impossibly beautiful women.

We car buyers are not handsome, we don't listen to music that loud, we don't drive on beaches (much less atop buttes in Monument Valley), and we sure as hell don't know any women who look like the ones in your ads, nor do we for one second believe that buying and driving your particular vehicle will suddenly make us irresistible to such exotic representatives of the opposite gender. We want reliable, reasonably priced, decent-looking vehicles that fit our individual wants. Preferably obtained via a buying process that doesn't entail dealing with characters

If You Shoot the Breeze, Are You Murdering the Weather?

who are all shady versions of William Macy's persona in *Fargo*, so that after we've made the second biggest purchases (after a home) of our lives, we can drive away feeling that we've acquired something worthwhile and that we haven't been cheated.

And if you think that interminable hammering of your product via television commercials is accomplishing that, then the only ones believing your own hooey for the last three-quarters of a century is you. Or to put it more succinctly.

It's... bad... science.

Pastafauteuils, with Fruits

He liked art, so he paid thirty bucks for them. Not apiece. For both paintings. At a lost/abandoned property auction. *"Fruits sur une Table ou Nature au Petit Chien."* Fruit on a table with a small dog. Not exactly dramatic subject matter. Neither is the subject of the second painting, *"La Femme aux Deux Fauteuils."* Woman with two armchairs. The fruit is nicely done. The woman in the armchair looks relaxed.

The first painting is by Paul Gauguin and is estimated to be worth between twenty and forty million dollars. The second is by Pierre Bonnard and is barely worth, oh, maybe a quick million.

The tale of how these two masterpieces ended up on the kitchen wall of an Italian factory worker is readily available for anyone to research. Or you can wait for the inevitable movie (where's Vittorio De Sica when you need him?). That's not what interests me here, nor the astonishing valuation of the two works. What fascinates me is what it tells us about the love of art and the perception of quality.

Our Italian, self-described art lover didn't work for the Uffizi Gallery, or the Borghese, or the Vatican museums. He was not a critic for one of the big newspapers in Rome or Milan, did not write learned treatises for slick magazines. He was a factory worker for Fiat. He made car parts. But he loved art, just like so many of the rest of us. And when the two paintings (unbeknownst to him, stolen in 1970 from the home of a British collector) came up for sale at that railroad lost property auction, he shelled out 45,000 of his hard-earned lira for them. He didn't know, or even suspect, that they might be valuable. He just liked the pretty pictures. Liked them more than whoever bid twenty dollars for them, or twenty-five.

In a department store or art shop you can pay a lot more than that for a halfway decent print of a Gauguin or Bonnard. Usually accompanied by some kind of printing beneath them identifying each painting as having been exhibited in Paris, or Berlin, or New York. Our unnamed art-lover didn't even get that bonus. There were only the pictures. Fruit on a table. A woman seated with a couple of chairs. Nice colors, nothing theatrical

about either composition, interesting brushwork. And the frames were good. They'll look nice in the kitchen.

Our preternaturally perceptive auto worker kept them for forty years. After a while, he could have sold them to a second-hand shop, or maybe at a garage sale. But he kept them, all that time. When he retired to Sicily he took both pictures with him. That must have required at least a bit of care and effort. The pictures aren't small. They would have had to have been packed carefully.

Did he see genius hidden in his two purchases? Did he suspect they might be worth more than he had paid for them? Maybe, oh, a hundred dollars?

No. I think he just liked—the art. He must have, to have kept and cared for them for four decades. How many of us acquire "art" and dispose of it when we move, or when we grow tired of it after ten or twenty years, or give it away to friends or relatives?

Forty years. The true nature of the paintings only came to light when the man's son saw another Gauguin in a book and remarked on the similarity to his dad's old kitchen décor.

So—what happens now?

The original owners have both died. They have apparently left no heirs. It is possible that their property went to a trust, a charity, or a museum. If that's the case then both paintings might legally belong to any one of those institutions.

And yet…

Our auto worker bought them fair and square, utterly ignorant of their burgled provenance. Forty years have passed. I don't know if there is a statute of limitations on charitable gifts in Britain, or what the legal ramifications might be. And of course it would now be dangerous for the present owner to keep two such hugely valuable works in his home. In Sicily, no less.

But as romantic and unreasonable as it may be, I prefer to think that they might stay with him, at least until he dies, the Gauguin and the Bonnard keeping one another company. Perhaps in the kitchen, while someone prepares bread and pasta and the rich warm smells of Italian cooking fill the little house. As well they stay there as in any museum.

Because I know they are appreciated by their owner. And that's what art is, ultimately, all about.

Artistic Obsession

What is artistic obsession? What drives individuals or groups to complete a work of art regardless of whatever the odds?

How about an eccentric forty-two-year-old composer dwelling in obscurity who spends eight years of his life writing a symphony larger than anything of its kind, with virtually no hope of hearing it performed? How about a group of dedicated music aficionados who spend twenty-eight years attempting to get it performed—in Brisbane, Australia. Not Sydney, not Melbourne: Brisbane. How about a small coterie of filmmakers who spend years striving to put together a documentary film about said performance—which may never occur?

There you have it. Artistic obsession in triplicate.

The composer's name is Havergal Brian, the piece in question is his first symphony, better known as *The Gothic*, and the documentary film is *The Curse of the Gothic Symphony*. Cursed, perhaps, because so many times performances that came near to happening ended up collapsing under the weight of the composer's specifications. Even those who are not fans of classical music can appreciate the daunting rehearsal requirements.

An orchestra of two hundred musicians, utilizing essentially every instrument known to the modern symphony orchestra. Thunder machine! Bird scare! Four separate symphonic brass bands. Four soloists. Two children's choirs. Four adult choirs of 150 singers each. About a thousand performers altogether.

One of the great problems in performing *The Gothic* is—where to put the audience?

This and hundreds of other difficulties, most notably financing, confronted the Australian Gary Thorpe when he began trying to get *The Gothic* performed in Brisbane beginning in 1982. Swept up later was the filmmaker Veronica Fury. Both, along with the dyspeptic but fascinated conductor John Curro, are among the many who appear simultaneously captivated and appalled at the prospect of trying to stage *The Gothic*.

There is nothing in all of music quite like Brian's first symphony. From a poor family, Brian was self-taught, largely ignored by the British

musical establishment, and after a few initial successes with much smaller and more conventional works, forced to eke out a living on an admiring industrialist's stipend that was abruptly cut off when the composer's first marriage fell apart. So while working assorted jobs during the day, Brian was forced (compelled?) to write out the gigantic score of *The Gothic* only in moments snatched during periods of spare time. Brian said that *The Gothic* "wrote itself." Sure it did—over eight years.

Who persists at something like that? If Brian's smaller, livelier pieces went unperformed, what chance was there for an enormously expensive colossus like *The Gothic*? That didn't dissuade the composer. Furthermore, he wrote the entire Godzilla of a symphony out on paper without even being able to compose it on the piano, or any other instrument normally utilized for such a purpose. It was all in his head.

Nobody did perform *The Gothic*. Not until a group of amateurs did their best to stage it in 1961. The first professional performance finally took place in 1966. And the still largely ignored composer was there to take a bow, at age 90. Not that age slowed Brian. Irrespective of indifference, he never stopped composing, and in fact wrote four operas and twenty symphonies after turning 80. Just like there is nothing like *The Gothic* in music, there is nothing like Brian's protean output at such an advanced age, though none of his subsequent works matched *The Gothic* in sheer scale.

Only possibly his setting of Shelly's poem *Prometheus Unbound*. Even bigger in ambition than *The Gothic*, this cantata requires similar orchestral and choral forces and runs four-and-a-half hours. But we'll never know how it compares to *The Gothic*.

A conductor lost the only manuscript.

Even today there are hopes it might surface, somewhere in the musty depths of the BBC's offices in London. What a performance that would be!

Like the symphony itself, like the Australian performance in 2010, the documentary *The Curse of the Gothic Symphony* reflects what many would call a deep well of artistic obsession on the part of its makers. Unlike the long-ignored symphony, the film has won numerous awards and been duly praised. I don't expect it to play Prescott-area cinemas. I'm not sure it will play Phoenix-area cinemas. But the dvd is available, and with luck the film might be shown one day on PBS or HBO or some other

venue. The appetite for new material on TV today is bottomless, and the film deserves a wider audience in this country.

By sheer coincidence, six months after the Brisbane performance, *The Gothic* was given its sixth performance to date, and the first with full forces, by the BBC as the opening concert of its venerable London Proms series. I was there. Greatest musical experience of my life. Having listened to recordings of *The Gothic* for years, I had not choice but to go.

It was something of an obsession, you see.

The Art and/or Science of Travel
(double column)

The closest I've come to writing a travel book is *Predators I Have Known* (Open Road Media). Useful perhaps if you expect in your journey to encounter tigers or leeches or great white sharks. Not so efficacious if you're having trouble deciding on a rental car or airline. For that, I heartily recommend Christopher Elliott's new book *How to be the World's Smartest Traveler*, an extensive and enlightening tome from National Geographic Books. It'll walk you through just about everything you need to know from before you leave until the time you get home… and afterwards, if there are subsequent problems.

But as I have picked up a few observations of interest in 40+ years of world travel, I thought it might be worth sharing them. Since these don't relate to dealing with lions or snakes or whale sharks, I'll call 'em the art and/or science of overseas traveling, and drop them off here. Maybe they'll do some travelers some good. I don't think I'm duplicating any of the stuff in Chris's book.

Passports & visas: Always make sure you have *plenty* of extra empty pages in your passport. Because where one country's visa will be the size of a postage stamp, the next one will require two entire blank pages (for entry & exit). Interestingly (and tellingly), the more third-world the country, the larger their visa stamps.

Planes: If you're in economy, get seats as close to Business Class as possible. It's quieter. If you're considering an unrestricted economy class ticket, always check out Business class: it often only costs a little bit more. Economy Plus seats offer more space and are, to me, always worth the extra money. Never sit in the last two or three rows because your aisle will eventually be full of lines of people waiting to use the rearward restrooms. The worst seat on a plane is the last aisle seat.

Don't be afraid to buy airline tickets when you are overseas. When I flew from Kiev to Odessa, I bought my tickets on the spot for a local airline. Cost much less than if I had purchased the very same tickets in the US, even utilizing the same airline's website. Same thing happened in

Malaysia. Why? Because it is assumed that mostly local people will be using local versions of an airline's website, and the airlines price tickets on those sites accordingly.

Budget airlines overseas can be a real mixed bag. Dragonair, for example, is excellent. So is Air Asia. Ryanair, not so much. Ask around before you fly.

Luggage: If you have to pay for a checked bag, use hard-sided luggage if you can. The difference in weight probably won't matter. The difference in protection of your stuff always will. Always put a strap around your checked luggage: protection in case TSA forgets to relock it, or latches break. Where luggage wrapping (with clear plastic wrap) is available overseas, always use it. You'll see the service offered at numerous airports. The heavy-duty wrap protects against casual thievery, luggage damage, and the intrusion of water and dust. The cost is minimal compared to the potential losses you prevent.

Never overpack. Include a small folding bag or case in your checked luggage. Better yet, if you need more luggage (to bring home all those extra goodies you'll buy overseas), buy a bag or suitcase there. Second-hand stores and flea markets are a great place to find cheap but good luggage.

If traveling light and flying only with carry-ons, consider backpacking luggage. This is backpack-style gear where one or more components zips off the main bag. This is particularly useful if you find yourself transferring from a large aircraft to something like a commuter jet. Zip off the smaller bag and hey presto, both bags fit in the tiny overhead luggage compartment. Zip them back together again for convenience while walking. And always, always, buy luggage with wheels! No matter how small the bag is.

Taxis: Always make sure your driver knows how to get to your destination before getting into his cab. Always agree on a fare ahead of time if there is no meter. If there *is* a meter, make sure the driver turns it on. If he says it's broken, find another taxi. Never put all your luggage in a taxi without ensuring that you can get in the car before or as rapidly as the driver. Years ago a nephew of mine arrived in Madrid, loaded his luggage into the trunk of a taxi, and watched dumbfoundedly as the driver got back in the car and drove off with all his stuff.

Food: Where can you find the best, most reasonably priced, most filling meal for the money, overseas? Any Chinese buffet restaurant. Lotsa

food, much of it familiar, at fair to downright cheap prices. Why? Because visitors to *other* countries don't eat at Chinese buffets, which means the owners have to satisfy *local* customers both in quality and price.

Okay: what about local food? Where can you find the most reasonable, tasty, authentic local food overseas? The restaurant(s) in a nice department store. For the same reasons as the Chinese buffet. In any country, including the US, department stores offer good food at reasonable prices to entice you to enter and hopefully shop in their establishment. They dare not overcharge or serve bad food.

What matters is not where the food is from, or even what it is, but that it is thoroughly cooked. I've had excellent street food in South America and Africa without ever getting sick, but contracted debilitating abdominal problems in fancy hotels in Lima and New Delhi. The street vendor dare not let his customers, who are all his neighbors, get sick, because word will get around and he'll be out of business the next day. Whereas cooks and food handlers and dishwashers in five-star hotels know they won't ever see you personally, so unless they're thoroughly supervised they don't give a damn.

Water: Wherever possible, always utilize bottled water. If you want an iced drink where the water supply is questionable, make sure the ice (even in fancy hotels) is made with filtered water. Don't be embarrassed to ask (traveler's diarrhea is more embarrassing than asking if the water is filtered). Watch out in certain third-world countries for bottled water where the bottle has been refilled with tap water and the cap has been resealed (look for melt lines around the seal).

Money: Traveler's Cheques are pretty useless anymore. ATM's are everywhere. The more tourists a place sees, the more likely it is to accept credit cards. But always have a decent amount of local cash on hand. For example, outside the big cities, gas stations in Turkey don't accept credit cards: only cash.

Watch your denominations. When a local currency boasts lots of zeros, it's easy to lose track of what your cost should be. Don't let yourself be rushed when counting your change. Always check your receipt *after* you have signed and your copy is returned to you. Make sure the amount hasn't been altered. As in, for example, that 40% tip you didn't write in or the expensive wine you never ordered.

One scam is to adjust calculators in small shops so that they add an extra five or ten percent to your bill. If confronted, the proprietor will

exclaim, "Oh, that one must be broken," and hand you an unaltered machine. Be aware.

Medicine: Three things I never travel anywhere without: aspirin, for general pain as well as headache. Imodium, for diarrhea. Aloe vera gel, which is dirt cheap and can be used to treat everything from sunburn to cuts to itching to the stings of tropical ants. Plus, a little goes a long way.

Hotels: I've walked in off the street into expensive hotels, asked if there were any rooms available, and been offered some terrific deals on the spot. If a hotel has space available (especially for a short stay), they'd much rather rent to you on the cheap than let it go empty. This works in any city on the planet. But you have to be willing to show up in, say, a place like Kota Kinabalu with luggage in hand, no reservation, and a willingness to shop around.

If commuting between cities, consider taking a sleeper compartment on a train, if one is available. Not only is it the most comfortable way to travel, but you'll save the cost of a hotel room for the night. Where crowded national trains offer only shared sleeping compartments, offer to pay for both berths. You'll have complete privacy and more space. It'll be worth it. You'll arrive in your new destination rested and refreshed. Plus, if you're crossing a national border, you'll be processed by Immigration and Customs on the train. No officious road guards and no airport security to mess with.

Customs & Immigration: Particularly in third-world countries, going through your luggage is the only entertainment these people will have all day. So be patient, never argue, and smile. If a Customs official holds up your camera and says, "Nice camera," he might be fishing by trying to intimidate you. Don't fall for it. Just say, "Not really." They'll figure out you're not going to offer them anything and let you pass. Never appear nervous or in a rush. If they see that you're in a hurry, to make a plane connection for example, they'll slow down until you offer money. For "expedited" service.

Never, ever, admit to anything even remotely illegal. In the city of Nagpur, India, I was pulled out of line and taken to a small office where a police officer said right off the bat, "I know you're carrying drugs. Why not tell me where they are now and save us time and trouble?"

I admitted that I was carrying drugs. Aspirin, Imodium, etc. This banter went on for half an hour. At the end, he apologized by saying he

was just doing his job, and put me on the plane. Last one on board. Moral: be pleasant, don't get angry. The guy really is just doing his job.

Second moral: Guys, especially older ones. Consider not traveling with a mullet, and take out that earring for the duration of travel. All Customs & Immigration officers have seen every episode of *Miami Vice* at least six times and it has messed with their heads.

Of Diseases and Wheezes

PETER BLOOD
"*And what becomes of his Excellency the governor's gouty foot?*"

COL. BISHOP
"*You'll not save yourself with that device this time. <u>Nothing</u> will save you!*"

Starts to horsewhip the pillar-bound Blood. CANNON FIRE! interrupts him.

LOOKOUT
(pointing toward the sea)
"*Pirates! Spanish pirates!*"

I was not saved by the timely arrival of Spanish pirates. Not from horsewhipping, nor more relevantly, from gout.
　I first heard of gout and had it forever embedded in my memory from repeatedly watching the greatest pirate film of all time, *Captain Blood*, over and over and over again as far back as the late '50s on Million Dollar Movie on Los Angeles's original channel 9. Yes, kiddies, it's even better than all the *Pirates of the Carribbean* films put together. Hell, it's even better than the *ride* (the original ride, of course… not the current bowdlerized one).
　But this isn't about pirate films, old or new. It's about gout, which flung itself out of an old black-and-white movie and into my body a couple of months ago.
　My left big toe had become red, swollen, and was burning as if a tribe of cannibal ants had decided to set up a cooking school somewhere in the vicinity of the first joint. I couldn't put any pressure on it. I didn't remember stubbing it, or kicking anything, or kicking anyone. Still, it could be broken. Or perhaps it was the long-dormant blossoming of some exotic tropical disease I had contracted in Gabon, or New Guinea, or some

other corner of the world where germs laugh at aspirin and anything less than doxycycline is regarded as a pre-dinner cocktail for the local bacteria.

At my wife's gentle admonition after gazing upon my now carmine-colored digit ("You're going to the doctor. *Now*.") I finally gave in to her good sense... and the pain... and betook myself to that venerable office. When was the last time you just walked into a doctor's office short of any major internal organs hanging out of your torso and actually got to see a physician? Or managed to battle your way past the now-standard outer office Pretorian Guard? Right.

So I highed myself to the nearest Urgent Care, where everyone was friendly and welcoming and I was seeing a physician's assistant within ten minutes. He listened to my description of symptoms and possibilities, took one look at my inflamed toe and said knowingly, "Gout."

Pirates! Spanish pirates!

I *couldn't* have *gout*, I protested. Gout was an affliction reserved for overweight, bewigged 18th-century gentlemen who dined on partridge tongues and quail eggs. For those who supped on creamed grouse and pate de fois whatever-liver-was-handy. For the giddy governor of Port Royal, Jamaica, whose condition essentially saved Errol Flynn's (sorry... Peter Blood's) life!

I work out regularly. I watch my diet (okay, I had that chocolate cake last night, but still...). Yes, my profession is a sedentary one, but I eat sensibly and keep moving. I couldn't have gout!

A prescription was called in for me. I picked it up at our local Walgreen's. The pharmacist glanced at it, looked at me, and said, "Gout?"

I conceded. I had gout.

Which got me to thinking. About how the human species is like a long-distance runner. We fool ourselves into thinking that we've conquered many, many diseases, and that cures for a great many more lie just around the pharmacological corner. But Nature, she's sneaky. She follows along in that race, drafting in our self-confidence. And when we trip over a rock, or slide down a mis-gauged slope, or lower our sight to check our shoelaces, she's right there to pass us and whack us on the head as she goes by.

True, we have beaten some ancient diseases. Because we kept our focus and kept charging resolutely toward that goal. Smallpox, the scourge

of the non-European world, is beaten. We would have crushed polio by now except that we keep tripping and stumbling in forlorn, sad places like the tribal areas of Pakistan and parts of west Africa. We're working hard on malaria, AIDS, all forms of cancer and heart disease, among others. We're leading the race, we brilliant, innovative humans.

But just when we're certain that modern medical science will find a cure for everything that has ever afflicted us, Nature reminds us that she, too, is always working. In the race to find new treatments, new vaccines, new prophylactics for common diseases, we all too often forget about the old ones that lurk in the dark places just waiting for us to slow our pace of discovery and look away.

Take Ebola. Please (no, that's not even slightly funny). Confined to a small part of central Africa, right? Until it shows up unexpectedly in west Africa, brought there by a single carrier. Over 200 dead from it in Sierra Leone alone. Or those horrible tropical diseases we don't have to worry about here in the good ol' US of A. Like dengue fever (24 cases in Florida in June) or the even more exotic chikungunya (18 cases in Florida in June). There are no vaccines for those pretties. None.

Alas, the old can be new again: even where disease is concerned. And can mutate into new and ever more virulent forms. Maybe even like gout. So we'd better keep running and keep our focus on the medicinal research that barely sustains our species, because one thing's for sure.

Spanish pirates won't save us.

Jihadi MTV

Social media used to report war: not drive it. Modern technology has not only changed how war is reported; it has changed how it is conducted. Fighters today need two sights. One to look down the barrel of their weapon to bring their target closer, and a second so they can locate TV reporters, internet tweeters, and the twelve-year-old down the bombed-out street holding up a camera-equipped cell phone. We've gone from waiting weeks and then days for war news to seeing it on the internet as soon as it can be posted. What not every media-enthused battlefield participant seems to understand is that this instant reportage can cut both ways.

"Hi folks! Here we are today on Normandy Beach, where as you can see the allies have established a secure beachhead. Even now, members of US, British, Canadian, and Free French forces are pushing hard inland, driving the enemy before them. We'll be uploading pictures from the liberation of Paris any day now!"

It's all well and good when events go that way. On the other hand, you might get...

"Good day from the Balaclava Heights. As we survey the magnificent panorama set out before us, the morning sun gleaming from the hundreds of helmets of the light brigade as they prepare for their triumphant charge up the North Valley, we expect shortly to be able to show you scenes of the Russians abandoning their positions in the face of the indomitable British Cavalry."

Note: Here we are, two hundred years later, back in Crimea again (does nothing change?). Only this time, war reporting is not conducted via telegraph wire and newspaper reports. It occurs nearly in real time, and knowing how to manipulate that media is as important— if not more important—than knowing how to manipulate lines of troops and artillery.

Technology changes tactics, and not just because satellites can see what opposite sides wish to keep secret. The battle these days is as much for hearts and minds as for acres of ground. The Russians didn't remove all identifying insignia from their vehicles and soldiers' uniforms in the eastern Ukraine because they planned on updating the units involved.

They did so because to maintain a battlefield fiction these days, you must be aware that there are cameras everywhere, and curious eyes abounding.

Yet—it's impossible to do. Modern technology reveals all, as in the hastily grabbed shots of invading armored vehicles making surreal sprints down backcountry roads, or the quick shot of a local Ukrainian "volunteer" with his watch set to Moscow time.

In contrast to those fighters who try to conceal their identities and activities we have those who strive to do the opposite: to utilize the availability of instant visibility to promote instead of disguise their particular agenda. Not only al-Qaeda but al-Shabab and now ISIS seem to compete as much with on-line video as with guns. One can almost envision their respective leaders surfing the net to compare, not material victories, but visuals.

"See how they shoot—I mean record—their advancing column from behind? It gives the immediate impression of pushing forward, of pushing the enemy back. Look at that guy running and firing his machine gun! He's not firing at anything in particular, of course, but the muzzle flash is a great image! We need more of that. And music—we need better music in our videos!"

Of course, to some extremist elements, music is something of the devil. That's been an ongoing argument in certain quarters for hundreds of years. But apparently it's wholly acceptable when it accompanies visuals of folks blowing other people up, because it makes for a better recruitment video.

How do you score a beheading?

Wouldn't it be nice if, instead of all these groups obliterating innocent civilians, they just cut to the chase and had a video competition? They could call it an "a-war-show." Winners receive a statue of the god Mars (no, wait... no representations of human figures allowed). A gold-plated AK-47 would work. Awards would be given for Best Infiltration, Most Effective Demolition, Most Skilled Armed Toyota Pickup Driver, Best Excuse for Invading (the Russian "I'm here on vacation" is leading contender in this category right now), Most Knowledgeable About War Movies, Most Skilled IED Placement, and so on. Whichever side wins the most prizes wins the war. For a year, anyway, until the next awards show, exclusive to the Atrocity Channel.

If You Shoot the Breeze, Are You Murdering the Weather?

If there's one truism about technology, it's that it invariably ends up being used for purposes that its inventors never intended (see: Nobel, Alfred). Sometimes, in war, these even overlap, as with the Russian minister who insisted that US satellite photos of Russian armor on Ukrainian soil were actually drawn from a video game.

Now *there's* an idea. Let's have all sides resort to a video game set in the theater of combat, and have the outcome determined by who wins the game. Nobody would get hurt. Combatants wouldn't even have to be present. They could compete safely from the confines of their own respective headquarters without ever risking actual physical contact with one another. The war could even be recorded for viewing later, preferably during prime time when it would sell lots of pickup truck commercials. One possible drawback is that such combat might drone on and on....

And yes, that pun was intended.

How to Create a Successful New TV Series (In One Column)

Even moreso than the movies, television has always been infamous as a medium in which lip service is given to originality. Ask the relevant executive or producer in Hollywood what they would like to see in the way of a pilot for a new show, and like as not they'll reply, "We want something original! Something new and unexpected, something edgy! Something nobody's seen before!" (All these folks end their spoken sentences with exclamation points that appear, hovering like drifting, dark spiderwebs, directly above their heads.)

This is entertainment industry-speak for, "What we really want is a copy of the current #1 hit show—but just different enough so that we can't be sued!"

It started with situation comedies, because they were cheap to make. It became egregious to the point of absurdity when police dramas and lawyer shows hit it big and immediately began slavishly imitating one another. The latter are particularly noted for their essential interchangeability. If you watch enough of them, it gets to the point where you can no longer tell who is prosecuting whom. There are more personal injury lawyers on American television than in all of Japan. As if that's not bad/sad enough, their presence is supplemented by the interminable advertisements for the real ones. You know the latter. My personal favorites are the ones that attempt to inveigle you into contacting them by alluding to incomprehensible but nearly universal diseases.

"HAVE YOU OR A LOVED ONE EVER WORKED IN A FAST FOOD ESTABLISHMENT? IF SO, AND YOU'VE EVER ENCOUNTERED DIFFICULTY SMELLING, YOU MAY BE ENTITLED TO A PORTION OF A CLASS ACTION SETTLEMENT ON BEHALF OF THOSE SUFFERING FROM A PERMANENT INABILITY TO DISTINGUISH BURNT BACON FROM BOILED SUCCOTASH. THE FIRM OF HIDE, DUCK, AND COVER MAY BE ABLE TO RECOVER A PORTION OF THE OUTSTANDING FUNDS FOR YOU. OPERATORS ARE STANDING BY.

"[This is not an offer of solicitation, even though we're plainly soliciting you. Offer not valid south of the 54th parallel or west of Guam. Principal attorney Lackland Quackenbush, lic. suspended, based in St. Kitts and Nevis]."

But I digress.

I didn't think this filmic copycatism could get any worse, but the entertainment industry never fails to surprise, and with the advent of "reality" shows, they have done so. The mad scramble to copy successful reality shows like *Deadliest Catch* and *Bering Sea Gold* reminds one of a procession of lemmings (and don't tell me that the lemming story has been scientifically disproved—you'll ruin my analogy).

Science says that to understand something, it is often best to reduce it to its most basic component. I therefore propose the creation of a can't-miss, sure-fire reality show based on reducing (yes, ad absurdum) the most pertinent ingredients to their primal elements, and then combining them. So... what do we have?

Dangerous fishing: *Deadliest Catch*, *Cold Water Cowboys*, *Catching Hell*, *Extreme Catches*, *Wicked Tuna* (I am not making these up).

Gold: *Bering Sea Gold*, *Bamazon*, *Gold Rush Alaska*, *Black Gold* (okay, that one's a cheat... but it's got "gold" in the title), *Jungle Gold*, *Yukon Gold*.

"Survival" shows: *Dual Survival*, *Man vs. Wild*, *Best Defense Survival*, *Surviving Disaster*, *I Shouldn't Be Alive*, *Expedition Impossible*, *Survival Life*, *Dude, You're Screwed* (points for not using "survival" in the title), and last but not least among this ignoble list, *Naked and Afraid*, whose attraction to viewers has nothing whatsoever to do with survival.

I'd mention *Survivor*, but that's a game show.

Aliens (okay, they're mostly un-reality, but that's how they're categorized): *Uncovering Aliens*, *Ancient Aliens*, *Alien Race*, *In Search of Aliens*. I don't include *Alien Encounters* because... because (mumble, mumble... I'm on it... additional mumbling...).

Okay; what've we got? Dangerous fishing. Gold. Survival. Aliens. Putting our collective genius together, we arrive at...

Fighting to survive among dangerous fish as we search for alien gold.

Can't miss. Now we need a title. Utilizing still another currently popular reality show trope, we announce the looming production of the hunt for...

Surviving Shark-Guarded Alien Gold!

Dangerous fish. Gold. Survival. Aliens. Sharks (bonus points).

I hereby declare the aforementioned idea copyrighted, notwithstanding an almost overwhelming urge to giggle uncontrollably. The show's symbol will consist of a lump of gleaming pyrite slashed in half by a Popeil Pocket Fisherman. Sponsors of new products, AS SHOWN ON TV!, who offer unconditional money-back guarantees (and which are invariably sold from a post office box in New Jersey, and for returning you pay only shipping and handling, which inevitably equals or exceeds the actual cost of the product), will fight to sponsor the show. A fortune will be made by all.

But I'll have to surrender my membership in any and all recognized writers' organizations, and never show my countenance at a writing confab ever again.

In the Eye of the Froot Loop

I don't mean to particularly pick on Froot Loops. Or instant coffee, or pretzels, or the potato chip flavor of the moment. Or Wheat Thins, or ice cream. It's just that anymore it seems that they all have something disgraceful in common. They lie.

Yes, that smiling Cap'n Crunch and grinning Count Chocula and even neighborly Juan Valdez and his patient donkey are liars. But they're not bold-faced liars. Their prevarications are subtle and carefully thought-out. I'm speak of the art of visual deception, of consumer product prestidigitation, of how contemporary manufacturers strive to convince your mind and your eyes that you're getting something you're actually not. It's been getting worse for years now.

Humans are a very visual species. We possess an excellent memory for observed objects. Nowhere is this predilection more evident than in the supermarket. We grow up tagging along with our parents as they shop. Without realizing it or intending to do so, we mark for future reference the size, shape, and contents of familiar containers. This is what the equivocators among present-day manufacturers rely upon: visual memories that are ingrained in our consciousness.

Like most of us, I've known this has been taking place for years, but it didn't really hit me until I was perusing the ice cream section and saw, bravely emblazoned across a container of Ben & Jerry's Chunky Monkey, "Still a pint!" So I did a little investigating and, sure enough, found all kinds of discrepancies in that one department. Like a "pint" of Häagen-Dazs that was actually 14.5 ounces. Or "half-gallon" sizes that contain 1.5 or 1.75 quarts (Blue Bell, a la Ben & Jerry's, is bold in proclaiming "Still a half-gallon!").

How do manufacturers get away with such patent double-dealing? By using the same methods as stage magicians. Both fool and confuse you by relying on your visual memory. One assumes that a container that appears to hold a pint still does so. When this approach fails to persuade, producers will change the packaging. Large cylindrical half-gallon containers will be replaced with fancy new oblong packages that contain

less product. But if they're all stocked side-by-side in the half-gallon section, a shopper will assume the new packaging will hold the same amount as the containers they have replaced. To divert your attention, and focus, the manufacturer will often plaster "New and Improved!" across their redesigned packaging, much as a magician will wave one hand to draw the eye away from the other hand that is performing the actual trick.

Sometimes it's not even necessary to change the packaging. A manufacturer will simply stop listing contents, replacing them with the presumably more informative "nutritional information." Studying all these details occupies the shopper's thoughts to the point where they forget to check the actual amount of food they're buying. My favorite method of visually fooling the shopper has nothing to do with changing the packaging so much as it does with simply reducing the contents.

When was the last time you bought a bag of chips that was noticeably more than half full? Or pretzels? Or loose crackers? Why have cough drop manufacturers switched to bags instead of boxes? The box may be the same size as the one your parents bought, but contain less food. The bag of cough drops may be bigger than the box it replaced yet container fewer drops. This deception fools not the eye but the mind. It's also usually accompanied by the manufacturers of dry foods' all-time favorite exculpatory line: "Contents may have settled during shipping."

True enough. Of course, there may also have been less in the way of contents to start with. If I ever opened a bag of loose crackers, or cookies, and found it full, I think my brain would seize up from the shock.

Medicine and not food is the worst offender. You know to what kind of packaging I refer. A box, containing a bottle one-third its size, which in turn is less than half full. One day I reckon we'll be down to a fist-sized box that holds a thumb-size bottle than has seven pills in it. The label, invariably written in the smallest print allowable, will truthfully declare, "Contains a full week's dosage." As opposed to saying; "contents: seven capsules."

So be alert while shopping for that pound of bacon that weighs 12 ounces, that bag of Cheetos that contains more air than the food item itself, and the two-liter bottle of soda that holds notably less than two quarts. You're no longer on the savanna gathering seeds, and you need to forget your eyes and use your mind.

I've found that shopping while maintaining a persistent sense of outrage is also helpful.

Don't Bach Down

As a lover of many kinds of music, from gamelan to guitar, from taiko to kazoo, the artificial gulf that continues to separate "popular" music from classical music has always bothered me. And by classical I don't mean the Beatles or Led Zeppelin. What's ironic is that pop musicians have always embraced classical music, and a surprising number of today's pop composers have had some classical training. On the other hand, the classical music establishment prefers to dwell in a terrible funk (we'll talk about funk another time). It desperately craves the adoration, attention, and income that pop produces while simultaneously decrying most popular music as a mere shadow of what "real" music ought to be.

None of which stops "serious" orchestras and serious musicians from making a good part of their income playing in Pops concerts every year. For many serious classical musicians, Pops series are a bit like the drunken uncle no one in the family really wants to discuss. He's part of the family, and he paid for that vacation in the Bahamas last year, so we have to tolerate him. But we gossip about him behind his back, and secretly wish he'd just go off on a permanent bender while leaving us the money.

This particular conundrum is less acidic than it used to be, though. Perhaps because so many orchestras drift in straits ranging from dire to difficult and there's money to be made by performing crossover concerts. It's really not a new idea, to which anyone who remembers Procol Harum's gig (and fine recording) with the Edmonton Symphony Orchestra can attest. There was a "band" called Electric Light Orchestra that synthesized pop and orchestra quite effectively, although their efforts were limited in scope due to budget constraints.

In fact, I don't understand why we don't see more straightforward orchestral transcriptions of pop music. Instead of bringing in Metallica to play in front of the orchestra, why doesn't some enterprising symphony association commission a suite of transcriptions of their perfectly marvelous music for the orchestra itself? I'd love to hear a concert overture based on "Enter Sandman."

Or consider AC/DC's *Who Made Who?*, a candidate for the full orchestral treatment if ever there was one. Crescendo with coda, and partially fugal in structure. Copland wrote a *Fanfare for the Common Man*. AC/DC does a Fanfare for the Common Fan. Where's Robert Russell Bennett when you need him? (hint: he's the composer who orchestrated Richard Rodger's award-winning music for the TV show *Victory at Sea*).

The opportunities for transcribing popular music for chamber orchestra are even greater than they are for full symphony orchestra. "Eleanor Rigby" would be terrific played by a standard chamber quartet. One of the best covers ever of Hendrix's "Purple Haze" is by the Kronos Quartet. I'm not sure garage metal lends itself to violin, viola, cello, and bass, but I'd sure love to hear someone give it a go.

It's not that the best efforts don't meet with a certain amount of acclaim, from both constituencies. Mark O'Connor may be a popular fiddle player, but his classical compositions garner accolades from both strait-laced classical aficionados as well as his "pop" audience. A lot has to do with presentation, as I had to explain to numerous concert goers who were sure that *Pictures at an Exhibition* was written by Emerson, Lake & Palmer. On the other hand, Mussorgsky never envisioned a rotating piano complete with player. Music as portrayed via aerodynamic engineering.

Heck, if George Gershwin could find acceptance as a classical composer, surely there are young musicians out there who can write the same music for strings as they do for strats. Modern orchestras want to know. They, and the young audiences they crave, are waiting for you.

Meeting Our Holidays Coming

It's getting worse, and I don't know if I can take any more coerced happiness.

JoAnn pointed it out to me the other day. We were discussing holidays, not Einsteinian physics, but somehow the two began to overlap.

"I understand," she said, "if you're making crafts for Christmas presents and you need to get started on the work by July… but otherwise, it's gone crazy!"

She's right. When did holidays start accelerating beyond their designated dates, leaping forward in the space-time continuum? Christmas is the worst offender, but it is no longer alone. The depressing situation now affects every holiday; even those bloated by the government for political purposes (Labor Day) or the greeting card companies for pure profit (Valentine's Day) or the candy companies for a boost to the bottom (our bottoms) line (Halloween). The proof can be found in any store.

Christmas was a couple of days ago. The speed with which the majority of Christmas products vanish immediately after Christmas is astounding. Do the companies that manufacture the relevant holiday-themed products tote around mini-black holes in which to dump the stuff? Do the bins filled with 50% off Christmas items contain mini-disintegrators that self-activate after one week? And what *immediately* fills the shelves formerly occupied by snow globes, enough colored lights to reach from the Earth to the Moon, faux wreaths, perfectly shaped mini-conifers, and Christmas-themed candy (which is really left-over Halloween candy that's been repurposed by the same manufacturers)?

Why, Valentine's Day themed candy, of course.

It didn't used to be this way. Growing up, I distinctly remember not seeing Christmas items in stores until after Thanksgiving, Halloween merchandise not appearing until the very end of September, and definitely no Valentine's chocolates until right around the first of February. What has happened in the interim to instigate this heinous time-shift?

I'll tell you what's happened. Technology has happened.

Everyone talks about the speed with which tech has accelerated contemporary life. The ability to immediately access news, friends, and information is matched by the corresponding ability of technical and mechanical sources to supply that instant gratification. Walmart didn't become Walmart just by offering low prices. The key is a distribution and warehousing network that allows the company to respond with astounding speed to the needs of far-flung stores. Other companies have swiftly copied. Technology is what permits this. Computers and the internet are what allow your local supermarket to restock twelve boxes of super high-density bath paper (not thirteen, not eleven) in less than twenty-four hours.

Obviously, thunk said merchants, why not apply the same techniques to holiday shopping?

Every year, those bins of 50% reduced holiday-themed items get smaller and fewer as advancing technology allows for better and quicker inventory control. Before long I expect the post-holiday bargain bin to disappear altogether. By monitoring ever more closely and ever more intimately the buying habits of shoppers, merchants will reach the point where they will know exactly how many cases of marshmallow Peeps orthodontically-challenged customers in Topeka will buy. Eliminating waste in manufacturing should also result in reduced costs to the customer. Both producer and consumer benefit.

But only financially.

Thanks to these developments, our wallets will likely be healthier. Our psyches—I'm not so sure. Because the acceleration of holidays and holiday merchandise due to continually advancing technology is stealing our downtime. It has reached the point where the "holiday" season is year-round. Valentine's Day gives way to St. Patrick's Day (an artificial "national" holiday if ever there was one) gives way to Easter gives way to the Fourth of July gives way to....

You get the idea. Ever notice that one section of every Walmart is virtually devoted to permanent floating holiday merchandise? It all blurs together. A few more heavily promoted and advertised holidays here and there, and there'll be no respite from this collective happiness whatsoever. Ordinary days, normal life, will surrender to an endless procession of holidays, interrupted only by time-outs for birthdays and anniversaries. There will be no days when we're allowed *not* to think of the next upcoming holiday.

People used to smile when a friend would say, weary from shopping and planning and decorating, "I need a holiday from the holiday!"

It's not so funny anymore.

The Art of Calling a Parade

Remember when broadcasting a parade focused on... broadcasting the parade? I mean, when did the parade itself become entirely subordinate to the jejune verbalizations of the broadcasting "talent"? Doesn't anyone in the broadcasting industry realize anymore that most basic tenet in properly and entertainingly describing a parade? It's not rocket science. Anyone watching any parade anywhere in the country, and quite likely anywhere on the planet, knows it instinctively.

The people who take the time to watch a parade are there to watch and enjoy the parade. Not improvisational comedy. Not vaudeville. Not promos for other shows, personalities, products, forthcoming events, celebrity birthdays, reality shows relying on exhausted concepts, or the comic travails of the broadcasters' relatives.

It's... all... about... the... parade.

When I was growing up in Los Angeles, we always watched the Rose Parade on channel 5. To my knowledge, channel 5 was the first TV station to show the parade sans commercials. And when I say sans commercials, I mean no more than a brief mention or two of a behind-the-scenes sponsor. The technology to generate the incredibly annoying bugs (those small visual inserts that are now terrifyingly omnipresent on seemingly every TV show) did not exist. So we were spared, for example, the superfluousness of a giant "G" in the upper left-hand corner of the TV image reminding us, in case anyone in this galaxy might be unaware of it, that the Rose Parade is a G-rated enterprise (I must have missed those R-rated Rose Parades).

Initial rule of broadcasting the Rose Parade. Shut up.

At first glance this instruction may appear counter-intuitive. But it's the only way I know to get the point across. Viewers have turned on the parade not only to watch the parade, but to listen to it. The marching bands, the cheers of the crowd, even the throaty mutter of the distant Goodyear blimp: this is what they want to hear.

At the risk of bruising fragile entertainment industry egos, I say with the cumulative experience of watching Rose Parades for more than sixty

years: you're not funny, you on-the-air "talent." Your painful witticisms don't work, your corny jokes fall flat after the first fifteen minutes, your desperate attempts to fill what producers would call dead air but what viewers would call blissful silence, are unappreciated, wasted, and an unwelcome distraction. Call the parade, and when you're not calling the parade, *be quiet*. Sip some coffee, send a text, check your mike volume, and otherwise *shut up*.

Rule #2: Describe the parade. Despite what you may think, this is not incidental to interminable blabbering about the weather, your friends back home, and what you got for Christmas/Hanukah/Kwanzaa/the winter solstice. This is why you are in Pasadena, and this is your job.

Viewers want to know as much about each float as you can properly convey. What flowers were used, where they came from, how they were applied, etc. They want to know the details of each float, preferably while seeing an image of what is being described. They want to know about the equestrian groups; where the come from, what they do when they're not in the parade, their origins, histories, the breeds of horses on display. Viewers want to know about the bands; not just where they're from, but what their uniforms represent, if they've won any awards, how often they've appeared in the parade.

Rule #3: No more than two broadcasters. Two broadcasters can talk back and forth. Three broadcasters is a drunken mob whose individual components invariably talk over one another, resulting in an incomprehensible babble that sounds like gay Klingon. This past year's HGTW coverage is an excellent example. Two's broadcasting. Three's a verbal riot.

Rule #4: This one's for the producers. Viewers want close-ups. Floats have become more and more detailed and elaborate over the years. Endless long shots reduce the most exquisite float to a smear of distant color. Within ten minutes of this, every float starts to look like every other float. Close-ups, folks.

Rule #5: Also for the producers. Learn how to properly mike a marching band. If the volume of 300 band members remains at the same broadcast level as your drooling commentators, the best marching band in the world comes off sounding like a collection of a dozen grinning toy monkeys banging toy cymbals at the bottom of a dry well. Get up close with your mikes, or at least figure out how to adjust the volume for the bands when they march past your location.

That's my first polemic for the New Year, in the hope that the telecast of the next Rose Parade, or Macy's Thanksgiving Day Parade, or the Mummers, or Kodos and Kang's triumphant arrival on Earth, will be about the broadcast and not the broadcasters, and conveyed with technology that is not thirty years old. Please.

Weather or Not

Major networks, on-line specialty sites, radio, print—all compete with one another to present the news in ways that they hope are sufficiently individualistic and compelling enough to induce watchers and listeners to choose them as their information source. With general news there isn't much they can do beyond varying video and images. That's one reason why TV news broadcasting is such a game of musical chairs. News anchors don't have much of an anchor, which must lead them to dwell in a constant state of paranoia as they obsessively consult their Q scores. There's only so much a news presenter can do; ranging from reading copy in a stately and steady manner a la Walter Cronkite, to Phoenix channel 3's energetic Brandon Lee, who reports every fender-bender and car chase as if describing the downing of the *Hindenburg*.

Such newscasting is often at its worst and most excessive when reporting on matters of science. It's hard to generate viewer or reader interest when describing yet another government revision of dietary guidelines (personally, I distill these to a single line from Woody Allen's *Sleeper*: "What!? You had no chocolate cream pies?"). But there's one bit of science that's in the news every day, in every format, be it in print, on the air, or on-line.

I refer, of course, to meteorology.

When I was a kid, I briefly considered making it a career, until I found out it had nothing to do with studying or forecasting the presence of meteors. It's all about the weather, of course. Something each of us has to deal with every day, an aspect of science we not only cannot avoid, but often look forward to discussing. Meteorology being a science, we expect it to be presented to us by a scientist; a meteorologist.

Well, sometimes. Because delivering your daily dose of weather prediction to you is about ratings, or selling papers, or accumulating clicks, far more than it is about the weather itself.

As I said at the beginning, there's only so much a news organization can do to differentiate its presentation from that of its competitors. That holds doubly true for anything related to science, and triply so when we're

referencing the weather. As a consequence, daily meteorological science is therefore very often not passed along to us by meteorologists. This is a tough call for producers of television and the internet. On the one hand, each company wants to present the weather with the gravity it deserves. On the other hand, there are those irritatingly critical ratings and clicks to worry about.

So you have stations like channel 5 out of Dallas-Ft. Worth, whose entire weathercasting staff is composed of qualified meteorologists. There's even a certificate for such: "Certified Broadcast Meteorologist," conferred by the American Meteorological Society (yes, that's a bona fide scientific organization).

And then, and then… you have weathercasters who are chosen for the job not because of their degrees in meteorology, not for their general scientific knowledge, but for… dare I say it… their looks. Usually, though not always, these tend to be of the female persuasion.

Because, in the final analysis, how many viewers actually care whether (okay, had to get that one pun in there) the presenter delivering the weather update actually knows something about isobars, and cloud formation, and why we don't hardly ever get to see the aurora borealis in places like Arizona? Weathercasting isn't about science… it's about ratings and clicks.

I suppose in the end it doesn't really matter. Do you think the casters at local channels are making daily trips to the Colorado River to take on-site humidity and wind measurements? Hail no; they're all using the official forecasts from the National Weather Service customized via their local TV or internet or print graphics. You can do exactly the same as they do anytime you wish: just go to weather.gov and winkle out the details that relate to where you live, or where you're traveling. You don't need an interlocutor to explain next week's temperature in Topeka if you happen to be headed that direction.

Which is why weathercasting is one aspect of science reporting that relies more than any other on personal appearance, and why there are more attractive blondes reporting the weather in the US than there are in Oslo. Nor is this phenomenon confined to the United States. It's the same across the globe: more than any other aspect of the news, when it comes to reporting the weather, looks trump knowledge every time. Nobody much pays attention to the appearance of the broadcaster reporting on a

drop in the sheep population in New Zealand, but when it comes to the weather....

There's a reason the internet has multiple sites devoted to every city's "Ten Hottest Weathergirls," and for better or worse, it has nothing to do with meteorology and everything to do with science of an entirely different persuasion.

Leash or Lease?

I suppose we could blame Disneyland. Specifically, the Enchanted Tiki Room.

Now don't get me wrong. I loved the Enchanted Tiki Room. The tropical storm that came and went on schedule, the talking flowers, the carved tiki walls that surprised you by coming to life just when you thought you'd seen everything. But I didn't care for the birds.

See, the birds were just too close to reality for me to entirely suspend disbelief. Talking walls, flowers, drumming tikis: the child in me knew they were fake. But I'd seen talking birds on television. Yet when the quartet of heavily accented *Psittacidae* started conversing in the Tiki Room, and in multiple European accents, it freaked me out a little. Because I knew real birds could at least approximate what I was seeing and hearing. But these weren't real birds. They were patently fake. Unlike the flowers and the tikis, with the birds the line between reality and unreality was so much thinner.

What I didn't know at the time was where all this was audio-animatronic (as the Disney folk called it) enchantment was leading. Nobody did. Where it was leading was to... robot pets.

They've been around for a while now. It started with simple talking dolls. Soon these were turned up a notch. Remember Chatty Cathy? Then some enterprising toy manufacturer thought: if talking human dolls, why not talking puppies? Or kittens? Or seriously down-sized horses?

Because the price of the requisite electronic components has dropped so steeply over the years, you can now buy novelty talking birds for a fraction of what the original Tiki Room schmoozers cost the Disney corporation. Cuddly dogs chat on command, kittens canoodle, ponies with manes that look like they came out of a Beverly Hills salon will learn your little girl's likes and dislikes and parrot them back to her.

There's no escaping this trend. In Japan, researchers have found that robotic pets make life better for lonely senior citizens, especially those with developing mental issues. So I suppose that's a good thing. But as I

If You Shoot the Breeze, Are You Murdering the Weather? 85

watch these developments from afar (our two dogs and eight cats are entirely organic), it creeps me out a bit.

It's one thing to try and build a humaniform robot and fool people with it. But we're getting closer and closer to surmounting what the cyberneticists called the Uncanny Valley. As we approach that achievement, you realize how much easier it will become to build a fully animate, fully responsive, and entirely believable robotic dog or cat.

I suppose there are advantages. No need for food or water, no waste to clean up, no worrying about having to take Fido 2.0 for a walk, no drifting fur or dander to activate one's allergies. Yet in these days of private drones and electronic surveillance, I worry about what's to prevent someone from hacking your dog (cats already do their own hacking, of a sort).

Robotic pets will certainly have their place. Manhattan, Hong Kong, Tokyo—these are cities where both living space and personal time are at a premium. If you don't have either to spare for a live pet, a robot that can be programmed or turned on and off would certainly present an attractive option. Even a goldfish requires more personal attention. A robot dog, like today's robot vacuum cleaners, could be set to recharge itself, freeing the owner from even that small concern. Why, a semi-autonomous pet could even take itself for a walk.

But while providing companionship, what else might a robot dog or cat do? Responsive electronic eyes would be everywhere in our cities. In our homes. Samsung recently ran into trouble when it was found that some of its hand gesture controlled TVs could, theoretically, be set to spy on their users.

And what happens when the cute robot puppy gives way to robot pit bulls and robot Rottweilers? Designed and built for personal protection, they would offer great defense for live-alones, but what if they too prove hackable? And then we have to worry about the pet canary with the camera eye.

We live in an age on the cusp of all manner of affordable, programmable, responsive robot pets. It remains to be seen whether the benefits will outweigh the potential hazards.

What hath Walt wrought?

The Tao of Mix-Ins

Ice cream.

There. Feel better already, don't you?

It's strange how just reading certain words can give us a little endorphin boost. You don't even have to hear them spoken out-loud. Food is especially effective this way. Watch.

Fried Chicken. Chocolate. Brussels sprouts.

Uh-oh. Killed the mood with that last one.

But seriously. *Ice cream.* Even if you can't eat dairy, there's soy ice cream, ice cream made with coconut milk, and other variants that allow for it to be degustatorily all-inclusive. Down the line, of course, there's sorbet, fruit popsicles, Italian ices, and more. But this is about *ice cream.* Specifically, what is currently defined as artisanal ice cream. Because this paper is about science and art, right?

I'm going to leave the "science" of ice cream aside. Maybe for another column. Can't write too much about ice cream, because every time I type the word, there's that little endorphin jolt again.

While history is full of references to what we would call sherbets, or flavored ices, what we today call ice cream first came to the fore in Italy in the 17^{th} century. Italians, and everybody else, have been monkeying with the process and ingredients ever since. It's hard to think of another popular food that has been subject to so many variations. You can buy ice cream in every imaginable (and some unimaginable) flavor. This makes artisanal ice cream makers hard-pressed to come up with new and intriguing tastes. Note that I said intriguing, not necessarily inviting. For all I know, someone has probably put together a few batches of Brussels sprout ice cream. Try not to contemplate.

I once spent a few days in Manaus, Brazil. Manaus is the biggest city in the Amazon, located where the river of the same name joins its major tributary, the Rio Negro, and it lies pretty much smack in the middle of endless rainforest. This results in a climate where both the temperature and the humidity seem like they both climb beyond 100. While perspiring uncontrollably in such surroundings, if someone says, "I

know a great place for ice cream," you're prepared to sell blood for the location.

In Portuguese, an ice cream parlor is called a *sorbeteria*. Manaus has a chain of them called Glacial, and very handsome establishments they are, too. What's fascinating is that once you get past the usual familiar flavors, all sorts of tropical ingredients you never heard of crop up on the menu. By now everyone has heard of Açai, but I first encountered it (purple ice cream!) in a Glacial sorbeteria in Manaus. Also tapareba and cupuraçu. When was the last time your tongue encountered an entirely new flavor? After that, I was much less interested in Manaus' famous opera house or natural history museum. All I wanted to do was sit in one of Glacial's elegant air-conditioned parlors and explore exotic ice creams.

Which brings me to the point of this month's bit of doggerel: what passes for artisanal ice creams here in the US these days is often disappointing. With great fanfare and innumerable articles in magazines and newspapers, one new ice cream maker after another is touted as having the latest, the greatest, the thickest, the richest, and the most inventive ice creams. And often that's true—provided one visits the small shop where said ice cream is made. Try to find it duplicated and sold in bulk at your local supermarket, however, and you're apt to be sorely disappointed.

When you pay five or six or more bucks for a pint of "artisanal" ice cream, get home, stick it in the freezer, anticipate, pull it out, break all your fingernails doing your best Arnold Schwarzenegger imitation in the exhausting ritual that involves prying off the top (why can't they invent an ice cream pint container that opens without requiring the application of the Jaws of Life?), and start digging away with your spoon, you expect the contents to reflect the list of ingredients on the side. Sadly, all too often it's a borderline sham.

I've tried and been disappointed by too many expensive pints to think this is just coincidence. It's either bad manufacturing, poor quality control, indifference, or a deliberate attempt to scam the buying public. Contemplate a peppermint stick-chocolate chunk-cherry flavor in a vanilla base. What you too frequently get is vanilla ice cream with a few fragments of peppermint stick, shaved chocolate, and specks of cherry.

I'm talking mix-ins here, folks. Mix-ins are serious business in the ice cream world. They're what made Ben & Jerry's a household name. B&J

continue to hold up their end of the bargain, but they're not what we mean when we refer to artisanal ice creams. That definition is reserved for the most exclusive brands, who ought to know better when it comes to mix-ins. If there's anything I hate about these new so-called artisanals, it's paying through the nose for a complex, intriguing mix that is devoid of—mix.

The most reliable brand I've found so far in the supermarket in regards to mix-ins is Graeter's. This is a company that understands the meaning, the *soul*, of "chocolate chip." Despite repeated disappointments I keep trying, and hoping, to find another store-sold brand to match Graeter's consistently high level.

Just don't mix in any vegetables.

Escape

This past weekend, I had to go to the San Diego Comic Con (also known as the SDCC) for a day. While I realize that the "had to" might provoke a few sneers among those for whom attending the SDCC remains yet a dream, I assure you that my visit was all business, to promote the forthcoming book version of *The Force Awakens*. I did not get to the beach, the zoo, Balboa Park, or even Seaport Village, which lies next to the convention center. I signed books and was on panels.

It might have been fun if I had not chosen to drive. 371 miles each way. Drive a day, day at the con, drive home. A bit too much. The highlight of this toasty commute was the train siding at Glamis, on highway 78 between El Centro and Quartzite, which was occupied by an idling freight train when I and a couple of dozen other vehicles found ourselves trapped in a landscape resembling an outtake from *Lawrence of Arabia*. It seems some pinhead of a railroad engineer thought it would be a good idea to place the siding, where one train waits for another to pass, directly athwart the highway. Not to the east of it nor to the west, where an idling train wouldn't block traffic, but directly across it. No wonder our rail system borders on the antique when compared to the rest of the world.

But I digress.

Having cleverly managed to wangle four days in San Diego, *New York Times* movie critic A.O. Scott sent back a couple of nice pieces on the con. His commentary is respectful and analytical, as it should be. But in providing an overview and context, especially for the bewildered who see a couple of clips from the con on TV and have no real idea what's going on, he has no space for causation.

What is generally overlooked by those who discuss the SDCC and its relatives like the recent Phoenix comicon is that there are few venues in this country where tens of thousands of like-minded people can get together for a weekend or more and have a great deal of fun assured that they are unlikely to be mugged, shot at, or confronted by drunken unsolicited auto window washers. The atmosphere at the SDCC is so buoyant, so energized by a desire to have a good time (and not waste the

small fortune it costs to attend), that everyone from the elderly to honeymooners to families with small children can run hither and yon, from panel to dealers' room to outside events, without being in fear of their personal safety. Something like Disneyland but with no rides.

One can be no less than awed by the sheer variety of entertainment on offer. Don't like movies? Attend the TV panels. Don't like TV? Attend the gaming panels. Don't care for comics? Peruse the books, marvel at the artwork (and talk to the artists), learn how to make your own costume. The SDCC and the bigger cons are a phantasmagoria of fantasy in which anyone, for the price of a single ticket, can for a few days escape from a daily humdrum existence and a barrage of depressing headlines.

When I last attended a Phoenix comicon, the attendance was 900. This year it was 75,501. People are desperate for entertainment, and for a chance to immerse themselves in a culture they, and not critics, have chosen. Unlike specialty venues like car shows or home and garden gatherings, at a comicon there's something for everyone. And everyone, from dealers to attendees to visiting actors, is unashamedly having a good time.

Unlike in professional sports, at a comicon the home team never loses.

Chains

I love it when science and art merge. When they do so in the service of something functional, that's even better.

My favorite example, albeit one that's fictional, is Captain Nemo's *Nautilus* from the Disney film version of Jules Verne's *20,000 Leagues Under the Sea*. The *Nautilus* is a work of art by Harper Goff that was designed as if it was to be a real, functioning Victorian-era submarine. I still remember the mixture of awe and delight that attended the first full sighting of it in the movie when I saw it in the theater way back in 1954. That the design continues to inspire to this day is a testament to Goff's artistic talent and the skills of the Disney special effects team that brought it to life. For many years, the original model used in the movie was on display in Disneyland.

Scientific function plus art. We never see enough of it. Moscow's subway system is another outstanding example. But those were made real by Hollywood and governments. It's rare when you can do something similar to your own home.

I'm going to speak now of rainchains.

Now, rainchains may be something most of you grew up with. They may be as common in your neighborhood as the rain gutters from which they usually hang. But until a couple of years ago I'd never heard of them, and if I'd seen any, they didn't stick in my mind.

Apparently originating in Japan, rainchains ("kusari doi" in Japanese) are long strings of chain links interspersed every so often with decorative water-slowing embellishments. Forged from copper or brass, these interrupters can take any shape. Flowers are an especially favored motif. Long strings of chained-together lotus blossoms, cherry blossoms, and other blooms are a common sight at the roof corners of Japanese temples. Rainfall spills off the roof or flows down a gutter and into a hole from which the chain hangs. The water then slides down the chain and through a succession of flowers, cups, birds, and sometimes animal shapes that slow its rush. At the bottom the water is deposited in a rain collecting barrel or onto a drainage channel on the ground.

Not only do the chains slow and guide the runoff, but the sight of the water gurgling through the various metal sculptures as well as sliding down the chain links is wonderfully relaxing to look at. So is the sound the water makes. During a heavy downpour the system can be overwhelmed by the amount of runoff, but the sight and sound still beat water simply cascading off the roof or vanishing into an ordinary downspout.

That's art. The science involves what we call cohesion. Being strongly cohesive, water molecules will tend to follow each other rather than, say, gravity. This is why rainwater running off your roof will tend to curl underneath the overhanging edge before finally falling to the ground. Give water a path to follow—a length of string, say—and the water molecules will try to stick to and follow one another rather than plunge straight to the ground.

Without the tiny gaps provided by cotton string, water has a harder time sticking to copper or brass. Still, given the path provided by the chain links, water will tend to follow them downward, from link to link and flower-shaped cup to cup. The links and the sculpted cups also serve to break up the water's rush, conveying it more gently to the ground than any downspout.

So—by adding rainchains to a building, you are actually sculpting water: something that sounds impossible but in the case of rainchains arose not from a desire to create art but from a very practical necessity. The physics of liquids, of gravity, and of metallurgy all end up serving an aesthetic purpose.

It may not be the *Nautilus*, but it sure looks good on the house.

Charge!

We love our electronic devices. We're a gadget-obsessed society. Fact is, many of us don't know how to survive without them. Don't believe it? Try taking a cell phone away from a teenage girl. Easier to draw blood. Phones, tablets, razors, info backups for your TV, laptops, cordless leaf blowers, yard trimmers, alarm clocks, watches, emergency camping gear, even full-sized lawnmowers: just go through your house or apartment and count the number of portable electronic gadgets. A thousand years ago, people would have thought that such devices were powered by magic.

That's why it's so easy to forget about or overlook their simultaneously most basic and most important component—their batteries.

Want to make a couple of billion dollars? Invent a better battery. Leave to others the further development of the electric car, the electric bus, the electric ship (yes, the Navy has them), the newest smartphone or laptop or music player. Focus your creative efforts on the humble battery. Because every technological leap forward that I've alluded to—plus thousands more—rely on batteries in order to function as something other than elaborate paperweights. Even solar and wind power, intended to help free us from our long-term dependency on fossil fuels, ultimately rely for their efficacy on batteries.

The actual impetus for this month's column is an electric airplane. Not the fragile gossamer-winged Solar Impulse that recently attempted a round-the-world flight, but a real, functional aircraft. Developed by Airbus Industries, it's called the e-Fan, carries two, and has a flight time of two hours. A pair of ducted fans are powered by two electric motors driven by 250 lithium-ion polymer batteries.

That's right. Variants of the same li-ion batteries that power all those home gadgets I referenced earlier.

An e-Fan and a competitor just completed crossings of the English channel, France to England. Airbus plans to produce the e-Fan in two- and four-seater versions. On the company's drawing board is the e-Thrust, a 90-seat regional aircraft.

Powered by... batteries.

As big an EV booster as I am, I thought we were 50–100 years away from being able to power any kind of commercial aircraft with electricity. Aviation fuel, kerosene, even fuel derived from the jojoba bean, yes. But batteries? Now it looks like in the near future, smaller airports (like Prescott's) will no longer have to worry about dealing with storage tanks brimming with volatile, dangerous aviation fuel. They'll just have to worry about chipmunks and pack rats chewing through charging cables. Pilots will fly in, park, and recharge instead of refueling. It will make for slow-going on long-distance travel, of course. Until we have... better batteries.

I'm always amazed at how commercial science-fiction films, in their haste to try and render believable starships and laser cannons and aliens, invariably manage to overlook the small things. The items of everyday future use. And what could be smaller and more everyday than the power source for all those high-tech devices? What, for example, powers the lightsabers in the universe of Star Wars? Are they AC or DC? And is the Force lithium-ion based?

Remember the scene in *Alien³* where Ripley and another character soon to be alien chow are seated atop a mountain of batteries, digging through them in hopes of finding some that aren't quite dead? What kind of batteries are they? Even though it's hundreds of years in the future, it looks like they're hunting for useable D cells. Heck, we've moved beyond that already. I mean, when was the last time you needed D cell batteries? It's all AA and AAA now, and hearing aid-size batteries, and smaller power sources still.

Today, scientists and engineers are talking about flexible batteries that can be bent, about increasing the energy density of existing batteries (same size battery but holds more power), about batteries that employ exotic materials or that charge in a tenth or twentieth the time. Recently, I've been seeing ads for wireless chargers for Nissan Leaf and Chevy Volt electric car batteries. Tesla has a serpentine charger that uncoils itself, automatically finds the charge port on the car, opens it, and plugs itself in. Better batteries mean better charging systems that when combined cram more power into less space.

I don't know how you feel about such an increasingly battery-powered future, but our Roomba is delighted.

The Reading of Pictures

Comic books have a checkered history in the United States. From the sanitized and idealized *True Romances* and their ilk, to the bland but often entertaining *Archie*, through Fredric Wertham's infamous 1954 anti-comic *Seduction of the Innocent*, to the explosion of underground comics in the 1960s and onward to contemporary adult titles, there's about as much variety in the comic arena as there is in general book publishing. A lot of something for everyone.

The Europeans have long regarded comics as serious art, in everything from *Tintin* and *Asterix* to less-well-known but immensely influential works like Calvo and Dancette's Disneyfied take on WWII, *The Beast is Dead*. In the last thirty years we've seen the transformation of the lowly comic book into the "graphic novel," of which there are hundreds of fine examples. I'll just mention a personal favorite, Canales and Guarnido's *Blacksad*, which puts anthropomorphized animals in an early 1950s' film noir setting and takes on murder, the Civil Rights movement, illegal experimental drugs, and more, with some of the most beautiful watercolor work to be found in any illustrated storytale book anywhere.

But my intention is not to praise the artwork in comic books, be it Frank Miller's transformative *The Dark Knight* or the tsunami of manga from Japan that has washed over the industry. Most folks think that the words in comics serve the art. They've got it backwards.

When I was four or five, my parents started buying me subscriptions to a dozen or so comics. It was a way of obtaining favorite titles without having to make interminable trips to the corner drugstore in the Bronx, where comics were sold from rotating metal racks. I had one small problem when I started perusing them.

I couldn't read.

But I wanted, I needed, I craved to know what was happening in those colorful panels. So my mother, who knew exactly what she was doing, would read to me. But only what I couldn't read for myself. No Dr. Seuss. No *Eloise at the Plaza*. I've forgotten a good deal of what was contained in those earliest comics, but one set stayed with me.

There once was a man named Carl Barks. Barks wrote and drew the great Donald Duck and Uncle Scrooge (a character he created) comics from post WWII right on into the '60s. He did so, as was the manner of those employed by the Disney Corp., in relative anonymity until late in life. Barks' work was distinctive for a number of reasons. His art was infused with human reality and proportion, even if the main characters were anthropomorphized ducks. He utilized real research in writing about real places and history, be it the mines of King Solomon, the seven cities of Cibola, or the Golden Fleece of mythological fame. Barks instilled in me a love of travel and adventure that persists to this day. After all, if an old man (never mind that he had feathers) who walked with a cane and needed glasses to see could get to someplace with the fantastical name of Famagusta, what was to stop someone like myself from doing the same?

In the course of entertaining, explaining, and educating the youthful me, Barks also taught me to read.

[Side note: when Barks was allowed to paint images of the Ducks and sell the originals and the subsequent prints… the only Disney artist ever allowed to do so utilizing copyrighted Disney characters… they were issued by a company called Another Rainbow that happened to be based in… Prescott, Arizona.]

Later, when I came upon other comics, from *Batman* to *Sgt. Rock* to *Green Lantern*, I always made it a point to keep a look-out for anything new by Barks. So apparently did others of my age who grew up to become successful creative individuals, such as George Lucas and Steven Spielberg. I wonder if Barks taught them how to read as well. Other artists would doubtless cite other comics as their inspiration and as drivers of their educations.

So, even though the Arizona Board of Education currently wallows in turmoil, I have a proposition. In a couple of test schools, get rid of every Reader between kindergarten and the 8^{th} grade. Give the kids comic books instead. Barks reprints would be a great way to go. In a couple of years, check the reading scores of the pupils in the test schools against those of students reading the traditional curriculum. I'll take bets right now on which group does better in reading comprehension and spelling, with a side bonus in history.

All over the world you find adults as well as children and teens learning how to read from working their way through comic books. Because the art supports the language.

And yes, I did eventually get to Famagusta.

The Science of (Selling) Sleep

The worst sleeping experience I ever had was in Manu National Park, in 1987 in the Peruvian Amazon. I spent a week in a surplus canvas tent by the side of a *cocha* (an oxbow lake) where a tenacious young Peruvian, Boris Gomez Luna, was struggling to build the first place in the vicinity, much less inside the park itself, for tourists to stay. The air mattress I was given didn't hold pressure, and the heat and humidity inside the tent was stifling except for a few hours just before dawn. But you had to keep the tent zipped shut, lest all manner of unwelcome nocturnal critters, from giant spiders to wandering fer-de-lance, pay you a night-time visit.

Also, I couldn't get out of my mind Boris's story of having a column of army ants eat through his own tent one night, waking him from a sound sleep as they made their way across his body and out through the other side of the tent. Bites and stings woke him and sent him plunging, in pitch-darkness, into the nearby caiman- and piranha-filled lake to get them off.

As one contemporary bed manufacturer might put it, on that night his "sleep number" was about a minus twelve.

Which gets me to thinking about the number of mattress stores I see around town. Just driving around Prescott, one is assailed every day by new storefronts selling nothing other than, or at least as their primary product, mattresses. We've got Mattress Firm, The Mattress Center, Yavapai Mattress Warehouse, Mattress & Furniture Gallery, and Mattress Factory Outlet. I was unable to find a Mattress City, Mattress Galaxy, or Mattress Cosmos, but it wouldn't surprise me a bit if one or all of them opened tomorrow. In addition to all the mattress specialty stores, all the local furniture stores also sell mattresses, from specialists like Sleep City (okay, there's your "City" designation) to generalists like Furniture Warehouse.

What is it about mattresses that makes them a product sufficient to support not only specialty stores, but extensive national *chains* of specialty stores? Sure, we all sleep, but we also utilize other pieces of furniture on a daily basis. I don't drive past Toilet City, or Stove Warehouse, or Chair Factory Outlet. Why mattresses?

Maybe it's because we spend more time in bed and on (hopefully) a mattress than any other piece of furniture in the home. And a good night's sleep, we are told, is vital to a healthy lifestyle. Except, recent research seems to indicate that our sleep needs and cycles really aren't all that different from our hunter-gatherer ancestors. Out on the veldt they slept where they could, the primary requirements for a good sleep site being shelter from the weather and dangerous animals and perhaps also access to water. Their sleep number was zero, yet every member of the tribe must have gotten adequate rest, or our species wouldn't be here. Or if that was the case, it seems to me we'd be really, really tired all the time.

Sleeping poorly would have been more a matter of being awakened by the yowl of a sabertooth or the moan of a cave bear. Today we fear forgetting to turn off our phones and being awakened in the middle of the night by Aunt Meryl wanting to know what you really thought of your Christmas tie. Sleep-wise, the biological effect may not be too dissimilar (unless your ringtone is the yowl of a sabertooth or moan of a cave bear, in which case you get a double wake-up whammy).

In addition to that enchanting Amazon sojourn, I've also had occasion to sleep on bare rock. When it was warm, I didn't even toss and turn. Maybe our ancestors were on to something. It works for lizards. Not that I don't prefer a comfortable bed in a high-class hotel. But experience suggests that silence and temperature are more important to a good night's rest than what's under my butt.

I don't mean to intimate that our myriad of metropolitan mattress vendors are competing to sell us a bill of fabric-wrapped goods. I'm just saying that the science of slumber, and what allows we humans to get a good night's sleep, involves much more than whether or not we're lying on memory foam, springs, down, feathers, water, gel, latex, air, or a pile of leaves scraped together into a dirt hollow dug in the ground. The mere fact that there are so many different types of mattress, each claiming to offer the healthiest, the soundest, the most restful night's sleep, indicates that we're still a long way from understanding what's best for relaxing our minds as well as our bodies.

I wonder what sleeping in space must be like, with no mattress, with nothing at all under your body no matter which way it happens to be facing. Do side sleepers sleep more on their backs, or their stomachs? Do folks spend more time curled up or with legs straight? All you need is a

net to keep you from floating off and bumping into something of possible importance, like the emergency airlock venting switch. There's no pressure on any part of the body. And no army ants. Unless one of the experiments gets loose. Sounds promising to me.

Mattress No-World....

Rise of the Pod People

The first car I ever owned was a 1969 Corvette. Maroon coupe with removable hardtop, modest 350 engine, gleaming factory side pipes. It was a thing of beauty and hopefully today, owned by someone else, remains a thing of beauty. While everyone I knew was buying their first car (or second, or third), I diligently squirreled away what money I could accumulate all through high school, college, and even graduate school. My intent when I had enough money was to try and buy a used Mercury Cougar, but Fate and the *L.A. Times* classified section intervened.

In the *used cars for sale* ads in the newspaper (some of you may remember when used cars were more commonly sold this way… some of you may remember newspapers), "Cougar" came in alphabetically just above "Corvette."

It was one year old and $2000… a good buy even back then. A good buy because the kid who owned it had accumulated so many speeding tickets that the judge in his traffic court case gave him a choice: get rid of the 'vette and buy a VW Bug, or have his driver's license suspended. Scarcely believing my luck, I got there in time with the two grand, and lo and behold, for many, many years I drove a car as flashy as most in L.A.

I'll never own another one.

Currently (pun intended, I suppose) I drive a two-year-old electric car, which due to inflation cost me rather more than a couple of grand, and I'm delighted with it. It's everything they say it is.

With luck, I'll never own another one.

Oh, my next car will likely also be electric, but I won't be driving it. Because we are on the cusp of the biggest revolution in personal transportation since the horse-and-buggy gave way to the first progenitors of that aforementioned Corvette. Just as electric cars stand on the verge of replacing those powered by petrol, so the ordinary automobile is about to be rendered obsolete by the self-driving people mover.

If you've seen Google's prototype autonomous vehicle, then you know it looks more like a toy than a "real" car. It's tiny, and pudgy as a pug, and has all the curb appeal of a beachball with doors. You might as well set a

Mercedes Smart car beside a Lamborghini. The folks at Google could care less, as could those at Tesla, Mercedes, and (probably) Apple. These companies have this entirely new vision of what a car should be. Instead of something fast, heavy, and able to leap tall buildings in a single bound, the engineers and designers working on the autonomous vehicle see it as... an appliance.

What a radical notion. Just as a refrigerator is designed to keep food cold, and a range is intended to cook it, and a telephone is intended to put people in touch with one another, so the self-driving car will be built to do one thing: convey people from one place to another as efficiently and with as little effort as possible on the part of its users.

Traditional vehicles won't disappear entirely. They'll still be present at races, and for a while at least, allowed to share the roadways with their newfangled autonomous offspring. But for the great bulk of the traveling public, a self-driving vehicle will become the overwhelming choice.

Envision it. You step into your transport and settle down in a comfortable seat that can be as padded as your favorite easy chair. It can swivel as you like, to face any direction. You punch in or give by voice command directions to your destination. Then you settle back and wait to get there. Along the way you might lose yourself in the scenery. You can text or talk on the phone without fear of breaking the soon-to-be archaic laws against such methods of communication. Mothers will no longer have to make a succession of near-instantaneous choices between watching the road ahead and dealing with rambunctious children.

On your way to work you can busy yourself on the internet or on your laptop or pad... or make a demonstration piece out of Legos. Missed breakfast? No problem. Just heat it in the vehicle's compact built-in microwave that's powered by the same battery system that propels the car, then sit back and smell the coffee. On long drives, watch a movie with the rest of the family.

Sight-impaired? No longer a problem. You a senior who is no longer able to qualify for that antique piece of plastic called a "driver's license"? Your freedom of movement is now fully restored. Pizza franchise owner? No need to hire a driver: just give your much smaller and cheaper-to-operate autonomous delivery vehicle a destination (unless you provide drone delivery service, which is faster still). Like to have a drink or two with the gang? No more worries. Computers don't have to take breathalyzer tests.

Bad weather? No more squinting to see through driving rain, snow, or sleet, and if conditions are too dangerous for driving, your transport will slow or stop accordingly until it is once again safe to proceed at speed.

Or… just take a nap.

I like sharp cars as much as the next guy, but my eyes aren't what they used to be, and when it comes to reaction time, I'm willing to surrender my options to the next generation of self-driving computers-on-wheels. They'll react faster and will make better driving decisions than any human.

Maybe I'll finally be able to catch up on my reading.

Planet of the Coywolves

So, you haven't heard of the coywolf yet? You will. It's just one more example of how Nature never sleeps, of how biology is always tick, ticking away while we're not paying attention. Because time moves so slowly for we human beings, because we live such short, preoccupied lives, and because recorded history only goes back a few thousand years, we are rarely privileged to see her in action.

When we tinker with Nature it's called genetic engineering, and for some folks that's not a good thing. When Nature does the tinkering on her own, that's called evolution—and for some folks that's not a good thing, either. But the fact of the matter is that whether we start slinging genes around or Nature does it on her own, such change is as inevitable as the rhetoric of political parties. Politicians may shout, Nature doesn't. She goes about her business quietly, slowly, and with utter disregard for what we might think of the consequences.

Take dogs for example. Looking at the multifarious breeds, a visitor from another planet might easily presume that a poodle and a mastiff are two entirely different species. Both are *canis lupus familiaris*, the domesticated dog. Same with Chihuahuas, pit bulls, Rottweilers, and greyhounds. Each and every one, good ol' *canis lupus familiaris*.

But the Australian wild dog, which looks far more like the ordinary dog you might meet trotting down the street than any of the aforementioned, is classed as *canis lupus dingo*. Though subtle, the differences are sufficient to justify the distinction, we declare. So—a wolfhound and a cockapoo are the "same." They're just different breeds, right? We humans haven't done any genetic engineering there, and it's certainly not an example of evolution... is it?

Which brings me back to the coywolf. Alias *canis latrans*. Midway in size between coyotes and wolves, these guys are the result of natural interbreeding between our familiar western coyotes and the eastern wolf (possibly also occasionally the more northerly gray wolf). Some half century or so ago, this interbreed started colonizing the northeastern US and Canada, and now the mix is widespread in the area. Not only are

coywolves intermediate in size, when young they have the deeper howl of wolves that gradually changes to more of coyote-ish yip.

What I want to know, and what researchers are puzzling over even now, is if Mother Nature has come up with a canine that has the size and power of a wolf and the wiliness of a coyote. Certainly the continuing spread of coywolf packs, whose members tend to be less aggressive toward one another, augurs well for the spread of the new species.

Did I say "species"? That would suggest evolution in progress. Or are coywolves simply another breed of coyote? Or wolf? Certainly they're not "dogs" as we like to think of them. Confoosing, isn't it?

Scientifically speaking, "the domestic dog allele averages 10% of the eastern coyote's genepool, while 26% is contributed by a cluster of both eastern wolves and western gray wolves, while the remaining 64% is mostly western coyote" (Wikipedia and elsewhere).

That's right. There's a dose of good old Fido in this interesting new critter as well. But that 10% doesn't make the coywolf a domestic animal. It makes it… the jury is still out, I reckon.

Which leads to all kinds of speculation. Our property here in Prescott is full of squirrels and chipmunks. Same family, species divergence from there. Will we one day peer out at the seed feeder only to find ourselves staring at some humungous squirrel adorned with racing stripes? Imagine elk and deer getting together, prompting local hunters to go crazy searching for trophy delk (as opposed to whelks, which are sea snails, but I couldn't resist the alliteration).

Horses and zebras can mate. So can, famously, lions and tigers (tigons, ligers). How many attempts does it take before the offspring qualifies as a new species, instead of just a sub-breed? We can no longer say nothing is certain except death and taxas, because those taxas appear to be in a constant state of flux even without the interference of meddling humans.

One thing, however, *is* for certain. Appearances around us notwithstanding, Nature is never satisfied. Instead of saying nothing ever changes, we should remind ourselves that everything always changes—albeit mostly very, very slowly. Me, I'm impatient. I want to see a big, dark-maned coywolf mingling with the coyotes in our yard.

Just wait until a jaguar or two starts getting it on with our local pumas.

Do Android Cats Dream of Electric Mice?

A recent scientific study undertook to find out if cats developed purring as a way of subjugating (alright, that's probably too strong a word)... as a way of encouraging humans to keep them as pets. From the cats' point of view, not specifically to keep them as "pets" so much as to provide them with free homes, free food, free toilet service, free snacks, and free objects with which to engage in play. Dogs do likewise, but dogs don't purr. Neither do pet rabbits, pet snakes, pet gerbils, or any other household pet.

Over the years we have had many cats (and dogs). The current roster in our household totals two dogs and eight cats. All of our pets have been rescued animals; some from shelters, some from folks who physically can no longer care for them, one from a burning house, several from a barn. Each and every one eventually settled in comfortably, at his or her own speed, because cats are not predictable. Something they have in common is that they all purr, which put me in mind of the aforementioned study. While its conclusions were indecisive, there were some indications that felines do indeed purr to make themselves more attractive to potential ~~suckers~~ human hosts. I found this conclusion an awkward one, however, because of a personal encounter.

In 1993 I spent several weeks driving across Namibia from north to south. Except for the lack of traffic and the occasional troop of baboons or flock of ostriches dashing across the road in front of you, Namibia looks more like Arizona than any place I have ever been. Located well off the main highway between Windhoek and Otjiwarongo, Mt. Etjo Game Reserve was mentioned to me by a friend in the capital as a place I might like to visit that was off the beaten track. Well-managed and not nearly as famous as Etosha N.P. and the bigger game reserves in Namibia, I was to find it appealing and uncrowded.

Namibia can also be every bit as hot as parts of Arizona. So it was when I dropped in at the reserve's lodge after the drive up from Windhoek (altitude 5436'; Prescott, 5400', depending on what part of town you happen to be in). I had no trouble securing a room for a couple of days

and, after checking in to my room, immediately made the acquaintance of the Lodge's swimming pool.

It was not long after, while wandering the grounds, that I came upon an unassuming enclosure made of posts and chicken wire. The fence itself was about five-feet high and in no way intimidating. Staring hard into the afternoon sun, I thought I could make out something lying in the shade of a couple of scraggly trees. Then it moved.

It was a full-grown male cheetah.

"That's Felix." Turning, I found myself confronting one of the reserve's rangers. "He is one of two cubs whose mother was killed by a car or truck. They were turned over to us. The other cub was killed by a cobra." (I make a mental note that this is not a problem with which cats in Prescott are commonly afflicted.)

I take another, longer look at Felix. Then at the fence forming his enclosure. I measure Felix's length against the enclosure's height. Something, needless to say, does not add up.

"Can't he jump this fence?"

"Oh, easily," the ranger informs me, not entirely reassuringly. "He just chooses not to." A nod at the shady, well-watered enclosure. "That's his home, and its been his choice to stay there."

Flash forward to the scientific study that prompted this reflection. Free housing, free food (no need to hunt), free water (no worries in the dry season), toys (yes, Felix had toys in his enclosure. None of them moving in frantic haste to get away, in case you're wondering), no worries about competition from other predators, no food-stealing hyenas or lions, and plenty of personal attention.

"If you want, you can go in and interact with him."

At this point I will refer you, if you wish to read about my encounter with Felix in more detail, to chapter III of my book *Predators I Have Known* (Open Road Media). Suffice to say, all went well. As proof, I am typing this with all ten fingers.

When petted, Felix purred.

It was a familiar, warm, friendly purr, exactly what you would expect from a house cat, except more Darth Vaderish in tone. Back now to present day and that study.

If cats developed purring to entice humans to take them in, of what use would that be to a cheetah? True, they were favorite pets of Egyptian

pharaohs, but there are plenty of recordings of cheetahs purring out in the veldt, and one has to assume they did so prior to the rise of bald Egyptian kings. Cheetahs also chirp.

I therefore will state for the record that, while cats have evolved all manner of cutsey-wootsey techniques intended to make humans love them and share our homes and food with them, my personal experience is that purring is not one of these, and that it existed in small cats (nothing bigger than a cheetah purrs; not lions, tigers, jaguars, or pumas) long before teeming hordes of hairless apes came to dominate their environment.

I can confess, however, that had Felix somehow indicated a desire for a bowl of milk, I would have embarked on an immediate search for one. Not a scientific reaction, perhaps, but that's what a cat can do to you. Even one big enough to take your face off.

Get Wood

My wife, JoAnn, is a wonderful cook. Of course when preparing a dish from a recipe, but where she really excels is in improvisational cooking. She can take mismatched leftovers, junk food, the skeletal remnants of last holiday's turkey, and turn them into a gourmet spectacular. She can even do it, and does so on a regular basis, with foods that I dislike.

Me: "The sauce on this pasta is amazing! What are the little green flecks? Parsley?"

JoAnn: "Broccoli."

Me (flummoxed): "But I hate broccoli."

JoAnn: "Well, you're eating it."

Me (wonderingly): "You could put this sauce on styrofoam packing pellets and eat them!"

If modern food science is to be half-believed, we may be doing just that (or something all too similar) already.

We, as Americans, pride ourselves on our standards of food safety. On our food science, if you will. And yet, somehow, holes in those standards have a disquieting habit of showing up on the evening news. Just recently, a number of cheese manufacturers have been hauled up on charges of including anywhere from 7–8% wood pulp in their product. Italian hard cheeses like parmesan and romano seem to have been especially susceptible to such cellulosic adulteration (is this why shavings of those particular cheeses so closely resemble wood splinters?).

In their defense, manufacturers say that a modest amount of wood pulp is completely harmless to the body. Aside from the fact that when I buy cheese, I expect to be buying cheese (except for "pasteurized processed cheese product," or "Cheez Whiz," which are subjects for another time), I feel that the portion of termite DNA in my system is minimal, and I have no wish to test its efficacy on a Reuben sandwich spiked with wood pulp.

Speaking of wood, have you ever heard of "ester of wood rosin"? Sounds like the stuff baseball pitchers put on their fingers. You may very well be drinking it as you read this. It's made from the stumps of long-leaf

pine trees. Just doesn't get any tastier than that, does it? Ester of wood rosin is used in, among other things, fruit-flavored drinks and sodas. Most of these are concocted with concentrated oils (orange, blackberry, lime—take your pick). But such oils and water, as the old saying goes, don't mix. That's where ester of wood rosin comes in. It allows those flavoring oils to mix freely with water and to remain in suspension within it, so that the last gulp of your favorite cherry soda pop tastes the same as the first. That's food science for you.

My favorite example of such charming explorations into the biology of comestibles involves seafood. No wood references this time. Just the fact that, according to recent research, something like one-third of all the seafood sold in the United States is mislabeled. Not just ordinary fish, but the contents of the dishes you order in fancy restaurants just as much as those you get fast-fried from Long John Silver's. Pollock often is passed off as cod, and monkfish as lobster. Seafood vendors, including your friendly neighborhood supermarket, try to get around this as surreptitiously as possible through the use of "scientifically" accurate labeling.

So when you're buying "krab salad," you're likely getting good old pollock again. It's that "k" instead of "c" that makes it all nice and legal, according to government regulations (recall for a moment the implications of that first "z" in "Cheez Whiz"). What you're actually buying is a product called surimi, a paste made from any kind of cheap fish that can be shaped and formed to look like other fish, or scallops, or crab. Just add a little (legal) red food dye and you're all set. And legal.

Speaking of scallops, there's no way to tell if you're really eating those tasty shellfish—or shark that has been cut to resemble scallops. Since the actual taste is close and can easily fool a diner, finding out which is which is a matter of science. Don't feel bad if you think you've been duped. Buyers for fancy restaurants are fooled by these oceanic subterfuges all the time.

Now that I've made you feel better about your next meal, I'm going to go have myself a nice, tall glass of iced ester of wood rosin. Cherry-flavored.

Is it Art or Is it Digital?

I was recently visited by an old friend who is a notable collector of, among other things, art. In the course of looking at my stuff (as George Carlin would have said), I pointed out a nicely framed print of the cover to a recent novel.

"It's all digital," I told him. He studied it for a moment.

"I don't consider digital 'art' to be art," he replied. And we moved on.

So—is it? Are compositions rendered entirely in a computer, in a manipulated succession of "1"s and "0"s, *art*? Is merely declaring such a composition "art" enough to define it as such? Or are such works nothing more than digital jigsaw puzzles, the bringing together of shards of software, the end result of which resembles art, but actually is not? I am of the opinion that it is.

I have yet to meet someone doing quality digital art who does not possess a certain degree of what we would call traditional artistic skills: the ability to draw, to combine paint or to work stone or wood or metal in at least some fashion. Certainly there are differences of talent, but the same differences exist within the realm of traditional art. Take metal as medium. At the high end we have sculptors who create wondrous apparitions in bronze. In the middle there are those who produce abstractions out of lumps and twists of metal. And near the bottom (these are all my personal opinions, obviously) we have those who put together sculptures out of found materials.

It's all art, they say. But whereas the artistic skills of the fine bronze sculptor are obvious, what distinguishes the "art" of someone utilizing found objects save the ability to use a welder? For that matter, what makes someone who sticks a bunch of old Cadillacs in the ground in Texas or moves a big rock over a ditch in Los Angeles an "artist"? Is it the execution of a skill or simply the blessings on high from one or more art critics?

For the artist who uses a welding torch (and these days, maybe some strong glue) and found materials, those are his tools. Why are they considered valid by the art establishment when software is not? How is

taking a bunch of scrap yard junk and twisting and turning and melting and welding it into a portrait of a striding horse considered art, but using Poser and Bryce and Daz and other software programs to generate an image of a horse in a mountain valley not?

Artists have always reached for new tools. A decoy carver may take months to make an exact reproduction of a mallard, complete down to intimations of feathers and the correct colors, while someone using a chainsaw in Idaho might reveal a standing bear from a pine log in a matter of hours. Both are considered art. The only difference is the time involved and the kinds of tools employed. Some folks might prefer the precisely rendered duck while others find their aesthetic sensibilities gravitating to the roughly hewn bear.

And what are we to make of the first compositions being produced by 3-D printers?

An ancient Egyptian artist might as well argue that if it's not painted on papyrus, it's not really art, and this new-fangled canvas material denigrates any result. I define art by how I respond to a creation, be it a bas-relief carved on the head of a pin or a new skyscraper. The Chrysler Building in Manhattan is frequently considered to be as valid an artistic statement as an architectural one. If the design for a new building is rendered in virtual reality by a computer instead of being sketched out on a drafting board, does that invalidate its aesthetic value?

I have a couple of professional artist friends whose work I wanted to buy, but they couldn't sell me the original because, as one put it plainly, "There is no original. It was all done on a wabag tablet." Both men moved from using paint and canvas to computer and tablet because it was so much easier to make changes and correct mistakes. This is exactly why writing programs for computers have been embraced by most authors (though I know at least one who still refuses to do so, and does all his writing on old typewriters). Does utilizing a writing program cheapen their writing? Of course not, because in the end it's the words that matter. Just as with any art, it is the results that matter, and not the tools that are used.

If I have to put something on the wall, I'll take a glossy still from a beautifully rendered videogame over a Warhol soup can any day. But that's just my taste, I suppose. That's what "art" is all about, but to call one invalid just because it uses different tools and processes to achieve a result is simply... wrong.

A Few Mild Shocks

As I've been driving an EV (electric vehicle) for three years now, I suppose it's understandable that some folks keep asking, since this column is about art and *science*, why I haven't written about the slow but steady rise of the EV. Partly it's because I thought it too obvious, because there is simply so much *being* written about EVs. I didn't see any point in being redundant when there seems to be at least one new media piece per day about the ongoing developments.

I'm always happy to talk about EVs, both from a personal as well as academic viewpoint. Folks new to the concept invariably inquire about range, how long it takes to charge, where the batteries are located, how much your electric bill goes up versus the cost of gasoline, and so on. But it occurs to me that a number of the advantages of driving an EV never make it into even lengthy related articles. Just as when you travel, the only way you really learn to appreciate the great ice cream at Glacial Sorbeteria in Manaus, Brazil, is to have some, or to figure out that the best food bargain in the busy tourist hub of York, England, is the local Chinese buffet.

So I thought I'd point out a few of the benefits that arise from the experience of actually owning and driving an EV that only become apparent with time. These are rarely if ever pointed out even by the folks who sell them. Because they're always being asked about range, cost, charging time… you know.

The first difference you notice is the acceleration. This is true of every EV, from the little Chevy Spark to the top-of-the-line Tesla P90DL. It's because with an EV you have instant torque. Unlike with an ICE (internal combustion engine) powered vehicle, in an EV all your power is available immediately and without having to ratchet through a bunch of gears. Imagine if, when turning on a flashlight, you had to wait for the light to slowly intensify before it reached full brightness. An EV is just like a flashlight. When it's on, it's on. I'm frankly surprised no manufacturer has come out with an EV named "Scoot." It's the kind of acceleration that changes the way you look at everything from merging onto a freeway to simply changing lanes.

If You Shoot the Breeze, Are You Murdering the Weather?

You never have to visit a gas station again. Ever. You'll still find yourself looking at and comparing gas prices (I do). But after a while the exercise becomes meaningless. EVs are especially popular with professional women because it means no more climbing out of the car into wind, rain, or snow to pump gas in a nice outfit and high heels.

EVs are... quiet. With no engine noise, you can actually have a normal conversation even in a small car.

EVs don't waste power. Sitting in backed-up freeway traffic, you don't "idle." When the motor isn't delivering power to the wheels, it only operates a tiny amount to power the a/c, or heater, or radio, etc. Anyone who's ever been stuck on the I-17 due to an accident ahead will immediately appreciate the advantage of this.

There's actually room for an adult in the middle in the back seat. This is because, since the motor in an EV is usually mounted directly over the axle, there's no need for a driveshaft. It's gone in front-wheel drive cars, too. The rear floor is flat.

If the battery pack is situated, sensibly, directly underneath the car's floor, the result is not only a hugely stable vehicle because of the resultant low center of gravity, but a very large trunk. In an EV hatchback, this can be enormous. In a Tesla, you get two trunks... one forward and one aft.

Then there's the refueling versatility. Everyone new to EVs always wonders where you can charge. The answer, generally speaking, is anywhere there's a plug. Suitable adapters (and custom-made ones) allow owners of an EV to plug into 110, 220, or specialized outlets. I'm always gently amused by skeptics who say, "Yeah, but how far is it to the nearest charging station?" I guarantee them that no matter where they theoretically might fetch up, it will be closer to an electrical outlet than to a gas station. All you need are adapters and an extension cord. If you're visiting Uncle Mo's cabin in the Bitterroots, and he has a generator, or solar, or wind, you can plug in.

As far as not having access to any power whatsoever, people also tend to forget that in the absence of electricity, gas pumps don't function. There's no such thing as an "off the grid" gas station. I still remember the story of the guy in New Jersey who, during Hurricane Sandy, when all the gas stations were shut down, was able to power up his Nissan Leaf using a home generator.

So those are a few of the less-publicized advantages that come with the owning of an EV. They'll all be EVs one day. BMW uses big EV trucks to move equipment between their plants in Germany. BYD and Proterra in California build emission-free, quiet EV city buses. Airbus is flying a prototype commuter airliner that uses rear-mounted props powered by batteries. I'd love to see one here in Prescott. No aviation fuel needed… just plug your plane in.

Think of that, you youngin's, when one day in the future your self-driving EV is taking you and your family on vacation and your smallest grandkid leans out the window, points, and inquires, "Daddy—what's a 'gas station'?"

An Uber Simpson's Couch Gag (Sort Of)

"That's a nice looking car."

"Thanks. I bought it for the tech. I would've bought it even if it had looked like a Pontiac Aztek."

It's at this point in the conversation that I start to get funny looks. But I'm being entirely truthful. This doesn't mean I'm utterly indifferent to the look of an automobile. Only that to me there are now far more important things than its appearance.

I know. Sacrilege to those of you who lust after Corvettes and Maseratis and Ferraris and such. But cars are a separate conversation. What I'm talking about when I respond to the aforementioned compliment is not cars: it's transportation.

When you're in your twenties and thirties, not to mention teenage years, cars are important. They're signs of status, of taste, of independence, and they make a personal statement. When one becomes… older… the general (although not exclusive) tendency is for one to focus more on getting successfully from one place to another as opposed to looking flashy when you arrive there.

I'm at that point. And that's why I'm looking forward to a future where the appearance of transportation is far less important than how efficiently it performs its intended function.

Already we're seeing predictions that no one who currently owns a car will bother to own one in the near future anyway. Why? Because it will be cheaper and easier for Uber and Lyft and related companies to do the buying and shuttle us all around in the vehicles they own. A fair number of folks are going that route (no pun intended) right now, especially in metropolitan areas. After all, by using such services all of the expenses of car ownership disappear. There's no maintenance, no monthly payments, no insurance costs, and someone else does the driving. And forget about obsessing over keeping a car clean and sharp looking. Such services are a practical option for many. But not the ultimate option.

That will come with the advent of self-driving vehicles. It's a technological development that will give rise to a sea change in social

habits. You buy the car but never drive it: just tell it, via verbal or keyboard input, where you want it to go. Utilizing its own technology plus GPS or some similar guidance system, the car hums off (for it will surely be electric) on its way. You are no longer a driver: you are now a passenger. You sit back, kick off your shoes, maybe recline your seat, and watch TV or mess with your pad or computer or... just take a nap.

No matter what auto purists say, that makes up a *lot* for how the vehicle you're riding in might happen to look.

Think of the other advantages. The legally blind gain instant mobility. So do the infirm and the elderly. No matter how severely you may happen to be handicapped, if you can get in your car it can get you to wherever you want to go.

Don't think that Uber and Lyft aren't equally aware of the same possibilities. Call on them in the near future and that car you don't have to wash, pay for, insure, or fuel arrives at your doorstep... sans driver. You don't have to tip a robot, they can work 24/7, and they never argue with Dispatch.

No more road rage. You can't get angry with a driverless car. Much more efficient use of freeways because speeds will be relatively constant and self-driving cars can follow much more closely than those driven by imperfect, impatient, sometimes hysterical human beings.

Interiors will be redesigned to be, not airplane uncomfortable, but cozy. Everyone will get around in First Class. I mentioned reclining seats. Reverse those in front and you can have a proper conversation with those in back. Or play cards, or entertain the kids. No more horrific accidents due to drunk drivers. Pile tipsy Uncle Phil into the car, program a destination, lock it in (and maybe lock Uncle Phil in, too) and the car delivers him safely home.

Nor will self-driving be limited to personal transport. We're already seeing the first experimental self-driving big rigs on the road. And imagine a self-driving school bus (okay, maybe that's a bit premature).

The day is on its way when you won't care what a car looks like, because it will have reverted from a symbol of status to a pure mode of transportation. Or... will it?

As sure as there's an American consumer there will be self-driving cars featuring self-contained kitchens, full-size beds (for long trips, for

long trips, you sly-eyed readers), hot tubs, and probably everything from aquariums (featuring robot fish?) to solariums.

At which point your grandkids will ask you, with a straight face, "Grandpa... what's a 'driver's license,' and why did everybody need one?"

Pixels and Doodles

Being a writer, you can understand that I am much taken with the science of language as well as with its artful uses. The fact that human beings can make a wide but still finite range of sounds in turn limits the total number of words that can be generated by our modest vocal apparatus. While such limitations and abilities are more commonly discussed in relation to singing (see Yma Sumac) rather than speaking, it remains that they are far more important when it comes to everyday communication.

Not all sounds need to be words in order to signify meaning. Among others, the San people of South Africa employ clicking and whistling noises as part of their language. Grunting, which is still with us from our most primitive days, continues to be a means of conveying a wide variety of feelings. Tim Allen based a career on it. I'm not aware that coughing or sneezing are utilized to convey anything more significant than "I'm sick—get away from me!" But I wouldn't be surprised to learn that there's a tribe in central New Guinea that makes more extensive use of it.

Difficulty and confusion arise not from the noises we make, but from the fact that the meaning we ascribe to them is constantly changing. This is less common with words based on real-world sounds. For example, *rana* means "frog" in both Spanish and Shona, two entirely unrelated languages that draw the word from the sound made by the animal. Yet much of our language(s) exists in a continual state of flux, and is ever changing. No wonder we have trouble communicating: consistency eludes us.

Take the languages of Polynesia. They all arise from the same linguistic base, yet over the centuries they have continued to morph, even though there's no scientific or cultural reason why they should. In Tahiti, where the word probably originated, "house" is *fare* (pronounced "fah-reh"). Move a little farther away, to Samoa, and it becomes *fale*. Travel still farther, to Hawaii, and now it's *hale*. Why? What prompts this continuous change? It's not a question of linguistic improvement. To mean "house," hale is no better than fale which is no better than fare.

If You Shoot the Breeze, Are You Murdering the Weather? 119

What is it with human beings and mutual communication that we continously need to change the pronounciation of our words? It makes communication more difficult, not easier. The differences between European languages constitute an even better known and more familiar example. Why should a Spaniard say "gracias" and an Italian "grazi" when they mean to say the same thing?

Even when the pronounciation of a word remains essentially the same, the meaning can change unexpectedly due to a fresh association with social, cultural, or even more interestingly, scientific changes. My favorite example is "pixelated."

Pixelated was introduced from its New England origins to a wider American public in the 1936 Frank Capra film *Mr. Deeds Goes to Town* (the film also made popular the word "doodling"). On Youtube, you can view clips of the word being used in the film. It means "the pixies have got to him." In other words, someone who is not right in the head is pixelated.

But today, pixelated has been borrowed to mean something entirely different. Ask any non-film loving teenager for a definition and they'll immediately point toward the nearest TV or computer or phone screen and they'll tell you that pixels are the tiny illuminated dots that, taken together, make up the images you are seeing. When the images suffer from pixelation, it means that the pixels are not aligning properly and the images are breaking up. Interestingly, another way of looking at pixelation is that your image is going crazy, which inadvertently refers back to the word's original meaning.

For another example, consider the social morphing of the word "gay." Kids can't help but giggle when movies like *The Gay Caballero* show up on Turner, or when they encounter a song like "Our Hearts Were Young and Gay." Poor Disney has to cope with a major song from the wonderful film *The Three Caballeros* ("We're three caballeros, three gay caballeros..." etc.). Social changes can force shifts in the way we perceive a word just as readily as scientific developments.

Sometimes these changes, like the two mentioned above, take place rapidly. Other times they occur so slowly, and over so such long spans of time, that we lose track of the word's original meaning, and only specialists in language can remember them. Shakespeare, for example, is full of words whose original English meaning has come and gone. Often

they're as surprising as any shifts that take place in contemporary linguistics.

For an example of that, I'll leave you with the Bard's admonition to "get thee to a nunnery." Language points for anyone who knows the true meaning of *that* particular Elizabethan English phrase.

Science... or Industry?

Did you ever get the feeling when strolling through the vitamin and supplement section of a supermarket, general store (Walmart, Target), or specialty vitamin store that it's a wonder you're alive because you don't take at least a pound of supplements a day? Between the relentless barrage of television ads touting unpronounceable medicines designed to cure all the diseases you don't have, to the row upon row of supplements intended to fill all the empty places in your body, brain, skeleton, and neuromuscular system, you end up agonizing that you won't survive until tomorrow unless you ingest half the Amazon rain forest.

Just last year, Walgreens, Walmart, Target, and GNC were told to cease selling a brace of supplements because, well, the bottles didn't contain the supplements they claimed. Or rather, the supplements were highly adulterated with other, useless substances. If you can't trust add-ons sold by some of the biggest retailers on the planet, who can you trust? Maybe, after all, Aunt Matilda's herb garden is a better place to look for peppers and mint.

Purity and truth in advertising aside, unless you are prescribed a specific supplement by a doctor, what's the point? My mother's parents both lived to be a healthy 94, and to the best of my knowledge, never took a supplement pill in their lives. My grandmother's idea of food supplementation was to add chicken fat and sour cream, while my grandfather would sneak out for a steak whenever he had the opportunity.

In reality, I know what their secret supplement was: it's called walking. They lived in Manhattan and they walked everywhere, including into their very late 80s. My grandmother would walk halfway across the island to buy the butter she liked (Julia Child would have approved). Certainly genetics played a large part in their long lives, but it was complimented by common sense eating and plenty of exercise. Our more distant ancestors did pretty well without supplements. Do we live longer now? Of course, but much of that is due to modern medicine—a great deal of which is devoted to coping with the problems that arise in our bodies from what we eat now.

I'm not saying all supplements are bad. I take a daily couple myself, largely to compensate for our unbalanced but tasty modern American diet. It's when we overcompensate, supplement-wise, that we get into trouble. It can be a tricky ground. For example, it's generally accepted that we don't get enough vitamin D, particularly D3. Vitamin D is made in our own bodies as a result of exposure to the sun. Office workers, cab drivers, teachers, etc. usually do not get enough sun, not even in Arizona. Hence a likely deficiency in vitamin D.

But... exposure to the sun causes skin cancer! That fact is driven into us relentlessly by the medical establishment, and rightly so. What to do? Take vitamin D supplements. But carefully, in measured amounts, and depending on your own individual situation. A street maintenance worker in Arizona needs less vitamin D supplementation than his administrator sitting in a Phoenix office. It's hard to know what to do because supplements are so oversold.

Some, like vitamin D, are well-studied and fairly safe (though you can overdose on anything). Some are not well understood even though they've been around for decades.

Take calcium. Kids need extra calcium because they're building bone. Older folks need calcium to offset the chance of developing osteoporosis. And here's where supplementation gets tricky. The best calcium, like anything for your body, comes from intake via actual food. Dairy, beans, vegetables, fish, and more. There is considerable evidence that calcium from tablets doesn't build back bone in older (over 50) folks. But the supplement industry is so powerful that you can be led to believe that taking those big horse-calcium pills will not only prevent but reverse the effects of osteoporosis. And they might, they might, except...

There's also plenty of evidence that a bunch of that supplementary calcium forms plaque in your arteries. Which leads to... heart attacks. Not to mention kidney stones and constipation.

The body is a wonderfully organized mechanism. Be careful what you put in it, no matter how flashy the advertisements, the number of bottles trying to entice you from the store shelf, and the miracle results touted by manufacturers who are neither supervised nor regulated by the FDA.

Never forget that snake oil, the real thing, is a supplement.

The Singularity May be Squishy

Everybody has a favorite robot. Even folks who don't especially like science-fiction have seen enough movies and watched enough TV to have fond memories of a particular mechanical person. Probably the most famous robot in film history is Robbie, from the great 1956 MGM film *Forbidden Planet*. Amusingly, and in keeping with the tenor of the cheaper SF films of the time that emphasized horror over science, the principal advertising for the film shows Robbie carrying Anne Francis, the female lead (actually, the only woman in the picture) as if menacing her. In reality, of course, Robbie was her best friend, personal jeweler, and potential savior. But that approach makes for a much less inviting movie poster. On the other hand, I can't blame Robbie. I would have jumped at the opportunity to carry Anne Francis around, too.

Film history is littered with robots: some friendly, some antagonistic (maybe they read their contracts), some indifferent, the great majority poorly made. Few were as intricately fashioned for their cinematic appearances as Robbie. My personal favorite remains the robot Maria from 1927's ground-breaking film *Metropolis*, even if she was made out of plywood. She certainly doesn't look wooden in the film, and possesses an unsettling grace and appearance that carries through even to today's viewers.

While nearly all cinematic robots are humanoid, in the 21st century we live with every shape imaginable, from massive single-armed machines that work in factories and can easily pick up an entire car, to cute toys like Furbys and talking dolls that in their innocent efforts to turn a profit for their manufacturers may actually represent the leading edge of artificial intelligence. In between there are machines like Honda's Asimo and Boston Dynamics' BigDog and spotmini, which mimic the movements and abilities of humans and animals with increasing accuracy.

All of these inventions, both imaginary and real, have one thing in common: they are constructed of solid materials. Metal, plastic, composites, hard wiring, and glass form their skins and sinews, their synthetic muscles and artificial eyes. So it has been for all robots since the

Czech writer Karel Capek first coined the term "robot" in his 1920 play *R.U.R.* (for *Rossum's Universal Robots*).

Until now.

Say hello to the octobot. With a body fashioned from silicone rubber, it has no wiring and uses no batteries. It runs on microfluidics, fueled by 50% hydrogen peroxide that is used to produce the oxygen (and water) that make its arms move. Yes, the same stuff you used to mess with your hair color now powers a flexible robot. Instead of electrical switches, octobot utilizes pressure-activated valves. Right now it can't do much more than twitch its arms. But imagine the possibilities....

Robots that can refuel themselves as easily as you'd gas up your car. Machines that can squeeze into cracks and crevices to do hard-to-reach repair work. Hospital helpers with soft arms and fingers instead of the potentially dangerous rigid ones currently in use. Robot pets with limbs that feel exactly like those of actual cats and dogs.

And eventually, robots with soft bodies that are virtually indistinguishable from our own, that leak hydrogen peroxide if damaged. I await the first humanoid robot to quote Shakespeare and say, "If you cut me, do I not bleed?"

A soft-bodied robot will seem far less alien than the mechanical contrivances of movies past, or the steel-framed ones that fill our manufacturing plants. Will hard-bodied robots turn out soft-bodied ones?

Or will they remain, perhaps subversively so, just "cute," like the octobot? Which already possesses one very human characteristic. When the oxygen it generates as it powers itself reaches the end of a limb, it is vented from the bot.

Welcome our first robot that farts.

Set in Stone

As I write this, Hurricane Matthew is set to hit the east coast of Florida tomorrow. Understandably, this puts me in mind of... no, not Disney World. I'm thinking about the science of... no, not Cape Canaveral and rocket flight.

Building materials.

Not as exotic as reusable rockets (hi Elon, Jeff) nor as fascinating or as strange as metallic glass, building materials are something we deal with every day. Assuming you live in a building, of course. This being Prescott there are, alas, all too many who are forced to adapt to less solid living situations. But I digress.

The media is full of talk of advances in building materials. As an example, one architect wants to build tall structures, perhaps even skyscrapers, out of wood. While we've been utilizing wood in our dwellings for thousands of years, it wouldn't be my first choice for building materials for a home on the Florida coast. Yet Floridians and the rest of us persist, putting up hundreds of new homes a year in hurricane- and storm-prone areas that rely on wood frames. And every decade or so, along comes a Cat 4 shower like Matthew to blow them all down. You'd think by now that the insurance industry, if nobody else, would insist on some changes. And by changes I don't mean stopgap, makeshift, temporary fixes like requiring roofs to be fastened to the (wooden) walls.

There's something else we humans have been building with for thousands of years. There's plenty of it around and we know how to work it. So... why aren't more homes and businesses in hurricane-prone regions constructed of it?

It's called rock. Maybe you've heard of it.

There's a home on Key Largo, Florida, called "the rock castle." Commissioned by a Dr. Engels, it's no castle, but it sure is a survivor. It was built around 1925, survived the great hurricane of 1935, and still stands on Oceana Avenue. Its "advanced, hurricane-resistant building materials"? Coral rock and concrete.

In Aransas County, Texas, stands the Fulton Mansion, originally the home of one George Fulton and now a state landmark. Aransas lies on the coast and is just about as flat as a good chicken-fried steak. In fact, before we moved to Prescott, my wife and I looked at a piece of land in coastal Aransas. Forty acres, directly across an inlet from the national whooping crane refuge. Beautiful location, with one significant drawback: the highest point of land on the property was maybe a meter above sea level. A year later, hurricane Allen roared through the area. No relation.

Constructed with a shellcrete basement, steel reinforcing rods, and a lot of *cut stone*, the Fulton Mansion has stayed in place, weathering hurricane after hurricane, since it was built... in 1877. Not a lot of surviving 1877 wood-frame homes in the area.

In the Orkney Islands north of Scotland proper lies an excavated settlement called Skara Brae. While the roofs are gone, many of the exterior and interior walls remain. Living rooms, kitchen areas, even purpose-built shelving stands intact. North Sea storms may not be hurricanes, but for sheer ferocity I'm glad I don't have to choose between the two. The inhabitants of now-deserted Skara Brae understood the science of building materials, and they built well. They used stone for its durability and perhaps also because there are essentially no trees in the Orkneys.

Scara Brae was built around 3200 BC.

I'm no architect and I'm no engineer, but it seems to me that if structures raised 5,000 years ago and subject to horrific storms can survive relatively intact until now, then that's the building material we ought to be using in storm-prone areas. Even if it has to be imported from exotic locales like Vermont. I guess it all comes down to how long you want your house to last.

The Romans used stone and concrete, and their structures have held up just fine (though admittedly not subject to hurricanes). In Cuzco, Peru, you can see Spanish colonial structures built atop original Inca foundations. While modern structures come tumbling down or are heavily damaged when earthquakes rumble through the Andes, those with Inca stonework foundations survive just fine. There's a reason Machu Picchu wasn't built of wood.

Even in Prescott, there are old stone houses still standing. I guess advertising and promotion by builders will always trump longetivity in the

construction industry. And of course, cost always seems to be the first consideration. On the plus side, I reckon Prescott is pretty safe from the threat of hurricanes (for now, anyway).

But if I lived on the Florida coast, never mind in the Keys, I'd be checking out the cost of rock and stone long before I put up anything made of wood, even if I could get cypress. Especially if I wanted something permanent. Something, maybe, to leave to my kids.

Everything old is, and sometimes should be, new again.

Enter: Backwards

Communication has been in the news a lot recently. More so than ever with the selection of Breitbart's Stephen Bannon as White House Strategist. I mention him not because I agree with his positions (I don't, but this column is not about politics), but because his selection only emphasizes how social media and the Net continue to slowly take the place of traditional means of communication. When people begin to turn for their daily information more to Twitter, Facebook, and on-line only news sites, it portends a real change in how ideas are exchanged and data is conveyed.

I'm not suggesting that the *New York Times*, the *Economist*, or CBS News are going to disappear any time soon. But the winds of change, they are blowing. All three of those legacy news sites have active on-line equivalents. More and more people want their information delivered faster and in easier-to-digest bytes. The Net and social media facilitate both. This is convenient, but dangerous.

When stories are reduced to headlines and knowledge to sound bites, it's all too easy to miss the real ramifications of any decisions on which they may be based. Simplification precludes analysis. Communication becomes a function of time instead of thought. It's fast and easy if you can just say "coal power is obsolete" versus "clean coal is vital to power production," but it doesn't explain, it doesn't argue. It reduces communication within a society to an endless succession of simplistic us-versus-them. Quick communication offers no opportunity for discussion, evaluation, or judgment. You pick quick because you're working at home, at your job, or (yes), working at "relaxation," and you don't have any time for... thinking.

"I don't have time for the news" is a refrain I hear all too often (I'm talking particularly to the 45% of the electorate, regardless of preference, that didn't vote in the last election). "I don't have time to read." And who needs to read, when someone else has already done the difficult job of perusing a subject, dissecting it, and reducing it to a tweet? That's all one needs to make a decision, isn't it? The basics? As filtered and compacted for you by... Someone Else.

If You Shoot the Breeze, Are You Murdering the Weather?

Beginning with grunts and wheezes, communication used to be strictly verbal. We advanced to more complex spoken language. Then writing was invented, which allowed for the dissemination of extended argument and complex ideas among an educated minority. When printing was invented, suddenly anyone who could read was able to discuss and debate the same multifarious notions as the hitherto privileged nobility and clergy. This earth-shaking advance in communication led to revolution, reformation, and the rise of the nation-state.

The development of radio suddenly allowed a single individual to share ideas with thousands, then millions of listeners. Television permitted the public to see the individuals propounding those ideas. The internet (at first) provided a means for one person to convey their ideas almost instantaneously to a substantial proportion of the planet's population. It would seem that the ability to communicate has continued to expand beyond hitherto unimaginable boundaries. When it comes to reaching sheer numbers of people, it has. Yet in another way, communication has gone backwards.

It does no good to be able to speak to your billions of fellow citizens if you have little to say: if you reduce the explication of important, complex matters to a few brief sentences. Compression and conciseness have their place, but not at the expense of discussion and debate. Where time is saved at the expense of comprehension, we lose. Alas, I think we're seeing more and more of that. Advances in communication technology have saved us time, sometimes valuable time, but it has come at the expense of understanding and the sharing of actual knowledge. It is a development that was not foreseen.

What it means is that our communication has regressed. We're back to grunts and wheezes, in 140 characters. Or worse, emojis. Birds tweet. Humans need to talk, and at length. Because without talk you have no explanations, and without explanations you have no communication, and without communication you have chaos.

I choose not to tweet. I write. There are 34,483 bytes in this column. I hoped they've enabled me to communicate something.

When Sometimes it's Better Not to Leave Well Enough Alone

In this case, the answer is chocolate. Come to think of it, that's not a bad answer for any question.

What do feel like doing today? Chocolate. Is there anything I can do for you? Chocolate. What do you think of Trump's latest cabinet appointment? Chocolate.

Just saying the word puts a smile on the face of most folks. Unless, alas, they happen to be allergic to the stuff. But for the rest of us, simply the mention of *chocolate!* conjures up a feeling of joyful expectation. Hearing the word brings forth remembrances of the taste, the silkiness, the sweet charge of energy and contentment as it melts in your mouth that....

Excuse me a moment. Time for a quick trip to the pantry.

There (*sigh*). That's better. You won't mind if I nibble a little while I pontificate, will you?

When I was growing up chocolate was, like so much else in life (especially pre-puberty), simple. There was Hershey's, and for the youthful connoisseur, Nestlé's, both simple milk chocolate loaded with sugar. That was it. If you wished to dally in exotics, you got Hershey's with almonds, or Nestlé's Crunch. I gravitated toward Crunch because it was made with crisped rice and I could, on occasion, fool myself into thinking that I was actually eating cereal heavily flavored with chocolate. As an adult I take no position on whether Nestlé's Crunch is cereal flavored with chocolate or if Count Chocula, Cocoa Puffs, and their breakfast ilk are chocolate flavored with cereal. This is why we have professional nutritionists and highly paid food industry lobbyists.

But, again like so much else, even chocolate has changed. We now have a galaxy of artisanal chocolates. To me, whenever the adjective "artisanal" is applied to food, that simply says to me that the product has been developed by someone who actually knows how to cook. Chocolate has been flavored, manipulated, and turned out in varieties that would

have astonished the Maya, who first made use of the stuff (as a drink, not as a food).

I'm not going to go into the background of chocolate here. There are ample resources freely available for those who wish to delve into its often fascinating history. What I'm on about is the *art* of chocolate and how it has evolved from the cave painting version (Hershey's and Nestlé's) to realist, impressionist, and even modernist chocolate (say, Lindt, Vahlrona, and Theo).

I remember clearly when a Hershey bar of some heft could be had for a dime. Nowadays a chocolate bar from an "artisan" chocolatier can cost from three to eight dollars and up, and I'm not even talking about shop window truffles from Belgium or Paris or New York. What you get for the extra money is not always better chocolate, but inevitably something far more complex.

Chocolate has become like wine or tea, with gourmet tastings and furrowed-brow analyses that would have flabbergasted Milton Hershey. The difference is that, instead of a bar having "flavors of goji and lavender with overtones of peach and pear," as (supposedly) might be found in a glass of wine, your chocolate will actually *have* goji and lavender and peach and pear right in the bar. If done right, the result is an entire complex dessert offering enclosed in a single wrapper. If done wrong, the result can be inedible. A fancy foiled wrapper and exalted price mean nothing.

As with wine and tea, the flavorings that go into chocolate are very much a matter of personal taste. I'm still trying to figure out the current craze for putting sea salt in chocolate. I mean, if I want salt in my snack, I'll buy a bag of pretzels. I don't know where in the mix that puts chocolate-covered pretzels.

Again, it's all a matter of taste. Some folk can't handle dark chocolate and prefer milk. Some adore white chocolate, which isn't really chocolate at all. Then there are those for whom chocolate means *chocolate* and nothing else. No fruits from the heart of the Amazon. No tea... tea is for drinking. No nuts. Nuts are for eating out of a can. Certainly no salt, whether it comes from the sea or a mine in Poland. But we're all different, and we all have different tastes.

Which is one of the great things about the explosion in artisanal chocolates. There's a flavor and a favorite for everyone, yet we can all agree that chocolate itself is a wonderful thing.

Myself, I favor straight dark chocolate, though I'm always willing to sample some of those artisanal ingredients. Favorites among the latter? Coconut and raspberry. Non-favorites? Pepper and of course, salt.

Furthermore, science has now determined that (dark) chocolate is good for you. Lots of antioxidants and stuff. My personal picks? Vahlrona and El Rey at the apex, followed by Chocolove and then an assortment of lesser brands.

Straight up, if you please, neither shaken nor stirred. My kind of art.

The Distancing has Begun

I have nothing against virtual reality. But I worry where it may lead.

It's just getting started and there's nothing to stop it. The idea that we can put on a pair of goggles and be anywhere, do anything, is too seductive to be disavowed, too tempting to be ignored. Want to be Superman for an hour? Slip on your VR goggles. Always wished to visit Bora Bora? It's VR time (and you can even eliminate the annoying jet skis in the lagoon). Have a fear of heights but always dreamed of scaling Everest? Move your arms and legs, and VR will do the rest.

Harmless entertainment, you say? I *suppose* it is. What concerns me are the inevitable ramifications as both the technology and its acceptance continue to mature.

I'm writing this just before Christmas. I love Christmas. The sparkling, chromatic municipal decorations as well as the lesser ones that are purely domestic. The excitement on the faces of children as their parents convoy them through the mall. Even the crowds in the stores, though there's always a grumpy gus standing in the checkout line complaining to all who'll listen about how long checkout is taking. I love the crispness and crackle in Prescott's air and the turquoise-framed view of snow on the San Francisco Peaks and the change of clothing necessary to cope with the change of seasons.

And I am very much afraid that the ongoing perfection of VR might make all of that go away.

After all, if it's sleeting and freezing outside but you still want to experience that, slip into your advanced VR gear. You'll have the same sensation of moving around in the wicked weather, but your body won't have to suffer the extremes. At least, it won't unless you intentionally activate your VR suit (that's in development) which will integrate with the goggles to allow you to feel cold, wind, and precipitation according to your chosen program. When you've had enough, you simply flip the off switch.

It's not the off switch that worries me. It's the on switch.

Imagine a future Christmas dinner. Uncle Mo and Aunt Cheryl don't want to spend the money to make it to the family homestead. But they're

present if you put on your VR goggles and everything has been appropriately programmed. Little cousin Betsy has the flu, but she can be there safely via VR. So can best friends Stan and Muriel, who are living in Ouagadougou. Doesn't it sound wonderful, being able to bring everyone together for Christmas irrespective of desire, cost, health, and distance? Just envision it.

You can have a whole family Christmas dinner… by yourself. Heck, if they were downloaded, you can even bring in your grandparents. Your deceased grandparents. And "interact" with them.

VR is liable to change society in ways we can't begin to imagine. Why spend the time and money to go to an amusement park when you can enjoy all the rides via VR, on the comfort of your own couch (I anticipate the forthcoming Disney release of all their park rides in VR format)? Why dream of visiting the Prado, or the Uffizi, or any of the world's great museums, in person when you can do it via VR? Study Bernini's sculpture, then head for the fridge for a cold one. Why struggle with driving and parking and rude fans to see an NFL game when you can do so via live VR, broadcast directly to your home goggles? No bad, overpriced seats anymore: you can even view the action in person, via on-field cameras. Teams will play before empty stadiums filled with computer generated crowds. There's just one thing is missing from all these time-saving, money-saving, travel-saving developments.

Interacting with other human beings.

Is that really necessary? Do we have to bump into other visitors at a museum in order to enjoy the exhibits? Is it important to listen to other fans yelling and howling at an NFL game in order to immerse ourselves in the action? How much of standing in line at Disneyland contributes to the enjoyment of the ride or the park "experience" when the latter includes blister-raising walking and pushy crowds?

Yes, VR is going to change our society. Whether for the better (certainly if you're physically challenged it will be better) or the worse (how can we get to know and understand our fellow citizens if we never actually meet them?).

To paraphrase Pogo; we have met the zombies and they is us.

Planetary Appropriation

I was born here. This is my culture: all of it. I cannot "appropriate" what I was born to.

By born here, I mean on this world. Planet Earth. I am, at base, not a tribalist. Don't get me wrong. I'm very glad to have been born into the largest, most powerful, and sometimes (though not always) the "best" tribe: the USA. But my home is the *planet*. Its cultures are my culture.

In the past couple of decades there has been a lot of talk, not to mention yelling and screaming, over something called cultural appropriation. To give one example, as residents of the state of Arizona we are probably more familiar than most with the term, given the interminable arguments over what constitutes cultural appropriation of Native American art.

There's a fine line (and there has to be a line) between utilizing cultural memes out of admiration and as the basis for one's own artistic endeavors. The best way to do this is via authentication. But even with authentication the lines can blur.

Take sand paintings. If the Navajo Nation was able to collect a royalty not only on every cheap rendition of a sand painting that's sold in the Southwest but also on every skirt, T-shirt, dinner plate, light switch cover, piece of upholstery, and bed sheet that utilizes those ancient patterns, they wouldn't need to bother with a casino in the boondocks east of Flagstaff. But it can't, because for better or worse, the use of those patterns have become so widespread not only in the US but across the world that fighting all the users would cost more than could be reaped in income. Navajo sand painting has become a part of world culture. Of course, none of these millions of imitations are genuine because they're not complete (the copies copy other copies, which are taken from originals left deliberately incomplete by their makers), but that doesn't trouble the manufacturers of pottery, bed sheets, etc. Nor, apparently, the millions of buyers.

What the Navajo *have* been able to do, and the Aborigines of Australia and Panama hat makers in Ecuador (you did know that's where "Panama"

hats come from, didn't you?) and Shona stonecarvers in Zimbabwe and, lately, Champagne producers in Champagne, is label the products of their culture as authentic representations of their particular culture. You can buy a Sami knife in Finland, but only those made by the Sami carry with them certificates of authenticity. Russia is full of imitation lacquer paintings, primarily on boxes, but only those from the three villages most famous for the art are allowed to legally indicate their origins.

As a citizen of Planet Earth I believe that this is all my culture, too. If I want to make a Sami-style knife or carve greenstone or make a Panama hat or paint the Dreamtime, no one should be able to stop me. What I *cannot* do is claim that my work is an authentic representation of that portion of terrestrial culture, because I'm not Sami or Shona or Ecuadorian or a child of the Outback. Nor would I claim to be. I'm proud to be a citizen of planet Earth and to be able, sometimes in words, to make use of various aspects of its multiplicity of cultures. For that I can be criticized or applauded, but not forbidden.

When the Mexican composer Silvestre Revueltas wrote the symphonic piece *Sensemayá*, was he "appropriating" European musical traditions in utilizing a standard symphony orchestra? Every classical composer sooner or later employs folk tunes from other cultures in their work; sometimes overtly, sometimes without any attribution at all. Pearl Buck won the Pulitzer and the Nobel for literature largely for her depictions of peasant life in China. Does that constitute an "appropriation" of Chinese culture? If Edgar Allan Poe truly invented the modern detective story with "The Murders in the Rue Morgue," is every subsequently written detective tale an appropriation of American culture?

I love this planet. I love its seas, its forests, its deserts, and mountains. I love its people and their multitudinous ways and inventions, their music and dances and stories. I will continue to utilize them in my own work because terrestrial culture is my culture, and I glory in it all. Meanwhile, others are welcome to borrow from my own imaginations.

As long as they don't try to copyright it as authentic me.

Everythings' Hometown

We've lived in Prescott for more than forty years and I still take the local nature for granted. It's amazing how downright blasé you can become over time about such things. It's usually when we have visitors from out of town, often from metropolitan areas where the only real wildlife tends to hang around liquor stores, that I realize how fortunate we are, and how each of us really needs to take time from work and commuting and the damn TV and the addictive internet to get out and have a look around town for something besides the weekly arts and crafts festival.

We're doubly fortunate because our house backs onto one of the several major creeks that run through town. That gives us access not only to more wildlife but to a greater variety of visitors, as critters that tend to hang out elsewhere come down for the occasional drink. There's the rare bobcat, and deer, and skunks. We had a bear once, a long time ago, and of course coyotes and javelinas are a steady presence. But to get a real feel for Prescott city wildlife you have to pay attention to the birds.

I'm not going to turn this into a birdwatcher column. For one thing, there are better local resources available and for another, I'd probably get every subspecies wrong. But as someone who originally moved here from Los Angeles, I can't help being endlessly fascinated by the diversity of our avian regulars.

There's a telephone pole on the property where red-tailed hawks nest every year. We can virtually predict the onset of Spring when they start showing up to circle over the creek and start hunting. The ravens annoy the heck out of them but they persist. Then there's the young bald eagle that seems to have made a dead tree out at Willow Lake its principle hunting spot. I know they nest out at Lynx Lake and elsewhere, but there's something about seeing a bald eagle in what is essentially an urban environment that gives one hope for the future of the planet. Traffic whizzes past on Willow Lake Road, and this huge raptor just sits there, ignoring the steady flow of cars while keeping a patient lookout for shallow-swimming fish. Compared to seeing the same bird in, say, coastal Alaska, the experience is almost surreal.

In the shallows dwell the herons. Tall, elegant birds, the Fred Astaire of the local bird world, they pick their way with stately, measured grace through the still waters, ever on the lookout for anything moving and edible.

Because they're full, Willow and Watson lakes are swarming with birds right now. More ducks than Disney, harriers sweeping low over the marshlands patrolling for rodents, our ever-present coots, geese, swans, and much more. If you block out the nearby traffic you can imagine yourself in the wilderness, yet this profusion of winged life lies only a short drive from the city center. Brewer's blackbirds haunt our grocery store parking lots, looking for leftovers, and there are enough sarcastic ravens on patrol to please the most devoted Poe fan (no, not the Star Wars variety).

In the summer we trade wintering birds for hummingbirds. What other city's avian population switches on such a regular, predictable basis from winter to tropical? Right now at the house we have white-crowned sparrows and juncos and the ever-resident blue jays, canyon and spotted-towhees, and of course quail. Flickers make a home in the roof of the garage. Great Horned Owls entertain us at night. Black-headed and Blue Grosbeaks will be showing up soon, and robins and woodpeckers and a resident small cloud of goldfinches. The first doves just arrived. The wrens and nuthatches will be checking out the smaller rentals. Saw a green-headed grosbeak last year; first one ever on the property.

Then there's the Crissal Thrasher. Except for its coloring it looks like an exotic that would be more at home in Central or South America. It has a hard time with the seed feeders, but it manages well enough. I love the names given to unusual birds, even if the best aren't bestowed on our common Prescott residents.

There's no Shining Sunbeam (an Ecuadorian hummingbird) here, or Spangled Cotinga (Ecuador again), but I'll settle for a daily visit from a Crissal Thrasher in between searching the internet and picking up the groceries.

Sometimes we here in Prescott don't realize how lucky we are. Remember that the next time you have to clean off the car.

Glassy-eyed

"I am large, I contain multitudes."

It's safe to say that Walt Whitman wasn't thinking of fun house mirrors when he composed that line, but it fits what has always been a historically popular combination of physics and art. The reproduction of self or other objects, ad infinitum, has long been both possible and fascinating. Best of all, it requires a minimum of investment and effort.

When I was a kid, there used to be an over-the-water entertainment venue in Santa Monica, California, called Pacific Ocean Park. It had one decent, expensive ride, the Banana Train, to which was appended a host of Coney Island-type games and rides with ocean themes. It was over the water, so I didn't care if some of it was a little tacky. But besides the classy Banana Train, I distinctly remember the park's version of funhouse mirrors. Along with the usual warped mirrors that made you look fat, or tall, there was an "infinity" room, where you could stand in the center surrounded by mirrors and see yourself reproduced over and over again, until your multitudinous tiny selves vanished like ants, swallowed up by distance and time. It was only simple optics, but it fascinated me.

It fascinated Orson Welles, too, who utilized the same funhouse mirrors in *The Lady from Shanghai* and, later and more memorably, in 1958's *Touch of Evil*.

Something in us responds to visual tricks involving a combination of distance and duplication. Purely on an intellectual level, we react to the science. On an emotional level, to the art. Dresses in India, especially wedding dresses, have traditionally made use of bits of mirror when the bride's family couldn't afford gems, a practice still much in vogue today. Brides reflect others in the wedding party, who reflect back on the bride, and so on. Maharajahs' palaces are filled with mirrored rooms, showing that our delight in infinite reflections reaches back hundreds, if not thousands of years. The Hall of Mirrors at Versailles enabled kings and nobles to see themselves magnified hundreds of times. Which, after all, is what they really wanted all along.

I expect a hall of mirrors installation in the White House any day now.

I bring all this up by way of referencing what is arguably the most popular art exhibition currently running in this country: Yayoi Kusama's Infinity Mirrors at the Hirshhorn museum in Washington. It looks like enormous fun, and the demand for tickets is overwhelming, but I see nothing that deviates from the old infinity mirror room at Pacific Ocean Park. In saying that I don't mean in any way to take away from the delight provided by Kusama's work. What's old is often new again, and if that means filling an infinity room with rows of illuminated polka-dotted fake pumpkins, why, I've always enjoyed whimsy in art, whether by Hogarth or Bosch or... Kusama.

If an art installation is worthwhile, you disappear into it, be it sculpture, painting, or glass. In Kusama's vision, you don't just disappear into it, you literally step inside it. It's what we might call hard virtual reality: no fancy lenses or adjuvant electronics necessary.

I have a small infinity box. Inside, a single light source is multiplied by mirrors. The idea is to stare deep, deep into the artificial infinity to help relax your mind. I guess it doesn't work appropriately for me because staring into it makes my mind churn as I contemplate physics and optics and bulbs and all the practical stuff.

There's a better example inside the elevators of the Burj Khalifa. Located in Dubai, the Burj is currently the tallest building on Earth. Visitors can only ride as far as the upper observation deck, located at 555 meters (1821'). To reach it, you rise via specially designated high-speed elevators which are lined inside with... mirrors. The lights go out, and you are invited to gaze into your own ascending infinity mirror room, inside a working elevator. The idea is to get your mind off the fact that you are rocketing skyward in a little box suspended on cables, and to make the journey pass more quickly. It works. I compare it to standing outside at night and gazing up at the night sky, trying to gather in all the stars, while time passes.

So... I love infinity mirrors. Art plus optics. Maybe another time, I'll talk about kaleidoscopes.

Right now, I'm thinking of Kusama's work, which contains multitudes. Even if, unlike Whitman's poetry, they do have to be plugged in.

Disney Versus the Death Channels

If there was any doubt how much I love Nature, the debut of a new photo accompanying this column ought to dispel that. I'm hanging out with a Mayotte brown lemur on the island of M'bouzi in the French Comoros islands (I'm the one with the sappy smile). M'bouzi has been turned into a sanctuary for the lemurs. They need one, since they have an unfortunate habit on the other islands of eating the farmers' bananas, mangoes, etc. right off the trees. The chap in the picture developed a serious fondness for the gold earring in my left ear. Lemurs are strong, but they're not chimps or gorillas, so I still have the ring. And the ear.

In 1951 my family moved from New York to Los Angeles. As I recall the television options at the time there were three major networks, Fox not having erupted yet from its alien egg, plus a handful of independent channels: 5, 9, 11, and 13. None of them were specialty channels. Such innovations lay far in the electronic future. There was nothing like the Discovery Channel, or the National Geographic channel, much less further specialized iterations of such channels such as those for kids, those devoted to the sea, and so on. And of course satellite television was still a gleam in a 1946 article by the science-fiction writer Arthur C. Clarke (ever wonder why communications satellites orbit in the "Clarke belt"?), so there was no access to the BBC or the CBC or other non-American television content. There was no PBS.

Anyone starved for television dealing with the natural world had to wait for an occasional visit by network anchors to some faraway place that happened to be in the news for some human-centric reason, and hope the reporters on site might occasionally digress into a discussion of the local wildlife. The options available at your local movie theater were little better.

But in 1948, Disney had completely revitalized what passed for the theatrical nature documentary with a two-reel short called *Seal Island*. Between then and 1960, the studio released a total of 14 such film titled *True-Life Adventures*. They won a total of eight academy awards. Today's nature documentarians look at them a bit askance, for everything from

their frequent attempts to anthropomorphize their subject matter, to the efforts to inject humor into natural situations, to the efforts to cue the audience's emotions with cinematic music, not so different from what *Bambi* had done.

To a kid just discovering his love for the natural world, however, they were a revelation. I couldn't get enough of the close-up color cinematography, the action, and the fact that so much of what I was seeing actually existed outside books. These were real creatures interacting in the real world. I promised myself that one day I would go and experience them in the wild, no matter the difficulties (see: *Predators I Have Known*).

To Disney's credit, the *True-Life Adventures* weren't completely sanitized. There was death as well as life. But death and dying were shown as a part of the natural cycle of existence. They were not the focal point of any of the films, nor did the footage linger excessively over any individual incident. Certainly the studio had in mind the fact that the films would be seen by children. So a balance was struck between pretending that death did not exist in the natural world and using such sequences to dominate a film. When the Disney TV shows came along, the *True-Life Adventures* provided hours of footage that Disney was able to cannibalize for various shows in addition to presenting the films in their original format.

Over the past half century, nature documentaries on television as well as in the theater sure have changed.

As usual, money is at the root of the situation. The sad fact seems to be that killing and death, in whatever form, drives ratings. Doesn't matter whether it's a detective show, doctor show, or the evening news. Killing sells. It's no different with nature films.

The Discovery Channel started it, and not just with Shark Week. To compete for viewers, National Geographic had to follow the trend. So did Animal Planet. Even the venerable BBC nature documentaries found themselves spending more and more time lingering over not just a lion kill, but the details. Today kids can watch as carnivores slowly dismember still-living prey, in extreme close-up and gloriously gory color. The nature documentary death spiral appears never-ending.

You know who really dislike this trend? The cinematographers who have to shoot the footage. I've spoken to some, and for many if not most of them, there is subject matter they would rather focus on. But, they tell

If You Shoot the Breeze, Are You Murdering the Weather?

me, that's not what their producers want. More hunts, more takedowns, more fights, more blood, blood, blood. An hour documentary on sharks isn't worth its weight in viewing time anymore unless the sharks are shown killing something. It's the same no matter the subject, be it fish, insects, birds, or wild pigs. It's the same deep-seated emotion, I reckon, that drives people to fascination with car wrecks.

But the need to come up with ever more violent and gruesome footage puts tremendous pressure on the photographers. I'm all for realism in nature cinematography, but there should be a better balance than what we're seeing today, if only for the sake of family viewing. Maybe we need a ratings system for nature docs akin to the one we have for movies.

Shark Week at one extreme and the Puppy Channel at the other.

Stravinsky: Dinosaurs Optional: Part I

Here's how you get kids interested in classical music: you throw out all the traditional "music appreciation" courses, haul your class to a theater, and have them watch the original Disney *Fantasia*. Then you go back to the classroom and spend a semester discussing it. That's what did it for me, and I did my own homework because the class in question didn't exist.

I remember being taken to see a re-release of the film when I was about 7. We had a little classical music in our house. Beethoven's Fifth, some Tchaikovsky, on 33 rpm records. My mother played a mean *Rhapsody in Blue* on her baby Steinway. But *Fantasia* simply overwhelmed me. I remember my initial reactions to it to this day. Confusion at the abstract visuals of Bach's *Toccata and Fugue*, mild amusement at Ponchielli's *Dance of the Hours*, quiet awe at the sheer beauty of Tchaikovsky's *Nutcracker* suite, wonderment at Beethoven's sixth symphony, amazement that Mickey Mouse could do more than giggle in Dukas' *The Sorceror's Apprentice*, and yawning at the concluding Schubert *Ave Maria*.

But... there were dinosaurs. Ah, dinosaurs! As part of the whole evolution them of the Stravinsky *Rite of Spring*. Stravinsky hated Disney's take on his ballet, but the appearance of the score in *Fantasia* has probably sold more copies of recordings of *Rite* than all the other sales put together. Ironically, in showing fast-moving, highly active dinosaurs, Disney's artists got the paleontology right decades before it was determined that dinos weren't lumbering, slow-moving, swamp-surfing critters.

Lastly, there was what for Disney was doubtless the greatest gamble in the film: a fairly literal visual interpretation of Mussorgsky's *Night on Bald Mountain*, with its howling, bare-breasted she-demons and a Chernobog/devil that scared the bejeezus out of me for many nights thereafter. Kid stuff, my ass.

As soon as I started buying classical music, my first purchases were all of music from the film. Which led me to other compositions by the same composers. I devoured all of Beethoven, Stravinsky, and Mussorgsky.

If You Shoot the Breeze, Are You Murdering the Weather? 145

None of this thanks to public school music appreciation classes; all of it because of the Disney version. Learning that Beethoven wasn't really thinking of gamboling Greek mythological characters when he wrote his sixth symphony, or Stravinsky of the march of life when he did *Rite of Spring* did nothing to mute my enthusiasm for the music itself.

When I started attending UCLA I learned that the Los Angeles Philharmonic sold student tickets, at the box office, just before performances. When I could get gas money I'd fire up the old Ford Galaxy and haul myself downtown. Though the last-minute student seats were usually in the first few rows, hard up against the stage, I didn't care. You could still hear the music, and as a bonus you got to observe the conductor and soloists up close. I saw some wonderful performances that further expanded my knowledge and love of classical music. Anyone who thinks of Los Angeles as a cultural wasteland is plainly unaware of the musical offerings to be had that extend far from Sunset Boulevard.

I remember seeing the legendary Otto Klemperer conduct in Pasadena, and regular spectacular performances led by Zubin Mehta (with whom, in one of the universe's odd coincidences, I shared a dentist). There was a grand performance of Mahler's second symphony back before Mahler became a staple of orchestral programming everywhere.

A used record shop on Santa Monica Boulevard near Vermont became a second home, so much so that the husband-and-wife owners got to know me by name. Perhaps because I was often the youngest customer browsing the classical section, they would sometimes give me unrequested discounts on multiple purchases. The neighborhood sucked, but the store was great. Both are long gone now, like the huge Tower Records store on Sunset where, when I became able to afford it, I used to go to shop for new releases. Or the numerous wonderful used book stores on Hollywood Boulevard. But I digress.

With *Fantasia* as my classical music foundation, I went on to explore more and more pieces by more and more composers, always trying to keep an open mind. Despite this, I never could get behind such developments as 12-tone music or the works of John Cage and his ilk. Call me old-fashioned, but to me music needs rhythm and melody. Throwing bricks at a piano is something I can do for myself. I don't count it as composition, just as I don't count blowing up balloon animals to Green Giant size or painting a black square in the center of a red canvas

as art. To me, the biggest problem with contemporary classical music is not a lack of new material but a turgid reliance on the same old standards.

Go to a typical classical concert in the US and who might you hear? Bach, Beethoven, Tchaikovsky... sound familiar? And not just Bach, Beethoven, and Tchaikovsky, but the same Bach, Beethoven and Tchaikovsky that was on the program last month, or last year. Great music to be sure, but isn't there anything else listenable out there? Anything? Orchestral programmers don't seem to think so. Well, they're wrong. Just as the writer Robert Bloch (of *Psycho* fame) once told me that he'd heard "everything worth listening to."

As I'll discuss in next month's column.

Stravinsky: Dinosaurs Optional: Part II

Bach, Beethoven, Tchaikovsky. Wonderful composers. Whose music, as I mentioned last month, retains its luster but after dozens of performances of the same works, tends to... not bore, necessarily. But to lose the excitement of the new. There are only so many ways to play Bach's "Toccata and Fugue," Beethoven's ninth symphony (interminable TV commercial excerpts notwithstanding), or Tchaikovsky's first piano concerto. Yet that's what most orchestras do, then wonder why attendance falls off and interest in classical music wanes.

I don't care how much you love Star Wars. You don't want to just see Star Wars every time you go to the movie theater. Ah, you say, but I'd go to see something *like* Star Wars. So, isn't there something like Bach, Beethoven, and Tchaikovsky?

There's plenty, and much more besides, but modern orchestras just won't program it.

Love Tchaikovsky? When was the last time you saw Sergei Bortkiewicz's first or second symphony on an orchestral program? Like, never?

There is so much wonderful music by so many fabulously talented composers that never, and I mean never, gets played. Here's a sample program of American classical music that I'd drive a long ways to hear, but that you'll never see on a domestic symphony orchestra program. Because, no Copland.

Rocky Point Holiday (yes, *that* Rocky Point) by Ron Nelson. "Fiddle Concerto," by Mark O'Connor. *A Night in the Tropics*, by Louis Gottshalk, and lastly Symphony #2 by Meredith Willson (yes, the same Meredith Willson who wrote *The Music Man*). Alternative: *Symphony in D*, by John Vincent. If you don't leave this hypothetical concert feeling good, you shouldn't be listening to music, period.

We can't even hear good ol' Howard Hanson these days. *Why* won't the Phoenix Symphony do Alan Hovhaness's *Mt. St. Helen's* symphony, never mind delightful early American composers like Strong and McDowell. Orchestras do Christmas concerts all the time.

Instead of the 4,863rd set of excerpts from Handel's *Messiah*, how about essaying Vaughne Williams's wonderful *Job*, or Fry's *Santa Claus* symphony?

If I was a trumpeter in a symphony orchestra, I'd be both terrified and exhilarated at the prospect of performing in a rendition of Bantock's *Hebridean Symphony*. What about celebrating the music of Iberia without yet again programming… well, Albéniz's *Iberia*? Instead of yet more de Falla, how about we hear Braga Santos's third or fourth symphonies, or Guridi's *Sinfonía pirenaica*?

Like film music? How about this for a lineup? *Theme, Variations, and Finale*, by Miklós Rósza; violin concerto by Erich Korngold, variations on a waltz by Jerome Moross, and *Moby Dick* by Bernard Herrman. All composers much better known for their film scores.

A fan of the comic book/movie *Thor*? You should hear Geirr Tveitt's *Prillar* or *Baldur's Dreams*.

There's just *so much* great, listenable music that never gets performed. I expect to die before I have a chance to hear Tournemire's Sixth symphony, *L'an Mil* by Vierne, or any of the great romantic French works for orchestra and chorus. Forget about ever hearing Bantock's huge setting of *Omar Khayyam*.

But, orchestral programmers say, these pieces are expensive to mount, and who would pay to hear them?

There follows a tale.

Havergal Brian. There's a great composer you never heard of, because he never gets played. At least, not in this country and certainly not by major orchestras. The word "iconoclast" was invented for Brian. An honorable definition for a true artist. Brian was British, self-taught, lived to be 96, wrote five operas, thirty-two symphonies (a bunch of them after he turned 80 (!)), and much else besides. Concertos. Orchestral suites. Songs. It took him eight years to finish his first symphony, *The Gothic*, which requires two double choruses, a children's chorus, four soloists, over 200 musicians in the main orchestra, an organ, and three separate, isolated brass groups. It had only been performed a handful of times, usually with reduced forces, until the BBC decided to open its 2011 Proms season with the first fully staffed compliment of performers. Expensive to mount? You bet. No one would come to hear it?

Tickets sold out in less than 24 hours.

If You Shoot the Breeze, Are You Murdering the Weather?

I flew to London to hear the performance... the only time I've ever done anything remotely like that. It turned out to be the greatest concert-going experience of my life. For the curious, there's an award-winning CD of the live performance and plenty of relevant material on line. Also my own partial video excerpt of the rehearsal, viewable on Vimeo. Sadly, no video was made of the actual performance itself.

I use this as an example of music that's rarely played but when it is, often draws a bigger response than the familiar Bach, Beethoven, and Tchaikovsky. Maybe if performances of wonderful music by composers like Büttner, Taneyev, Klami, Steinberg, and others were more frequent, classical music performances might sell out more often. Maybe if instead of the *Nutcracker* suite we heard some excerpts from Tchaikovsky's *Vakula the Smith*, those who love Tchaikovsky might come out for a concert they would otherwise have skipped.

Maybe then I wouldn't have had to inform a wide-eyed concert goer at a live performance many years ago by Emerson, Lake, and Palmer, that no, they didn't write *Pictures at an Exhibition*, but that it was actually composed by some Russian chap named Mussorgsky, and maybe she should go see *Fantasia*.

Inka-dinka-do You... and Me

"Inka-dinka-dee, Inka-dinka-doo..."

That was the great Jimmy Durante's signature song. Later recorded by, among others, John Lithgow and Ann-Margret. For those of you who remember or enjoy the music of the '50s, comic songs did not begin with Ray Stevens (kind of hard to imagine something like "Ahab the Arab" making it into the Top 40 these days) or Sheb Wooley or Allan Sherman. I'll grant you Gilbert and Sullivan.

Ah, Allan Sherman, the lyrics of whose parody song "Hello Muddah, Hello Faddah" was set to Ponticelli's *Dance of the Hours*... a ballet to which I alluded in my column on classical music a couple of months ago because it also provided a source of amusement to Walt Disney and his animators, who parodied it in their own way in *Fantasia*.

Which naturally leads us into a discussion of the art of scarification, body modification, and tattoos.

I have to laugh at the people who think the current frenzy for tattoos is a passing fad or something new. Human beings have been treating their bodies like collagenic versions of Silly Putty since time immemorial. What possessed the first person, possibly a Neanderthal (Neanderthal jewelry has been recorded back as far as 130,000 years) to pierce their ears, or their nasal septum, or some other unknown body part, and then stick a talon or bone through it may well remain forever unknown.

"Hey Uluk, why you put piece of food through your nose? Goes in mouth. You want to become extinct?"

Following animal parts, people subsequently started to make holes to receive cut fragments of stone, then gemstone. Gold work of increasingly delicate and skillful design followed. When tattooing began thousands of years ago, it was applied not only to enhance the attractiveness of the wearer but to signify status and, in ancient China, identify criminals. The word "tattoo" comes either from the Tahitian "tatu" or the Samoan "tatau": a moot point, since all the Polynesian languages are closely related to one another. Picked up from the Polynesians by visiting sailors, tattooing naturally became particularly identified with seafaring. My older

cousin Joe, who served in the Korean war, had a tattoo. Primitive by contemporary standards, it was not especially well done, but it was considered a mark of manhood as well as of maritime service.

I wonder sometimes what Joe would have made of women who today completely cover themselves with tattoos. Not to mention body piercings containing enough metal to set off alarms in even small airports, and ear stretching enhanced with plugs, the results of which are significant enough to astonish a Maasai warrior.

According to one Nielsen poll, in 2015 one in five Americans had a tattoo. It's always interesting and amusing to see how acceptance of such body mods vacillates down through the ages as cultures undergo their inevitable changes. Even though society's acceptance of such modifications was already well underway, when I acquired an earring back in 1991 I occasionally received a sideways glance or, more rarely, a snide comment about it being feminine. I sometimes replied that the individual making the comment should imagine voicing the same observation to Blackbeard, who was noted for wearing rather more than one earring, and who would have responded to such an accusation with other than a polite rebuttal.

Nowadays only some old folks (those who didn't have relatives in the Navy, anyway) blink at the profusion and astonishing variety of body art, be it a simple ankle tattoo of a chain or a full sleeve or ear plugs or nose rings. As for myself, I choose not to indulge since, well, since the canvas is a bit old and fragile these days. But I do admire the artwork on others, much as I admire the classical tattoos of Japan, the earpieces of the Maasai, and the crocodile skin scarification of those who dwell along the Sepik River in Papua New Guinea. The men who undergo the latter ceremony, which involves cutting the skin and rubbing ash from a fire into it to produce raised bumps, believe looking like the crocodile gives them the power of the crocodile.

Remember that the next time you might be inclined to chastise someone younger than yourself for having a butterfly inscribed on their butt.

Everybody Was Here

Why selfies?

I mean, I already know what I look like. That's what mirrors, hairstylists, bad home videos, and good grandparents are for. Why go the trouble of taking a picture of myself in front of Big Ben, or a rainforest river, or six drunken fake Spider-Men in Times Square? Why not just take pictures of each place? Doesn't inserting oneself in front of the presumably interesting locale spoil the picture?

I reckon it's because humans have always had this incorrigible desire to validate their existence; first through art, then graffiti, and today via the ubiquitous selfie. Regardless of the form it takes, the selfie declares "I was here! I existed. I meant something—even if only for the brief time it required to paint this image, etch these words, or take this snapshot." Selfies are an expression of the id and a desire to find permanence in an impermanent universe.

Much to humanity's surprise, like so many things over time, these intensely personal expressions quite inadvertently become history and art.

That's not to say the shaky quickie pix of you and your date smooching on Whiskey Row at one on a Saturday morning will some day appear in a celebrated visual history of the 21^{st} century—but it might. A lot depends on the lighting, what you're wearing, your makeup, what's visible in the background, and a lot more. What becomes art and history is determined not by us but by what future generations decide is important. We can never know when a selfie might prove invaluable to the future. That rum-soaked individual photobombing you might turn out to be an important scientist... or axe murderer, or politician. The building site that currently houses a bar or hotel might in the future become a center of great learning. One never knows.

I suspect that the Cro-Magnons who left us the great cave paintings at Lascaux, France, were not attempting to create the first great art. They were doing selfies. One can imagine them squatting by torchlight, painstakingly layering the visual magic on stone walls that our generation would come to view as an artistic miracle, all the while arguing over

whose nose was too big. In a procession of hunters, did one disgruntled individual sneak back in at a later date to insert his own figure, his own selfie, in the front of the line? Did they delete their hand painted images as frequently as we do ours with our cell phones? For sure—selfies one and all.

On the island of Mainland (yes, that's what it's called) in the Orkney islands lies a Neolithic cairn, a tomb some 2800 years old. In roughly 1000 AD the Vikings broke in and stole pretty much everything (hey, you know... Vikings). But they left behind selfies, in the form of graffiti. The best preserved runic writing in Europe. What do these hand-carved selfies tell us about these bold seafaring warriors? Pretty much the same things selfies tell us about ourselves today.

"Ngigerth is the most beautiful of all women," reads one. Another tersely describes sex in terms familiar to anyone today. But most, like "Haermund Hardaxe carved these runes" is straightforwardly the Viking version of a selfie.

Nothing changes. People don't take selfies to remember themselves: they take them so *other* people will remember them, and what they've done.

I recall the first time I saw a bus disgorge a load of Japanese tourists at the Grand Canyon. They spent a few minutes (maybe seconds) eying the canyon before turning their cameras on themselves. I learned that seeing the Canyon wasn't nearly as important as being able to prove to the folks back home that the travelers had *been* to the Canyon. The selfie as proof of social status.

I imagine motivation was the same with those unknown artists who painted themselves onto the walls of the caves of Lascaux, the same with good ol' Haermund Hardaxe, and the same with those young folks out late on a Friday night on Whiskey Row. That's just humankind for you. We're all one big selfie.

And if we're fortunate, in the end some of us end up as art.

The Aesthetics of Gurgle

So... water has taste? Is that aesthetics, or is there science behind the claim?

I can remember when water was just water. At least, so it was for most Americans. Europeans always seemed to feel differently about it. I guess because they've been parsing foods longer than us. But... water?

Nowadays people have taken to speaking about water the same way oenophiles (I love that word... it's stupid, but lovable) talk about wine. A glass of water might be "crisp" (as opposed to what... damp?) or "lightly mineralized" or "slightly acidic" (ah, there's the science!) or having a taste like a "fresh spring morning." Sometimes I can't tell if the testers are talking about water or room deodorizer. I can see the difference between plain water and alkaline water, but some of the rest of the so-called differences leave me cold. As to alkaline water, why would people boast about drinking rock? Not for me to criticize individual tastes, I suppose, no matter how confounding they may be.

Sparkling water seems to be a thing of the moment. Especially sparkling water flavored with "essence." When I was young we used to call "essence" "concentrated," but hey, whatever sells.

Perrier has been selling sparkling water, i.e., water full of bubbles, since 1863, so plainly there's something to it. In order to compete with fashionable soda waters infused with essence, you can now find Perrier flavored with lemon, lime, L'Orange (because the water is French, you know), strawberry, pink grapefruit, green apple, and watermelon (because "watermelon" sounds better than "pastéque"). I wonder what the original founders of Perrier would have made of all this? Despite calling itself the "anti-Perrier," La Croix, the "in" favored water of the moment, still employs a French name. Interestingly, it's bottle in La Crosse, Wisconsin. Vive la France Americain.

In 1799 one Augustine Thwaites of Dublin became, possibly, the first vendor to sell "soda water" under that name (personally, I think "Thwaites" has "Perrier" or "La Croix" all beat as a brand name). When I was a lad in New York, we used to get the form of soda water called

seltzer delivered to our apartment in large bottles (take that, Amazon!). Seltzer was important to our family because, unlike some bottled soda waters, it contained no additives such as sodium citrate or potassium bicarbonate. Each bottle was stoppered with its own metal dispenser. As I recall, these were fashioned from a mysterious alloy of pewter, iron, and possibly moon rocks. Pressing down on the handle would release a powerful stream of seltzer into a glass or, if you were in need of an audience, somebody's face. Hence the immortal line from the Chuckles the Clown episode of *The Mary Tyler Moore Show*, "A little song, a little dance, a little seltzer down his pants." "Perrier" just doesn't work in that oration (although "Thwaite" might).

These massive bottles would be returned to be refilled by the vendor. They eventually went out of style, not only because home delivery went out of style (until now) but because if the carbonation process was not carefully monitored, the pressurized bottles could turn into early IEDs, with catastrophic results.

Enough of deliberate flavoring, with "essence" or otherwise. What of the supposed differences in plain water? Do they exist? Do they matter?

In annual still (i.e., uncarbonated) water taste tests, one of the regular winners is New York City tap water. Plain ol' tap water. This perennial result tends to have multiple consequences. It temporarily shuts up those who profess to be water gourmets. It lifts the spirits of New Yorkers, who can always use a boost to the collective municipal *geist*. And it sets those giant corporations that have leaped into the bottled water business to muttering. Because if one city's tap water can best exotic bottled waters in a taste test, then how can they charge a buck for a bottle of their brand?

Advertising helps. All those quotes about "crispness" (geez, get an apple, already) and clarity and purity. This works because most folks don't realize that a good deal of bottled water is simply local city tap water that's been put through a rudimentary but adequate purification process. The water costs the bottling company virtually nothing. What you're paying for is the bottle, shipping... and that advertising.

If you really want to drink something reasonably pure, look for a still water that's been sourced from as remote and unpolluted a location as possible. Don't take at face value claims that water might come from a deep well in, say, Michigan. Of Nestle's Poland Spring water, about 30% comes from the area around the original Poland Spring (which dried up

decades ago) and the rest from "other sources." You want water from a real Poland spring, try Naleczowianka (on second thought, pronouncing "Perrier" is easier).

If you want to drink something approaching true pure water, dihydrogen monoxide that actually might be deserving of the adjective "crisp," look for water sourced from glacial origins. "Voss" (Norway) is probably more famous for their bottles (and their prices) than their water, but the water is fine. "Glacial" comes from British Columbia. My personal favorite is "Icelandic," which is drawn from glacial sources in… you know. My reasoning is that if it's been frozen since before civilization, the taste can rightly be called something akin to pure. Not expensive, better for you than a soft drink, and I like their bottle, too.

When it comes to the science of carbonation, sometimes less is indeed more. But I guess that's a matter of taste.

Nostalgia or Art?

"Art is in the eye of the beholder." The first known mention of this common aphorism is from the 3rd century Greek, and nothing much has changed regarding what is "art" since then. Opinions rage on. Is a boulder placed over a ditch, art? The Los Angeles County Museum of Art seems to think so. Is a cartoon balloon animal blown up to Green Giant size art? Some believe it makes Jeff Koons, and others who execute likewise, artists. For that matter, is the rendering of the Green Giant on cans of vegetables, art?

Here's where it gets interesting.

Of the enormous, indeed unquantifiable, amount of art produced over the last few centuries originally for purposes of advertising, what can be considered "art" and what is simply junk? While a small quantity of such material was considered art (or at least containing some artistic merit) when it was originally produced, how does the vast volume of such endeavors hold up today?

One only has to drop in on PBS's highly entertaining and informative program *Antiques Roadshow* to find out. Substantial valuations are proposed for everything from travel posters to general store box displays. None of this material was birthed for the purpose of creating art. Yet people will pay thousands, sometimes tens of thousands, of dollars for a poster promoting ship travel to South America, or cans of shoe polish, or plain old sacks of flour. But are people buying such items interested in them as art, or for purposes of nostalgia?

The answer often seems to be both.

It cannot be denied that there are places where art and nostalgia combine to drive buyer interest. What particularly interests me is the artistic overlap. Did the artist involved intend to produce something of artistic merit from the very beginning of the relevant commission, or did art eventuate not because of the subject matter but in spite of it?

A good example are the covers and interior illustrations that graced American magazines and paperback books from the late 19th to the mid-twentieth century. This is advertising art at its purest. The intent is to

utilize "art" to sell content. Since it was only the content that was important, the art itself was often simply given away, or in many cases, thrown away.

Today, such paintings and drawings comprise a hugely popular subset of modern art called illustration art. Illustration goes back to the first books, or if one prefers, to Egyptian hieroglyphics. The idea is not to create something worthy in itself but to sell content. The shift from recognizing such work as mere sales accoutrements to art that is of value separate from content seems to evolve over time. No one now denies the artistic value of work by Arthur Rackham or Harry Clarke if presented apart from the writings they were originally commissioned to illustrate.

A better and more recent example of this continuing trend involves the cover art for pulp magazines and paperbacks. The work of commercial artists from the '30s and '40s such as Walter Baumhofer, Margaret Brundage, Edd Cartier, Nick Eggenhofer, Norman Saunders, and others was not only consistently disparaged (when it wasn't being utterly ignored) by the "serious" art community, when the material was published the original art was often given away by the publisher, since the artist usually had no rights to their finished work. Which didn't matter much since at the time such "art" had no value.

Try to tell someone today that an original Margaret Brundage cover painting for *Weird Tales* magazine has no value.

It's not just nostalgia that's driving the market for such artwork, be it a cover painting for *Saucy Western Stories* magazine or a 19th-century ad for coffee. Such work has come to be recognized as art for its own sake. Like any art, the results vary widely from skilled to crude. Sometimes the results are easy to appraise. Who would turn down one of N.C. Wyeth's illustrations for *Argosy Magazine*?

On the other hand, what determines the artistic value of an original illustration advertising sewing machines that originally appeared in a New York newspaper? Just as in ancient Greece, it's all in the eye of the beholder.

Original art advertising Nestlé's baby food today might not be considered worthy of consideration as art for its own sake. But the only thing that may differentiate it from Alphonse Mucha's 1897 work also advertising Nestlé's baby food is time and perception. We all have to rely on the latter because we aren't allotted enough of the former.

I haven't even mentioned posters advertising concerts. The impetus behind them was to promote concerts, not to be recognized as art. Yet today concert posters from the '60s are not only recognized as such, they spawned their own artistic movement.

Speaking of commercial posters promoting concerts, if anyone has any Toulouse-Lautrec posters lying around advertising the Folies Bergère, you own Art with a capital "A"… even if the original purpose behind such work was nothing more than a lowly bit of advertising.

The Tao of Pussyfoot

Okay, let's get the title of this column out of the way fast. Pussyfoot is the name of a small black kitten that features in five Warner Bros. cartoons directed by the great Chuck Jones. Arguably the best one, "Feed the Kitty," features the kitten subduing an enormous, ferocious bulldog by the name of Marc Antony. Pussyfoot accomplishes this via a combination of unrestrained love, impossible cuteness, and general indifference.

I am moved to mention this by way of providing proof that the Beatles' song "All You Need is Love" may have more than a little scientific truth behind it, at least where domestic cats are concerned. I am further impelled to bring up the subject because the internet has been inundated by a flood, a veritable tsunami, of videos featuring cats. If some sources are to be believed, when ranked by subject matter cat videos draw the most views of anything on the net. In turn, this popularity has given rise to an entire subset of articles and scholarly treatises that attempt to explain the phenomena, such as The Cute Cat Theory of Digital Activism (Ethan Zuckerman, 2008). It is worthy of note that there is no corresponding Cute Dog Theory of Digital Activism—or Horse Theory, or even Baby Theory.

Disclaimer: just as programs on ABC promoting Disney have to add a proviso that the ABC network is owned by Disney, I need to mention here that we have (currently) seven cats. Or the seven cats have us. I'm not going to go into the chronological history of why people love cats (hint: it's not telepathic control... I think), or how the interdependent relationship between small felines and susceptible humans got started. Plenty of information on such matters is widely available elsewhere.

What I'm exploring here is why we primates seem so fascinated by the ordinary actions of what, after all, are the relatives of much larger kin who spent millions of years treating us as not friends but potential prey. Our relationship with dogs is arguably older and stronger, but cute dog videos come nowhere near dominating the internet in the manner of cute cat videos.

Speaking from the standpoint of psychology, could the cat/human prey connection have something more to do with it? Does some ancient,

tucked-away corner of the human brain still secretly fear that one day we could conceivably be attacked and eaten by cats? But we have a similar history with dogs. Until recently, our species maintained a visceral fear of being eaten by canids such as wolves (not to mention, in an earlier time, dire wolves).

I think it's the contrast between the cute cat and the predator cat that deeply fascinates us. Dogs have teeth; cats have fangs. Both have claws, but dog claws scratch while cat claws are talons. Maybe the relief we instinctively feel at seeing a creature equipped with such exquisite killing gear using it to play with a ball of twine or a toy mouse is emotionally reassuring. Especially if one adds in the distinctive feline stare.

A dog can stare at you, even an angry dog, but a dog either stays or charges. It might want to attack. The feeling when a barking, growling dog comes at you is that it maybe wants to injure you. You never have the feeling that it is doing so because it wants to *eat* you.

On the other hand the aspect, the look in the eyes, of a stalking cat implies that it exists in full possession of all the desires of its larger ancestors. At that moment you are not a friend, you are not an enemy. You are not being assaulted, you are being stalked. You are... food.

So when instead, this downsized perfect carnivore tosses around a plastic straw, or a lump of crumpled aluminum foil, or hides behind a pillow, it is using its inherent cuteness factor to disabuse us of the notion that, were we to suddenly expire, it might commence gnawing on our face. It is demonstrating a survival trait par excellence, and there seems to be no end to it. Nor with our need to willingly, even enthusiastically, participate in the comforting fiction. Hence the popularity of the seemingly infinite supply of cat videos on YouTube.

Hence the recent arrival of the TV show, *Meow Manor*.

I kid you not. This show is nothing more than an extended cat video, accompanied by suitably goofy music (cue the cat falling off a platform) and painfully earnest attempts at comic narration. Narration of what? Well, cats being cats. That seems to be what we all crave, and nothing more. Something cute, furry, and reassuringly non-predatory.

Maybe Congress would function more effectively if everyone had to break every half hour to watch five minutes of cat videos. But then, *Meow Manor* takes place in a cat house, and if history is anything to go by, some of our Congressmen might get the wrong idea.

The Blue Raspberry of Forgetfulness

When we think of science, our initial thoughts likely turn to physics, chemistry, geology, or biology, zoology, and the other life sciences. I doubt anyone's first thought is of food science. But there really is such a thing, and it impacts our daily lives as profoundly if not more so than any of the others.

If you live in the woods and off the land, you're not likely to have much interaction with food science. If, on the other hand, like most of us you buy your food in a store, you're much more likely to encounter food that has been intensively studied, dissected, modified, and very possibly enhanced. As the old adage says, "Better living through chemistry."

I was reminded of this by seeing on the soft drinks' shelf of a local supermarket several bottles of blue raspberry soda. I bought one, took it home, drank it. It wasn't bad and it certainly tasted of raspberries. But it didn't have any raspberry in it (artificial flavor) and it didn't look like any raspberry I ever encountered in its natural state. Blue raspberry is also a popular flavor of shave ice and other "foods." But... there is no such thing as a blue raspberry. Raspberries are red, shading decidedly to black.

For the food industry, that presents a problem. Because a more popular flavor, cherry, is red. Strawberry is also red. So in an obvious effort to avoid further confusion among a visually oriented purchasing species (us), someone decided that most raspberry-flavored liquids should either be blue or colorless. Why blue? Well, probably because the rest of the primary colors were already taken by other flavors.

On the face of it, this makes no sense. Given that mature raspberries tend toward blackness, black would be a much more accurate coloring. But black sodas, black shave ice, etc., would likely tend to put consumers more in mind of, say, asphalt, than a refreshing beverage. So the choice was blue, almost by default.

Yet my mind knows raspberries are red. So drinking blue raspberry soda presents a visual contradiction. It helps if you close your eyes when

drinking it. Children have less of a problem with the color, and certainly don't ponder the chemistry involved.

As a public service, I now offer for your contemplation the synthetic food dye *Brilliant Blue BCF*, which is probably what is tinting your blue raspberry soda. Though it is an approved food coloring, it can induce allergic reactions in folks with pre-existing moderate asthma. So, no blue shave ice for you overheated asthmatics.

On a side note, "scientists who were conducting in vivo studies of compounds to lessen the severity of inflammation following experimental spinal cord injury had previously tested a compound called OxATP to block a key ATP receptor in spinal neurons. However, OxATP has toxic effects and must be injected directly into the spinal cord. This led them to test a related dye, Brilliant Blue G, in rats, which improved recovery from spinal cord injury while temporarily turning them blue" (source: Wikipedia).

This naturally leads one to wonder if the favorite drink of the Blue Man group is blue raspberry soda. Food science = unnatural food coloring = innovative biochemistry = fictional speculation. But only, I suppose, in the mind of someone who occasionally writes fantasy for a living. Oh, and BCF is pharmacologically inactive and 95% of what you ingest of it ends up in your poop.

Now, doesn't all that info you didn't ask for make you just want to rush out and buy a nice, cool, blue raspberry soda?

I use this as an example to show that what goes into your gut these days is decided as much by a committee of chemists as by a farrago of farmers. All the uproar and print raging about pesticides and hormones in our food drowns out the fact that nearly all that we consume except purely "organic" edibles have in some way been chemically altered to appear tastier and more visually appealing than they would in their natural state. That includes everything from tomatoes, potatoes, and frozen foods to—Count Chocula help us—childrens' breakfast cereals. You really do need a degree in chemistry to figure out half of what is listed under "ingredients."

As for The Blue Rose of Forgetfulness, that was a flower in the great 1940 film *The Thief of Bagdad* that, when its fragrance was inhaled, caused the sniffer to lose all memory of everything. The food industry hasn't quite figured out how to do that to us yet, but you can be sure that somewhere, someone is working on it.

Meanwhile, instead of maybe a banana, I think I'll go heat up a nice, tasty, frosted strawberry pop tart. Here are the ingredients:

Enriched flour (wheat flour, niacin, reduced iron, vitamin B_1 [thiamin mononitrate], vitamin B_2 [riboflavin], folic acid), corn syrup, high fructose corn syrup, dextrose, soybean and palm oil (with TBHQ for freshness), sugar, cracker meal, contains two percent or less of wheat starch, salt, dried strawberries, dried pears, dried apples, leavening (baking soda, sodium acid pyrophosphate, monocalcium phosphate), citric acid, milled corn, gelatin, soybean oil, modified corn starch, caramel color, soy lecithin, xanthan gum, modified wheat starch, vitamin A palmitate, red 40, niacinamide, reduced iron, color added, turmeric extract, vitamin B_6 (pyridoxine hydrochloride), yellow 6, vitamin B_2 (riboflavin), vitamin B_1 (thiamin hydrochloride), blue 1.

Chemistry quiz next week. Have a cookie.

The Robots are Coming, and They Have Broccoli!

Tesla, which is leading the way in the development of autonomous cars, is not alone in that endeavor. Over the course of the past couple of years it seems like everyone has jumped on that bandwagon. Not only auto manufacturers but companies like Google, Waymo, Nvidia, Qualcomm, and many more are working feverishly to perfect the technology that will allow you to text freely in your car without risking a citation, not to mention watch a movie, nosh a burrito, chat with your Aunt Bernice about her latest operation, and turn around to yell at the kids without pancaking into the nearest brick wall. But the media has been so focused on the development of autonomous driving for cars that they often overlook equally if not more important applications of the same technology.

Autonomous buses. Autonomous trollies. Autonomous trains. And the wholesale transformation of the trucking industry.

When the media does discuss such applications, the reportage is usually slathered with a soupçon of woe lamenting the number of jobs that will be affected by such changes. Take the trucking industry. What will all those soon to be out-of-work truckers do? Truckers can make pretty good money. On the other hand the hours are terrible, the stress is unrelenting, a normal home life is impossible, in certain states and along certain routes the attention of the local highway patrol can make life miserable, the weather is frequently uncooperative, and unless one is inclined to a life of hermitage, the loneliness can become dangerously oppressive. Which brings me to an article titled "Trucker Shortage Affecting Grocery Store Prices" (CBS Investigates, 22 January 2018). That's right... all those truckers who are going to lose their jobs apparently don't exist. To quote from the article:

> Transportation brokers estimate there are 1,500 trucks sitting in Nogales right now because they don't have drivers.

"I have announced my job openings in newspapers, on craigslist. We have job fairs," said Jim Watson, who runs local trucking company JSJ Enterprises. "I think I've had one application."

Setting aside the situation of all those folks who complain there are no jobs, given this predicament I think Mr. Watson and his colleagues and competitors would be delighted to have access to a fleet of autonomous trucks. All of the problems I alluded to that afflict human drivers disappear when the occupant of the cab blinks and beeps and doesn't drift off while listening to country music. Autonomous trucks will not string out on white crosses, will work 24/7 without complaint, will not unionize, will not need to take bathroom breaks, will not be responsible for family breakups, and will comply without an endless flow of muttered harsh language to any request put forth by a highway patrol officer or customs official.

Furthermore, if Tesla and a few others have their way, all such rigs will be electric. That means they'll be able to operate in metropolitan areas currently off-limits to trucks now because of noise or pollution restrictions. Tesla has promised trucks with 300- and 500-mile ranges while pulling an 82,000-pound load (if you're interested in learning more, you can go to tesla.com/semi). And no, I'm not selling trucks, nor do I own stock in the company.

Right now, operators like JSJ Enterprises have to utilize Mexican truckers due to the lack of available drivers in the US. Through no fault of their own, these drivers have to go directly from their place of origin in Mexico to their US destinations. They can't, for example, stop in Nogales to pick up produce for delivery to Arizona grocery stores. There'll be no reason to place such restrictions on autonomous big rigs. Computers that work in Mexico work just fine in the US, and vice versa (side note: "vice versa" in Spanish is "viceversa").

If there's a possible downside to this future, it's that smugglers will also utilize autonomous trucks because if they're stopped at Customs and found to contain contraband, the smugglers lose a truck and its cargo but no driver. You can't bargain for amnesty with a computer, and it won't rat out its owner. Customs won't merely need more officers: they're going to need some with computer savvy. Unless, of course, our robots end up grilling their robots.

I know it all sounds like an episode of *Futurama*, but we're very near to it becoming reality. GM has even shown a prototype of a car with no steering wheel. And an autonomous cab won't try to charge you $863 for a ride from JFK to downtown Manhattan. It will also likely be equipped with instantaneous translation, so that when you climb into a taxi anywhere in the world it will understand you. True, some things may be lost in the changeover.

For example, nobody can swear more colorfully than Moscow cab drivers. I'll trade that for an honest fare to my destination.

Who Steals Unsellable Art?

I love art, and I like to think I have reasonably wide-ranging tastes. As I've said before in these columns, I don't have much use for modern art of the Koons/Johns/Lichtenstein variety because I don't think "repurposing" another artist's work constitutes a valid expression of originality. Or to put it another way, it's plagiarism. The "art world" apparently thinks otherwise, and who am I to criticize when someone takes a panel of a comic strip (drawn by a real artist, who can actually like, you know... draw), blows it up to giant size, and puts a six-figure price tag on the bottom? I do confess to a certain liking for Jackson Pollock's work, perhaps because my wife does a better Pollock than Pollock (the artist, not the fish). Notwithstanding that, I'm still waiting for someone to explain the difference to me between a Koon balloon dog and one from the Macy's Thanksgiving Day parade. Come to think of it, if Macy's blew up a balloon dog and used it in the parade, would it count as a parade balloon or art?

If I had the money (and more wall space), there *is* certain art I'd like to own. I'd love to have a Margaret Brundage, and a Chesley Bonestell, and a Bierstadt or a Church. But it's not necessary, because you can now purchase reproductions that are virtually indistinguishable from the original, professionally printed on canvas. Art.com, for example, partners directly with museums to produce museum curated reproductions according to customer demand.

Which beggars the question... why steal something and risk prison if you're caught when you can have a near-perfect copy for a fraction of the cost of the original? For most art-lovers, that should be enough. The answer, of course, is that those who steal well-known works of art are either in it just for the money, or are stealing to order.

As to the first, it plainly has nothing to do with art. For art thieves, the art itself is nothing more than a commodity, no different from jewelry or car parts. Unscrupulous dealers then sell stolen art so they can buy things that are not-art, such as food and aircraft. But in order to sell a famous piece of stolen art, crooked dealers and independent contractors need to

have a client in mind beforehand. You can't just steal a Degas and put it out on the open market. Like the Degas that was stolen from a Marseille museum in 2009 (it was on loan from the Musee d'Orsay in Paris) that was found yesterday on a bus outside Paris. Almost a decade has passed since the original theft, during which time the thief or thieves were unable to find a buyer.

Obviously they were amateurs. Because anyone with a knowledge of art encountering the painting in someone's house might also be aware of the original theft, and subsequently report the owner to Interpol. That's the drawback to art theft on demand: only the owner can enjoy it. It needs to be kept locked up and out of sight of everyone else, and art that is not shared becomes very tired art indeed.

History is replete with similar tales of great art stolen from museums or private collections that suddenly surfaces in a flea market, or is turned in anonymously to the authorities, because it's too well known to find a buyer. The rise of the internet has allowed anyone with even a casual interest in art who encounters a suspicious original to quickly and easily research its provenance. Of course, there are always those small of mind but large of wallet who are content to view a piece in a small, private room without ever sharing it with anyone else. But it's for them alone. They can't leave it to friends or heirs because eventually someone is bound to see it and report it. Those who have a work of art stolen to order risk incriminating their offspring.

Better to purchase a high-quality reproduction. It looks the same, possesses virtually the same visual impact, and costs infinitely less. Additionally, there is the matter of keeping one's soul.

One of the world's most famous paintings—*The Kiss*, by Gustav Klimt—resides in the Belvedere in Vienna. You can't take pictures of it, but there is a reproduction nearby you can photograph to your heart's content. No one seems to care, and visitors eagerly snap away at the copy.

If only those who finance art theft were of similar mind. When art becomes all about money, it's no longer art. It has become a commodity.

Your Science Conspiracies May Be Charged at a Higher Rate

Washington, DC, Councilman Trayon White recently said (on multiple occasions) that the Rothschild family controls the weather. Leaving aside the fact that Councilman White's social as well as formal education is manifestly sadly deficient, it got me to thinking yet again about the many current conspiracy theories that involve science. It's easy to construct a conspiracy theory centered around science because so few people bother to take any time to understand it.

But in this particular instance, while yet again causing me to deplore the state of the species of which I have to count myself a member, it struck me that all the propounders of these intrigues must be deeply involved in making oodles of cash off their exercises. Otherwise why bother? I therefore furrowed my brow (don't worry, it goes away) with an eye toward unearthing the nefarious subtleties behind their global plots.

Let's start with Councilman White's contention. How would one profit off controlling the weather? Based on Washington, DC's recent stormy conditions (sorry... couldn't resist), one would expect any businesses they control to immediately stock as much bad weather gear as possible. According to my research via Cambridge Analytics (that's Cambridge, Idaho), the most recommended stores in DC for such gear are Comfort One Shoes, Hudson Trail Outfitters, Simply Soles, the Smithsonian Store, and Lou Lou.

Aside from the fact that I cannot see a family as venerable as the Rothschilds being professionally involved with any establishment that calls itself Lou Lou, it quickly became clear from my in-depth investigation that that great European banking family had nothing to do with any of the aforementioned enterprises… although I suppose, being a government entity obviously controlled by outside forces, the Smithsonian must at least remain suspect because their museum shop does sell raincoats. Clearly, the Rothschilds have conceded a huge money-making opportunity to a clutch of small stores and Walmart,

therefore making money off the weather is patently not part of their scheming.

Now if I were able to control the weather in Washington, DC, I wouldn't do it simply to make commuters miserable. Surely, based on Councilman White's claim, there has to be something far more sinister behind it. Yet all the Rothschilds' efforts to give Mr. Trump a serious cold seem to have failed: his sinuses and throat appear to be in excellent health. One can't correlate really bad weather with critical votes in Congress, so that rationale is also out. I must be overlooking something.

Ah. Got it. If, as Councilman White says, the Rothschilds can control the weather in DC, then they should be able to control it anywhere. Plainly, it's just a matter of pressing the right button on the weather control machine, or inserting the appropriate punch cards, or programming the correct floppy discs, or turning the crank in front of the giant machine. This (as most science conspiracies do) explains *everything* about not only our weather but everybody else's weather, too.

If you're going to promote a conspiracy theory, always go big.

Droughts in the southwest, multiple Nor'easters in the Nor'east, floods in the central plains: patently all controlled by the Rothschilds and their marvelous magical weather machine. Fires in Portugal and Greece, blizzards in Britain, sandstorms in the Sahel, more drought in South Africa, more fires in Australia: all controlled and manipulated by the Rothschilds.

How is this possible? It's very simple. It's easier to believe in a conspiracy theory than it is to try to understand science. Because understanding requires thinking. Believing is easy. Thinking is hard. Or as Mark Twain said, "I wonder if God invented man because he was disappointed in the monkey."

I'm sure that in addition to controlling the weather, the Rothschilds are behind UFOs, vaccination causing autism, birth control for poor people, Ebola, AIDS, the recent bad flu season, and probably Bigfoot. Because… well, because the family is rich, and worked hard as hell to acquire their wealth, and have somehow managed to hang onto it in spite of naked prejudice, rapacious competitors, and an interminable line of eager conspiracy theorists.

But the latter flutter of fogheads is wrong. I know who really controls the weather. I even know where he does it. So shrewdly and quietly that no one notices.

Next time video shows Warren Buffet buying a hamburger in his favorite restaurant, just watch the hand signals that pass between him and the waitress. You won't be surprised by the following week's smothering blizzard in Chicago.

Of course, the Rothschilds control Warren Buffet, too. Just ask him.

Have Your Cake and Shoot it Up, Too

Something a little different this month. Something maybe even a little more controversial than arguing about the aesthetic viability of giant balloon dogs or the presence of artificial coloring in food. A tad hard to justify as being about either science or art, although people have long spoken about the art of compromise.

Understand that the following is not necessarily the preferred political position I would take were it possible for me to adjudicate on the matter. But the essence of our democracy is cooperation. This usually entails both sides giving up something they want. It's a difficult and laudable achievement because when a politician or government entity manages to pull it off, they're more likely to be harangued and despised by both sides rather than applauded. The more difficult the compromise, the more contentious the issue, the harder it is to persuade multiple individuals and entities in government to deal with it. It's so much easier just to stand back and shout, "This is my stance and I'm not wavering from it!" That doesn't solve problems. So here's my take on a simple, uncontroversial, hardly ever discussed matter. Bear in mind I would rather be discussing favorite flavors of doughnuts. But that isn't a matter of national concern at the moment.

What to do about the private ownership of automatic and semi-automatic weapons, is.

You can have your AR-15. As many as you want. You can have your Kalashnikovs, your classic Thompson, your M107 Barrett, your Armsel Striker. You can even have bump stocks.

Here's how it works.

You purchase your weapon from an authorized dealer, or if you prefer, at a gun show. You and the seller register your weapon; just like you'd register your car or your dog. Hunting rifles and home defense pistols you take home. For the rest, the dealer packs and ships the weapon and any ammo or related devices to the authorized gun range or club of your choice. It is held there until you unpack it, whereupon it slots neatly into the locker you rent. Kinda like golf clubs, only... different.

The range or club has twenty-four hour security on site. Only you and club security have access to the combination and/or the two keys that are required to open your locker. Your weapons are fully protected, which means that you don't have to worry about criminals, a disgruntled spouse, or your Aunt Bea's son Billy, who has problems, stealing your weapons and taking them on a rampage at a school or mall or anywhere else. You have peace of mind because the range or club is taking responsibility for their security. Ultimate liability is theirs, not yours. You can insure your valuable guns separately if you wish, plus the club will have its own insurance.

Whenever you feel like it, you can go to the range/club and blast away at as many targets, cans, bottles, pictures of politicians you particularly dislike, and yes, cake, until your urge to sniff propellant is satisfied. Then you lock up your weapons and go home, worry-free.

You don't have to buy an expensive and potentially failable gun safe. The range/club makes money on locker rentals which helps to cover security. Your collection is safer at the facility than it ever would be in your living room/basement/kitchen (yes, I've seen that). Kids and mentally challenged adults can't access your weapons. Your right to bear arms isn't infringed. And if you need to form a militia to fight off an invasion, or theorized fascist/communist/take-your-pickist, why, you don't need to struggle to organize your resistance via likely destroyed or compromised phones and computers. You already have an assembly point.

Everyone wins. Especially the rest of us.

Excavating a Drink of Water

World-famous archeological sites, especially those that have become tourist attractions, need little introduction. Machu Picchu, the Roman Forum, the Acropolis, the Taj Mahal—mention their names and for anyone whose interest in images extends beyond family photos and possibly NFL highlights, pictures of those locations immediately flash in the mind.

Lesser known sites readily activate mental video among the more knowledgeable; among those interested in the ancient world. Such folk might know that the fabulous bronze paneling that used to cover the ceiling of the Pantheon in Rome was ordered torn off by Pope Urban VIII and melted down to make cannons (sort of a reversal of the "beat swords into plowshares" meme). Or that the "simple" islanders of the Pacific raised something akin to a stone Venice on the island of Pohnpei. Or that the Chachapoyan civilization of northern Peru constructed massive stone cities like Kuelap that sometimes rivaled those of the Inca.

But hardly anybody has heard of Sagalassos.

Founded around 333 BC, Sagalassos lies in the Taurus mountains about 100 kilometers north of the port city of Antalya. Whereas ancient peoples of the Mediterranean tended to cluster around the coast, Sagalassos lies inland at an altitude of 1500–1700 meters. Why the variation in altitude? Because it's kinda like Prescott. Or Jerome.

Built on the slope of a mountain, the old trading town had more than its share of steps. It also suffered, as much of Turkey still does today, from periodic devastating earthquakes. After being conquered first by Alexander the Great, and then the Romans, and then the Arabs, and having their beautiful town repeatedly knocked down by Mother Nature, given that huge pieces of marble are harder to put back together than Legos, the hardy but not obdurate citizens finally gave up and dispersed.

Yet all those earthquakes combined with the town's comparatively remote location had one benefit. Instead of being continuously looted and having its stonework repurposed (i.e., stolen) for later construction efforts, as was common in the ancient world, much of Sagalassos's construction

was buried and left in situ. With archeology in Turkey long focused on better known and more accessible sites along the country's extensive coast, the stone-filled hillsides of Sagalassos were left to grazing goats and wandering nomads until an Anglo-Belgian team began serious excavations and restoration in 1990... yesterday, in archeological terms.

That work is ongoing, but Sagalassos's location means that even today it receives far fewer visitors that famous coastal sites such as Ephesus. Now, Ephesus is wonderful, and fascinating, but being on the coast it is inundated daily by tourists who arrive nearby by boat, transfer to buses, and are disgorged en masse to chatter interminably while clambering over the ruins and restored buildings. So bad is it that the place can feel like Disneyland on a Sunday in September. The same is true of many other noted historical locations in Turkey. Not Sagalassos. It's too far from the coast and the mountain roads require too much travel for buses to arrive easily from cruise ships.

The city is full of fascinating structures, from the Nymphaeum (restoration completed 2010), to the upper and lower agoras (markets), to the library and the typical Roman amphitheater, in addition to assorted monuments, floor mosaics, streets, and stairways. There is much work still to be done, and one can only hope the money will be provided to complete it.

When I visited Sagalassos in 2005, much of this painstaking archeological effort was just beginning to come to fruition. Spending an entire day there, I encountered perhaps a dozen other visitors. There were a few guides and guards, the latter to prevent looting. Spectacular finds are still being made, including a colossal statue of the emperor Hadrian.

I was soon drawn to the first structure to be fully restored: a Hellenistic fountain house dating to the first century BC. Constructed in the shape of a "U," with the water source located at the bottom of the letter shape, I was surprised to find it and the two channels that ran down the arms of the "U" filled with flowing water. As I stared, and occasionally paused to shoot video, I heard a voice behind me.

"Have a drink," the man said in English. Turning, I saw someone about my age, with a sandy spade beard, wearing everyday work clothes typical of the region. He was not dressed as a guard. He might or might not have been a guide.

I hesitated, eying the ancient stonework. "Are you sure it's safe?"

If You Shoot the Breeze, Are You Murdering the Weather? 177

He smiled. "People having been using it for two thousand years. Best water you ever tasted."

That threw me. "You mean, this is still the original spring, still running? It's not piped in?"

He nodded. "Two thousand years, still running. No pipes."

So I bent over the old stonework, and cupped my hands, and drank from a spring that despite earthquakes and invaders had been running clear and strong for at least two millennia. The water was cold, fresh, and copious.

You can keep your monumental statues and your towering walls and your colossal temples, oh Ozymandias. I'll take a long, cool, refreshing drink of water from Sagalassos any day.

(He)Art Beats and Flowers

The program I'm going to talk about is called *Art Beats* and even if you're an art lover, you probably haven't seen it. Or heard of it. Not your fault. I only came across it because we recently purchased a 4K-capable TV. I hadn't bought a new TV in ten years and wanted one because as my vision gets worse, TVs thankfully get larger. But I didn't know much about 4K. Roughly speaking, 4K provides four times the definition of HD (high-definition) TV. For a great deal of television, that doesn't make any difference. Talk shows don't benefit from being shot in 4K. Neither do situation comedies or *Bob Bakes Burgers*.

It makes a huge difference for a show like *Art Beats*.

Not only is resolution, color, etc. astounding in 4K, but for the first time I found myself looking at images on TV of artworks I had seen in person and finding the reproduction true to life. Utilizing 4K cameras, the production team for *Art Beats* was able to take its time lingering lovingly over not just individual art works but small sections of those works, much as an art book would employ closeup shots of different parts of a painting or sculpture to emphasize specific aspects of an artist's work. This wasn't as important when the subject was as massive as Michelangelo's *David*, but when used to scan over Botticelli's *Primavera* it was a revelation.

All one had to do to recognize the importance was point the 4K camera at the flowers.

Unless a viewer is aware of the significance of the flowers in *Primavera*, they tend to be overlooked. Overwhelmed, actually, by the sybaritic flow of the overall composition and the stunning beauty of its people. *Primavera* is a huge painting. After showing us faces and figures, a program like *Art Beats* can drop down to the field of blooms and pick them out one at a time, presenting them to the viewer in detail never before possible with a video or film camera. It's said that there are some 500 individual flowering plants depicted in *Primavera*, representing up to 200 different species, some of which are now extinct, or possibly a sophisticated blossoming (if you will) of Botticelli's imagination.

This optical fidelity is crucial because the Art Beat shows are intended not for television viewing but to be seen in theaters. If your resolution isn't exceptional, blowing tiny flowers up to theater screen size would be a waste of time. You'd see nothing but colorful blurs. Botticelli was specific, not psychedelic, and he was no impressionist.

Every painting, every work of art in the *Art Beats* series benefits to a greater or lesser degree from being carefully documented in 4K. The lighting, camera work, even the music is designed to enhance the fine detail that the new cameras can bring out. Here in the US we benefit unduly from these efforts.

Why? Because few people in this country are going to pay to go to a movie theater to see a ninety-minute film about Florence and the Uffizi museum, or Leonardo da Vinci, or Raphael. So for the producers, the realistic US market for such films becomes—4K TV.

You can't see programs shot in 4K unless you have a 4K set plus a program supplier who broadcasts in 4K. There isn't much original programming available in the format (I'm discounting pay channels that show movies in 4K). This kind of content will, and should, increase. In its absence, distributors looking for content are forced to look to material originally shot for theatrical release. Fortunately for all of us, that includes wonderful, otherwise inaccessible material such as *Art Beats*.

Pannonia, the company that produces *Art Beats*, is Hungarian. They also release films of opera, ballet, and classical music concerts, though their website doesn't specify if these are also shot in 4K. If so, one can only hope to see them released here on 4K-capable TV. Meanwhile, I'll just have to wait for their other productions to make their way to channel 104 on DirecTV. Hopefully their production *Hitler vs. Picasso* (I am not making that up) will make its appearance soon.

Since technology, especially consumer technology, never stands still, even higher resolution 8K is in the works. I don't know how *Jeopardy!* will play in 8K, but I know that Georgia O'Keeffe would look just fine. While waiting for that, Pannonia, can we have a program devoted to 19th-century American landscape greats like Bierstadt and Church? They did flowers, too.

Science and Silence

The history of science is replete with examples of men and women who spent their lives searching for answers to specific questions. The Curies and radium. Goodyear and the vulcanization of rubber. Pasteur and vaccination. The Wright Brothers and powered flight. But there are also marvelous examples of scientific serendipity. Times when researchers and experimenters made discoveries without fully realizing to what uses their discovery might be put.

Based on pioneering theoretical work by Charles Townes and Arthur Schawlow, Theodore Maiman constructed the first laser at Hughes Research Laboratories back in 1960. Think about that a moment. 1960. No so very long ago. I doubt any of them realized their work would lead to enormous changes in the entertainment industry, or in communications, or in medicine. They probably just thought, as a surprising number of scientists do, that their work was "cool." It's hard to imagine how contemporary society would function without the laser.

But we could manage without lasers long before we could without something that in its fashion is even more miraculous, and certainly more indispensable: the humble battery.

Ponder how many devices we take for granted that use batteries. From tiny ones that power hearing aids and cell phones to now-clumsy but once ubiquitous D-cells, from squarish 12 volts to giant batteries that back up hospitals and store megawatts from enormous solar and wind farms, to those that keep communications satellites functioning, we would have a hard time keeping our world running without batteries. So much so that people take them entirely for granted, like fresh winter fruits and veggies sourced from Chile, or the infinite supply of argumentative folks who populate interminable talk shows.

For a long time, science had a hard time scaling batteries up. The same D-cell that can be found in contemporary police flashlights would also fit and work fine in the camp flashlight my father used in WWII. One reason is because it proved harder than expected to increase the energy density inside a battery. The quest became how to get more power out of the same

size unit. To do that, you needed to somehow change the chemistry, and also the way the battery's power was managed.

Then along came, in fairly rapid succession, lithium-ion battery chemistry and thermal battery management.

More power and better-managed power in the same size and weight. A good example are the batteries used in some electric cars. These look almost exactly like standard AA batteries, but they pack a lot more power in the same size. Linked together by software and effectively managed, they can deliver power that half a century ago could only be imagined. It's a breakthrough whose ramifications are only starting to be realized.

Electric cars. Yes, we have those now (we had them at the dawn of the automobile, but the heavy and dangerous lead-acid batteries that powered those early vehicles soon lost out to more energy-intensive petroleum derivatives). Also electric leaf blowers, electric snow blowers, and even electric hand warmers. Scale the systems up and you have electric lawnmowers, electric scooters, electric motorcycles, electric boats (Mercedes, among others, has been testing one for a while), electric snowmobiles (coming for sure), electric delivery vans (already flooding the market in Europe), electric garbage trucks (Sweden and Switzerland), electric city buses (everywhere now, with use increasing exponentially), electric school buses (Bluebird and other manufacturers), and electric 18-wheelers (Tesla, Thor, Nikola, Mercedes, BMW, Volvo, and others).

Which brings me to Prescott, and the dawn of the electric airplane.

As you may have read recently in *The Courier*, the Israeli startup Eviation is going to make Prescott its American headquarters. What separates, for the moment, Eviation's aircraft from those already being flown by Airbus, Pipistrel, and other innovators is that they are working with small 2–4 seaters, whereas Eviation intends to produce a nine-seater commuter aircraft. This will change short-range aviation as profoundly as the electric car is changing the development of ground-based vehicles.

Imagine such an aircraft taking off, not from Prescott, but from somewhere like Santa Monica Municipal Airport, or Van Nuys Airport, in Los Angeles. A major reason for the lack of commercial service from such convenient centralized urban locations is the problem of noise. With electric aircraft, that problem goes away. So does the issue of toxic fumes from aviation fuel, and the danger of storing such explosive liquids in populated areas. Flying in such aircraft will be more akin to soaring in a

glider than bumping along in a machine powered by noisy propellers. Instead of having to constantly monitor fuel gauges, fuel lines, fuel pressure, and much more, pilots will simply check a battery gauge, much as you periodically check the charge on your cell phone.

Downsizing the development, imagine living in Prescott, or anywhere else, and not hearing dozens of private planes puttering past overhead, day in and day out, like so many angry giant bees. I can't wait to see, much less ride in, one of Eviation's aircraft and the flood of imitators and competitors that is guaranteed to put in an appearance in the next five, ten years.

And as much as I love Prescott, I can't help but imagine what the noise-polluted island of Manhattan will become when all vehicles allowed thereon become silent, odorless, and electric.

Heck, if I was the mayor, I'd be mandating it right now....

Adrenaline Low

You hear about an "adrenaline rush" or "adrenaline high" all the time, most commonly in relation to sports. Especially extreme sports such as skydiving, rock climbing, big wave surfing, motocross, and—of especial note for Prescott residents—assorted rodeo activities. One needn't be involved in any of these to experience such a high, albeit perhaps not to such a great degree. Ordinary sports provide a lesser degree of stimulation, particularly when competition is involved. In these instances the old saying "It's in our blood" is more than just a cliché. It's all about the biochemistry.

Adrenaline is mostly produced by the—surprise—adrenal glands, although some neurons are also responsible. The chemical is produced in response to signals from the brain, usually in reaction to a need to acquire food or to fight.

So what are we to make of situations where one gets an adrenaline rush in response to pleasure (assuming said pleasure doesn't involve food or fighting)? Note that I'm not talking about endorphins, which are produced elsewhere in the body and are intended to relax or reward you in pleasurable situations.

I don't have to jump out of a plane or cling by my fingernails to get an adrenaline rush. Walking through the rainforest is what does it for me. I think it's a combination of excitement, of not knowing what's around the next tree, that I find so exciting. With big wave surfing, you can see the wave coming. When climbing, you see the rock wall above you. And with skydiving—well, everything is spread out in plain view before you take the leap.

But in the rainforest, or if we want to be more theatrical, in the jungle, you never know what is going to leap, fly, crawl, slither, or cut across the path in front of you. Surprise is a far bigger generator of adrenaline than a known quantity, except for a direct attack by an animal or another human. And I've found that nothing holds more surprises than the jungle. You can see trees and vines, but not much else. The excitement and tension come from the *not* knowing. In a way, the process is not too

different from watching a well-made horror movie. You *expect* something to jump out at you.

In a horror movie you usually have some idea of what's coming: Jason, Freddy, the Wolf Man, Anthony Perkins: just not when and from where. In the jungle you have no idea. The expectation is magnified by the realization that whatever might confront you could be too small to see (parasites), too big to fight off (jaguar), too numerous to battle (army ants), extraordinarily painful (tarantula hawk wasps), deadly poisonous (fer-de-lance), or even unobtrusive (leeches).

There. I bet you raised your adrenaline level simply by reading that short list. That's how the body responds to the threat of danger. And yet, even as my adrenaline level rises I find beauty in every one of those creatures. The excitement of recognition clashes with the reality of danger.

I haven't set foot in a rainforest in many years and—I miss it. There is nothing like making your way through primary rainforest alone, accompanied by only the sound of birds and the occasional percussive chitter of insects. You don't see much. Everything tries to hide from everything else, because in the rainforest everything tends to try to eat everything else. You watch your footing lest you sink up to your knee in mud, or trip over a root, or accidentally pick up a hitchhiker that might not take kindly to your presence. The fact that so much of the wildlife might have an interest in eating you stimulates your senses and makes you wary.

But the beauty of those same creatures is what makes the trek worthwhile. The tarantula that's made a nest in a tree hollow. The stripes on a tiger leech. The martial perfection of a column of army ants streaming across a log (you can safely get quite close). The iridescent chitin of a wasp or biting fly or a hundred other potentially dangerous insects. Howler monkeys baring their teeth at you. Huge caimans hugging the shore of a river or lake on the lookout for fish, turtles, lizards, and errant swimmers. Even the piranha that you know are highly unlikely to bite—but the possibility is always there. The leaf that hides a chromatic poison arrow frog. The buttress root where a bushmaster makes its home. All of it contributes to a thrill and excitement so very different from scaling rock walls and jumping out of a plane and contesting gravity from the back of a horse.

I miss it, yes, and the result is an adrenaline low no amount of pleasant, relaxed, civilized existence can supplant.

On the other hand, if you need that rush, there's always driving in Prescott....

Go Pound Rocks

The term "over-engineered" is a common one. It usually refers to something like emplacing three buttons on a car dash when a single button would accomplish the same task. Or installing multiple controls on a TV when the result is little more than duplication. Not to mention gadgets like expensive electric juicers, when all you need to do is put a neatly sliced hemisphere of fruit (orange, lime, *pamplemousse*, whatever) atop an old-fashioned glass or ceramic cone and—push down.

We have come to expect devices to handle such everyday chores for us. Sometimes they're useful. Sometimes repetitious. Occasionally they expand and diversify in a way no one could have anticipated. Who saw the humble telephone replacing, for many folks, an entire computer? For that matter, who saw the formerly hideously expensive home computer replacing the abacus? After all, an abacus requires no electricity and allows one to do sums quite well. Just as the slide rule permitted manual, non-battery powered calculations.

But sometimes, well, you just have to shake your head at some of the developments that inflict themselves on the modern world in the name of advancing technology.

I'm speaking, of course, about laundry.

In many parts of the world people (by who I mean women) still do laundry by hand. You take your basket of clothing down to the local river that you hope is not too polluted from the companies upstream making cell phones and electric juicers, soak the attire in the current, wring it out, rub it against flat rocks, soak it again, repeating as often as necessary. When you think you've got all the dirt and shit and dead bugs out of your clothing, you spread it out to dry in the sun. No batteries required.

It's labor intensive. It's backbreaking work. So people invented clotheslines to at least help with the drying. Then when metal-bashing became practical, steel washtubs were developed. Wooden mangles were added. As technology accelerated, electric washers were invented. Someone had the bright idea to add soap to the wash. Not just any soap,

If You Shoot the Breeze, Are You Murdering the Weather? 187

but soap especially designed to go in the washer. Lo, detergent was born, and it was proclaimed Good.

The first laundry detergent consisted of ground-up... soap. Soon it became more specialized, because specialization equals profits. Niche detergents were invented. There was detergent for silks, detergent for jeans, detergent for everything you can think of. Bleach came along to make whites whiter than white. Then softeners; most welcome among those who drew hard water from wells and delinquent urban water authorities. Someone thought to counter the wash "smell" by developing additives that added fragrance to the wash, so that your favorite dude gym shorts could smell like—I dunno. Lavender? Coquille St. Jacques? Attar of roses?

Detergent, bleach, softener, fragrance: the list of laundry additives is doubtless longer by now. What fascinates me is that there are folks who attend prestigious universities to obtain a degree in chemistry who then go on to develop better—detergent, bleach, softener, and fragrance. And there are companies like Unilever that will pay them plenty to do so. It wouldn't surprise me to learn that there are specialty degrees offered in laundry chemistry. After all, Edward E. "Doc" Smith, creator of the early ground-breaking science-fiction *Lensmen* tales, had a Ph.D. in doughnut chemistry. Why not laundry chemistry?

The chemicals used in laundry had to become more specific because the machines they fed grew more specialized. Nowadays it seems like to do ordinary laundry you need your own degree in engineering. There are innumerable choices to make and buttons to push. You can buy a washer-dryer combo that is controllable via the internet (how do you respond if someone hacks your socks?). We have "hc" washers that, of course, require you to use hc-specialty detergent.

Under development are washers (although that term will not be strictly applicable) that eschew the use of water altogether, cleaning clothing by treating it with sonic waves to shake off the dirt. Other washers will use infrared technology to kill germs. I bet they'll all work. I also bet they'll cost thousands of dollars. Because, you know: upscaling also drives profits.

You can still buy Speed Queen washers and dryers. These are the simple washers and dryers you usually see in coin laundromats. The ones that don't require an advance degree to operate. They're made right here

in the USA (Ripon, Wisconsin) and are as simple to use as can be, though the company has been forced to add digital controls to some models in order to compete with imports. They're also virtually indestructible, which is why they dominate the coin laundry business. But the company still struggles to sell them to the general public. Not enough bells, whistles, and no internet connection.

Now we're told to use the cold-cold water combination for much of our laundry. The gals working the rocks at the riverside must be smiling.

Depth Perception

I never tire of looking at art. Even bad art can be instructive, by showing that you can do better than those who are making millions hauling scrap from yards and calling it art (what really differs so much modern "art" from what you see jumbled together at your neighbor's yard sale?).

But sometimes, it's just as entertaining and enlightening to look at people looking at art. I don't mean folks muttering fraught pseudo-intellectual claptrap while gawking at a toilet installed in a bare white museum room. I'm referring to art that is, or was, seriously controversial. Unsettling, even, to its audience. The 20th, let alone the 21st, century did not invent disturbing art. Work that was truly groundbreaking likely goes back to some scribe surreptitiously scribbling something outrageous on the walls of the king's new bedchamber, and then ducking out before it was discovered so he wouldn't lose his head.

I just got back from Paris (I always wanted to be able to say that). Naturally I spent endless hours, accompanied by increasingly sore feet, exploring the Louvre and the Musee d'Orsay and the Luxembourg museum, and others. I feasted upon works famous and less so, encountering the expected and the unfamiliar. It was while viewing the collection of the much smaller but still notable Petit Palais that I found myself sufficiently intrigued to spend some time observing other art-lovers and their diverse encounters with one particular controversial painting.

Gustave Courbet was the leader of the Realism movement in painting in the mid-nineteenth century. A superb technician, he and other Realists such as Daumier, Millet, and Corot rejected Romanticism in favor of painting what they actually saw. The movement was a consequence of the most recent French revolution and a deliberate rejection of the dreamy, idealized portraits of the human form that were previously in vogue.

In 1863, Manet scandalized the art world with his painting *Olympia*, which for the first time depicts a female nude in a straightforward, non-idealized pose. Prior to *Olympia*, western European art was replete with thousands of nudes rendered in often idealized perfection. This was

considered perfectly acceptable so long as said nudes were depicted in scenes from mythology, or in religious tableaux. In contrast, *Olympia* shows us a Parisian courtesan reclining on a couch, staring directly back at the viewer. No references to Greek myths required or implied.

With his less well-known but famous *Le Sommeil*, Courbet takes such realism a step further. It says something that while *Olympia* no longer has the power to startle, *Le Sommeil* still does.

That's why it's so interesting to observe people encountering Courbet's painting.

With all the considerable artistic and painterly skill at his command, Courbet presents us with a picture of two women who have just concluded a sojourn at play. They are completely nude. No cards are in evidence, no chessboard, no tennis rackets. But there is a stray comb, and a broken string of pearls, and much rumpling of expertly depicted bed linen. Their respective expressions tell you all you need to know about what has just transpired, and it was not a round of croquet. To say that the painting shocked even the art world of 1866 Paris, already exposed to *Olympia*, is an understatement. That it still has the power to unnerve viewers is fascinating.

The curving hall with its white walls in which *Le Sommeil* is hung, just one more painting among others, is wide enough to allow the observer to stand at a distance and note the encounters between painting and viewers. These are eternally instructive and sometimes amusing. Very few people approach *Le Sommeil* in the same fashion as they do the *Mona Lisa*, or David's *Coronation of the Empress Josephine*, or Vermeer's *The Lace Maker* (all in the Louvre).

Several people come near, perceive the subject matter, and accelerate, as if examining the painting in detail might somehow mark them. Two women pause and spend some time studying the work. Two men: one middle-aged and the other the perfect vision of a wizened, elderly elf straight out of Tolkien, halt to take in Courbet's effort. The old man moves on with a slight smile on his face: an indication that while aged, he is far from dead.

Other male viewers seem more intimidated by the painting than do women. Upon encountering the painting men continue to eye it, but while simultaneously edging away, as if it might bite them or somehow impugn their masculinity. Catching her initial glimpse of *Le Sommeil*, one elderly

If You Shoot the Breeze, Are You Murdering the Weather?

woman accelerates away from its proximity like a sprinter leaving the blocks. My favorite viewer had to be the single woman, perhaps in her late 30s, who saw the painting while walking down the middle of the hall and promptly made a beeline directly toward it. Whether the content spoke to her specifically or somehow exerted an actual measurable magnetic pull I do not know, but she spends some time examining it closely and carefully before moving on.

All these disparate reactions to a painting from 1866. And in our hubris, we think modern art invented the power to shock.

You can always Google *Le Sommeil* and decide about it for yourself. And you know you are going to.

Does History Anoint Your Taste?

Everyone knows the Louvre and the Musee d'Orsay, but the fact is that Paris is full of museums: everything from the Dali museum to small museums that focus on the history of the city to collections specific to certain religions. If you can think of it, there's probably a museum in Paris that is centered on it.

It's a good idea to explore such locales. They often feature special exhibitions that are important but not quite iconic enough to enlist the attention of the larger museums. The Luxembourg museum in Paris currently showcases a wonderful special exhibition on the master of Art Nouveau, Alphonse Mucha.

But what if you don't have the time? Or if you're on a package tour that only leaves you something like half a day at the Louvre or d'Orsay? Or more importantly, what if you don't know much about art?

The resultant expedition should be treated like any other excursion. Plan, prepare, and try to maximize your time with respect to how much of it you have available. The trouble is, most travelers do none of that. Instead of focusing on what they like, they let their schedule or their tour guide do their perceiving for them.

I hear this all the time. "Oh, I didn't know that was there." "What a wonderful piece—why didn't our guide mention that?" "I'm especially interested in this artist—how can I find out where his/her work is located?"

You have to prepare for your own visit. Don't trust your guide—any guide. Their job is neither to educate nor satisfy your personal likes. It is to get you from point A to point B on schedule.

Everybody who visits the Louvre wants to see the *Mona Lisa*. Perfectly understandable. It's a nice portrait. The hundreds of people who crowd in front of it certainly think so—because most of them have been told to think so. They'll spend ten-fifteen minutes of their precious visitation time edging and pushing closer and closer for a better look. Meanwhile, there are another couple of da Vinci's nearby, both of which I think are more intriguing works than poor Mona. I watched as people

If You Shoot the Breeze, Are You Murdering the Weather? 193

caught sight of these in passing, paused to check the provenance, and move on.

Why? What makes the *Mona Lisa* so much more viewable than da Vinci's other paintings? It's because we are told it is so. Yet a careful study of the other da Vinci's in the Louvre exhibits just as much if not more mastery of technique.

Two Vermeers hang side by side in one small room. Vermeer is one of my favorite painters. If you've seen the movie *Girl With a Pearl Earring* you'll understand whereof I speak. The smaller painting, *The Lace Maker*, is exquisite. I'm not saying it's better or worse than the painting that hangs next to it, *The Astronomer*. Personally, of the two I prefer *The Astronomer*. But in writing about Vermeer, all the talk is about *The Lacemaker* and *Girl With a Pearl Earring*.

I came back to *The Astronomer* several times. People would go up to *The Lace Maker*, study it, step back, and read about it in their guides, or listen to their guide lecture about it. Then people would move up to it for a closer look—and zip right past *The Astronomer*. Because it's not nearly as highly publicized, and heaven help anyone who tries to make up their own mind about great art.

The *Aphrodite of Milos*, better known as the *Venus di Milo*, is also in the Louvre, and immortal because some ancient art critic said it exhibited the perfect womanly proportions. Perfect for whom? I think the museum holds far better ancient Greek sculptures of women, complete with arms. When did it become a "thing" to lavish praise on one piece of art while virtually ignoring everything around it? Everyone needs to make up their own minds and not rely solely on historical acclaim.

Among all the famed Egyptian relics to be found in the Louvre, lost among dozens of decorated mummy cases, beyond the Assyrian reliefs and gold jewelry, is a small statue that has to be discovered by accident. I did not see it pointed out by tour guides or highlighted in guidebooks. But to me it spoke more of a connection with ancient Egypt, its culture, and its people, than even the massive obelisk in Concorde square.

Done in (I believe) painted terracotta, it shows a man and a woman seated side-by-side. It is not as static as most such surviving pieces from ancient Egypt. The woman has her right arm around the man's shoulders. Her left hand rests on his left arm. For something thousands of years old it is so modern in its posing, so emotional in its implication, that I was

taken aback by its appearance among dozens of other far less animated pieces.

Nobody told me it existed. It doesn't inspire raves in guidebooks. But it brings a past era to life and connects it immediately with our own. Two people long, long dead who lived and loved one another. In Paris now. Not a bad immortality.

Ignore the guide and the guidebooks sometimes, explore, and you will find art that speaks to you rather than to the opinions of others. Even across the ages.

The Taste of Nothing

It's a funny sense, taste. All other things being equal, sight is pretty straightforward. Blue is blue, green is green, red is red, and infrared is something—we can't see. Screaming is screaming, Mozart is Mozart, the lullaby of waves on a beach are gentle to most hearing. Fire is hot, ice is cold. Skunks and politics stink, a rose is a rose, and so on and smell forth. Sight, hearing, touch, smell.

But taste—one could easily call it the only wholly subjective sense. To an experienced *affineur* (cheese expert), a fine aged Roquefort detonates the same exquisite effect on the palate as a 72% cocoa bar made with 100% crillo chocolate does to a chocolatier. Whereas to another person, that same expensive cheese might taste like the sole of an old flip-flop that's been left out in the sun too long. Subjective taste.

Some folks prefer grass-fed beef to corn-fed, and can actually tell the difference, while others are repulsed by the taste of any kind of beef. Those who devour sushi tend to rave about it, when a majority of folks prefer their seafood cooked. It's all a matter of taste.

But what about something that theoretically tastes like nothing?

Let's talk about water.

There is some disagreement as to whether or not water actually does have a taste. While some science says it does not actually activate the taste receptors on the tongue, others insist that it does activate the receptors for sour. Others insist that this is merely the interaction of water with the mouth's saliva (which fluid the body is used to and therefore doesn't "taste").

And yet, there are water tasting events every year, in many countries. Perhaps the best known is the Berkeley Springs International Water Tasting competition, held annually in Berkeley Springs, West Virginia—lest you think West Virginia be known only for out-of-work coal miners. 2018 was the 29th year of the competition. Categories include best municipal water (Clearbrook, British Columbia, which sounds like a winner even before its water is tested), best bottled water (Frequency H_2O, Major Creek, Queensland, Australia) and so on. More than 100

countries enter every year. They come together so that the judges can award prizes for the best tasting—water. For something that many believe has no taste.

I've tried a lot of bottled water (we can discuss its economic and ecological impact another time). Assuming it is served at similar temperature, most of it tastes relatively the same. To me, the differences between brands has more to do with pH than with "taste." Water can be a little hard (many mineral waters) or even a little soft (Fiji Water is notable for this). Whether these differences constitute taste in the scientific sense is the source (no pun intended) of innumerable arguments.

Obviously there must be some perceptible "taste" differences, or such competitions would be an exercise in futility. Or prevarication. For years, the number one "tasting" municipal water was what came out of the taps in New York City. While those results may have heartened metropolitan dwellers, they're hard to square with the journey said water takes through hundreds of miles of piping large and small. It's far easier to believe that someplace like Clearbrook, BC, boasts great tasting water because the water itself has far fewer miles to travel, needs to be distributed to infinitely fewer people, and is located right next to a major source of clean dihydrogen monoxide. That's not to disparage the Big Apple's city water, which is fine. But to argue that tap water in Manhattan tastes better than tap water in near-rural British Columbia?

I guess I'd make a pretty poor water judge.

What I have noticed is that water from glacial sources tends to score very high, taste-wise, in these contests. I've already mentioned British Columbia's award. Other trophy-winning bottled waters from the most recent Berkeley competition include waters from Longyearbyen, Norway, and Whakatane, New Zealand. While I haven't had the opportunity to taste these, I have had Voss (Norway), IceAge (Canada), and a few others. My personal favorite so far is Icelandic (from guess where?).

It's hard to explain the taste of something that theoretically doesn't have any taste. I can say that the aforementioned waters, at least to me, "taste" clean and crisp. Certainly it has something to do with the pristine environments from which they are sourced. But I can't help but wonder if the fact that the original waters were laid down prior to the industrial revolution might have something to do with it.

Whether you believe water has a genuine taste or not, our bodies tell us that nothing satisfies thirst better than water. Doctors tell us the same. Despite the fact that most municipalities insist that their treated water is not only safe to drink but "tastes" just as good as that which comes in bottles, we persist in believing that bottled water from specific origins not only tastes better but is better for us.

Myself, I blame Perrier for starting the whole bottled water craze in the US. Italians, who receive excellent water from their utilities, are crazy for bottled water. So, after all, maybe there's nothing particularly scientific about it and it's all a matter of psychology.

Babies are 78% water. Adult males are about 60%. Maybe if we were 60 or 70% Coca-Cola, we'd feel different about how water... tastes.

The Death of Western Civilization

It is something that has bothered me ever since I was a child. The inescapable sign of the aesthetic apocalypse. A constant reminder that no matter how developed, how mature we consider our artistic achievements, we have hardly advanced beyond the cave paintings at Lascaux and Chauvet—and in many cases have arguably regressed.

We are convinced that our art has advanced since then. That we have progressed beyond taking a mouthful of paint and spitting it against our hand in order to utilize it as a stencil. Despite the sere barrenness of "modern" art, there are still those creative individuals who believe that an artist should be able to draw, a sculptor should be able to bend materials to his or her will, a woodcarver ought to empathize with the grain in a piece of wood. Well, that's nothing but folly, absurdity, and species self-delusion. I have proof. It lies in plain sight, flaunted with abandon for all to see: a mind-numbing profligacy of banality.

I refer, painful as it is to debase the term, to the "art" that decorates the office walls of the majority of doctors and dentists.

Who buys this stuff? Two-dollar prints of arty inanity set in seventy-five-dollar frames. More importantly, who generates it? I say "generate" rather than "create," because there is no creativity involved beyond a brutal ability to defile a pristine piece of paper or canvas with two or three color patterns. There is more art in your average tablecloth.

Somebody must do it. I know such tinted squares and rectangles (they're always squares and rectangles) are not fashioned by robots. Robots have better aesthetic sensibility. Perhaps the intent is to inflict on those confined to the interminable dreariness of doctors' waiting rooms a kind of slowly increasing stupor: a kind of visual Novocaine. Dull the senses first and the body to be treated will succumb more easily to whatever treatment is prescribed.

If there is more than one such visual abomination, they're always affixed to the walls in a straight line. Always. There's never any effort to vary them in a sequence that might tease the eye. Regardless of the graphical content imprisoned in the frames, the effect is akin to driving

If You Shoot the Breeze, Are You Murdering the Weather? 199

down a highway in central Iowa at noon on a July day: straight, unvarying, soul-deadening.

Seriously now—do live creatures actually spend time, unrecoverable moments of life, producing such pap? The upshot invariably is an insult to the ghosts of the trees that died to provide them with an underpinning. Sometimes these scandals of blandness even have names. If you can call them names. "Series #6." "Sketches, 4 of 24." I keep hunting, when it doesn't pain my retinas too much, for one titled "Entropy #3."

These particular purloined moments of existence no doubt cost twice as much as the rest because they have numbers attached.

Don't the physicians care? Does it really matter if you have no artistic sense but are an expert at installing implants or diagnosing Crohn's disease? Okay, I can understand that. But surely someone in your office, or family, or a total stranger suffering from gout who happens to be visiting from Pocatello and is afflicted with honesty, could point that out? And then you could respond by letting someone who *does* have an eye for art decorate your facility? That would not only be righteous of you, it would be noble. Your patients would thank you, even if only silently.

There exists a solution for the aesthetically challenged medical professional. Though all too infrequently have I seen it in use, it always works. Instead of the ghastly paint splashes produced by the art factory in Poughkeepsie, or wherever, put up photographs. This is Arizona. One large-format photo print of any part of the Grand Canyon, or Sedona, or Bisbee or Greer or the Superstitions, or a broken-down and abandoned car, or a dozen ice cream cones, is more interesting and pleasing to the patient's eye than every piece of commercial "art" hanging on every wall of every physician's office in Yavapai County.

They don't have to be signed prints. They don't have to be taken from the pages of *Arizona Highways*. They can be the work of students. Family members. Doctors, dentists, psychologists—here's the golden opportunity you've always wanted: a captive audience for your vacation snapshots! Doesn't matter if it's Disneyland, or the beach, or the flowers in Uncle Yunkle's backyard: it's all better than the "art" that some office decorator has sold you.

If you absolutely can't stand the idea of decorating your office complex with photographs and simply must have some *art*, get your kids to do some drawings. Even finger-painting. I guarantee you that your

patients will find them of more interest than what you have hanging there now. Do that, at least until the robots deign to start painting for us.

As an added bonus, the framing will be cheaper.

Faster Processor, Same Hard Drive

It is said that the continually accelerating pace of technological advancement is changing us. I would like to disagree, but I can't. Not after struggling to watch TV commercials that assault one's optics with a blizzard of images that change too fast for any human mind to process. What do the companies behind such advertisements hope to do? Blind the observers so they are forced only to listen to the accompanying spiel? Send them careening into something resembling a catatonic state so that they have no choice but to continue staring at the TV screen? If you are like me, the instant one of these tornadic adverts begins its assault on the senses, you hastily switch channels.

I wonder if any of the corporations behind these ads actually bother to study them to see if they are effective? If everyone who is subjected to them immediately changes channels, or at minimum mutes the sound, in order to avoid the sensory barrage, then the advertiser is not getting its message across and is wasting money.

But advertisements are avoidable, or at least mutable. What about people who *willingly* subject themselves to such speeded up visual and auditory overload?

Video games used to be like this. Back in the days when the first vid games were played on hulking machines in arcades, where the speed of the action was exceeded only by the clink! of quarters dropping into slots, the better a player grew at a game, the faster became the corresponding action on screen. It did not matter if the subject was a plumber dodging flung barrels, the segments of a centipede being destroyed while rushing to destroy you, or tiny triangular spaceships blasting asteroids moving ever faster. When you did better, the game speeded up.

As computer games matured and moved into the home, makers discovered that enhanced graphics did not necessarily equate with increasing speed. Story and character began to take precedence over velocity, and good plotting and deep characterization take time. Many games, even *Grand Theft Auto*, slowed down to allow traditional story elements to take hold. There is still plenty of fast action in today's video

games, in everything from *Fortnite* to *Red Dead Redemption 2*, but the need to make the action and dialogue flow ever faster reached a point where player comprehension became more important than how fast fingers can move.

But for every realization that people—whether a TV or film or game audience—need time to process what they are seeing and hearing, there is one element that continues to go relentlessly against the grain.

I refer, of course, to television weather reporting.

I can't point to a moment or even a year when this began to trend. Nor can I offer a motive why. I suppose a network executive or two could argue that the weather is not as important as other stories on a TV news broadcast or morning show, but I can't fathom that. The weather is important to everyone, and everyone is interested in the weather. Likely more interested than what happened today in Burkina Faso or an upcoming segment featuring bargains on bedsheets.

If that is so, why do we now see this trend for weathermen (oops, can't say that—how about "weatherfolk"—that sounds almost charmingly elvish) to talk as fast as humanly possible. *Why?* Why is so little time allowed for what is arguably the most relevant subject reported on the daily news?

Not to pick on him, but let's take *Good Morning America*'s Rob Marciano as an example. He is a meteorologist, and a good TV weatherman. Insofar as his time slot permits he delivers the weather report competently and without missing a syllable. So why has he, like so many of his brethren, taken to delivering the weather seemingly without pause? Or without periods? Commas will doubtless go next. It is as if there is now a speed Olympics of weather reporting. And the accompanying graphics have been accelerated to match.

Those maps on TV that show weather, in the form of rain or snow in your state or your area? Green for rain, red for freezing rain, and blue for snow, they move so swiftly across the screen, accompanied by an equally rapidly rotating digital clock/timer, that they are over and across your town and your home in seconds. The visual representation of the weather is there and gone so fast that there is hardly any point in even trying to follow it. If an incipient asteroid strike was to be indicated by the color orange, the target strike would appear and vanish from your TV screen so fast you would never notice what was coming (on second thought, maybe that's not a bad thing).

If You Shoot the Breeze, Are You Murdering the Weather?

I don't know who started this trend, but I do know that my interest in the local weather extends beyond the seconds of screen time it is all too often allowed. Until things slow down, I refuse to watch it on national television shows. Who would have thought that the greatest occupational hazard in being a television weather person would be voluntary asphyxiation?

Get a Horse (If You Want to Drive)

"Why, Johnny, grandpa remembers when people had to drive vehicles *themselves*. Not only that—people actually had to *buy* their cars. And pay for the 'lectricity to run them, and insurance, and have special cards that permitted them to drive."

Sitting wide-eyed on the floor as the robarber that had arrived at the house earlier finished trimming his hair, Johnny gazed up at his grandpa in amazement.

"You mean, you couldn't just call transport?"

Leaning back his chair, Grandpa Jones shook his head sadly. "Nope. Had to do it all ourselves. Waste of money. More importantly, waste of time."

I expect to be that grandpa someday—and sooner than you would expect.

While all the major auto manufacturers are obsessed with trying to find ways to sell cars to drivers, the clock on their industry is clicking down around them. Because advances in FSD (full self-driving) are happening so fast that tech writers and the general media cannot keep pace.

Tesla just introduced auto lane-change to its Navigate on Autopilot feature. Previously, if you set the NonA to take you to a destination, you had to flip the turn post to allow the car to change lanes. Now it will do so automatically, as part of driving you toward your destination. Some followers have openly wondered why it took so long to activate this feature.

Because having to flip a turn indicator to allow your car to make a lane change all by itself is now so primitive. And no, if there is another vehicle in the lane to which you wish to switch, the car won't do it. A driver might, if they were careless or tired or sleepy. But the car will not. We have finally reached the point where our cars are beginning to become better drivers than we are.

It is easy enough to see where this is leading. If a car can now automatically take you most of the way to your intended destination, and do so more safely and expeditiously than you can drive there yourself, what's left except for you to relax and enjoy the ride?

If You Shoot the Breeze, Are You Murdering the Weather? 205

Many states, and many cities in Arizona, have only recently managed to pass distracted driving laws. No texting or talking on your phone, no blocking your view of the road with a giant burrito, no glancing to your right to flip through a newspaper grocery add. You must keep your eyes and attention on the road at all times. Excellent reasoning and good advice.

What happens to such laws when, as will begin to happen shortly, paying such attention is no longer necessary?

"Ma'am," says the stopping officer politely, "you were texting on your phone. You are guilty of distracted driving."

"No sir," comes the assured reply. "I wasn't driving. My car was. How can I be guilty of distracted driving when I wasn't driving?"

Expect this defense to assert itself any day now, not just by Tesla drivers but as other new vehicles equipped with similar technology begin to make their appearance on the road.

It is going to play out much sooner than you think. The next step will be to allow vehicles equipped with FSD to talk to one another. Your car wants to pass a slower car in the same lane. It not only accelerates on its own, it informs the car immediately ahead of its intentions. That car communicates back that it intends to maintain speed, please move to pass, and by the way, where is the nearest charge point?

If you think the FSD vehicles currently being tested by Uber, Lyft, Google, and others look strange, any day soon we'll be seeing transports on the road that no only do not have steering wheels, they won't have front or back ends, either. The FSD commuter vehicles of the near future will more closely resemble the people movers you encounter at airports. You'll enter, inform the vehicle's AI of your destination, sit down, and happily engage in all those elements of distracted driving that can presently get you a citation. Nor will your transport be completely isolated. The progress and problems of every vehicle will be instantaneously tracked at a central (or at several) monitoring facilities.

If we can monitor pilotless drones from halfway around the planet, we can certainly monitor driverless cars—and buses, and trucks—from within a city, or a rural county. If you own or have a seen a robot vacuum cleaner, then you already are familiar with the future of transportation. Myself, I can't wait.

Driving can be fun, but I'd rather take a nap.

The Death of Film

Film has been pretty much dead for some time now. I don't mean movies. I mean the strip of transparent plastic film base that's coated on one side with a gelatin emulsion containing microscopically small light-sensitive silver halide crystals. That film. It's mostly dead because it has been replaced. More and more movies (for the sake of convenience we can also call them "films") are shot digitally. No transparent plastic film, etc., involved.

In its own distinctive, rollicking way, the history of motion pictures is as much a history of 20^{th} and 21^{st} century science as it is the history of a comparatively modern form of entertainment. Contrary to what many folks might think, it is the science that has driven the medium and not the other way around. The same is true of the food we eat, the way we get around, the kinds of housing we live in, even how we take care of our children and pets (not to confuse the two). It's science that drives it all forward. It is just that science is more front and center with the development of motion pictures than it is with other aspects of our daily lives.

As with each new scientific development, advances in filmmaking are often greeted not with acclaim but with resistance. No doubt when movies were first projected on a screen, in tents and rented barns, there were even then entertainment Luddites who insisted that was no way to watch movin' pitchers. The only proper way to watch was to dump a penny into a slot on a machine weighing only slightly less than a wood-burning stove, place your eyes against a metal frame, and turn a crank. That way you could even control the speed of the movement of the pictures within, and freeze your favorite image of Little Egypt wherever and whenever you liked. When innovation drove the price from a penny to a nickel (especially in the case of "films" like those of Little Egypt), Nickelodeons began to appear in every bar and pool hall in the United States.

But the reproduction of life was not quite true and the films, lasting a minute or two, were over all too soon. Also, your wrist tended to lock up. After a while, the projection of moving pictures in barns and tents gave

way to purpose-built emporiums for the showing of longer and longer films, and the movie theater was born. It's difficult for us today to imagine the impact of those first films in those early theaters. When *The Great Train Robbery*—which is considered to be the first "feature" film—made its appearance, it caused a sensation. The final frames, which have nothing to do with the film story, consist of an outlaw pointing his weapon at the camera and firing his revolver. People in theaters actually screamed and ducked. And this in the absence of sound.

When the first color films appeared, their arrival was not greeted with universal approbation. Having reached its aesthetic apex in films like *The Wind* and *Intolerance*, *The Cabinet of Dr. Caligari* and *Metropolis*, silent black and white cinematography had come to be regarded as an actual art form. Hand-tinting and then two-strip Technicolor were novelties. Interesting novelties to be sure, but like the color sequence of the masqued ball in *The Phantom of the Opera*, just novelties.

Lurking on the horizon at about the same time was another, far more potent disruptor: sound.

Another scientific gimmick, the studio bosses insisted. Suitable for inserting a song or two into a film, or a musical dance number, but the sound was tinny and voices did not sound natural. Much better to stick with subtitles and let the audience imagine what the voices of their favorite actors sounded like. Except the audience happened to disagree. While *The Jazz Singer* was a sensation, it really was something of a novelty. What finally killed the silent film was not Al Jolson but Busby Berkeley and his ilk. All-singing, all-dancing films were the development that broke silent film. Or to be more inclusive, it was musicals, Mae West, and the Marx Brothers.

Nothing much changed, from a scientific standpoint, until the advent of an entirely new invention that had little to do with film. Something called television.

Desperate to get their former audience off their couches and back into theaters, studios tried everything they could think of. Wide-screen formats like Cinerama turned out to be gimmicks while Panavision did not. 3-D enjoyed a brief flurry of interest until people realized it was little more than a variant of 19^{th} century stereoscopic photos with the added inconvenience of having to wear cheap cardboard glasses. Improved sound helped the theaters, and better sound continues to drive the content

of many films. Watching something like *The Lord of the Rings* in cut-rate mono sound is a good way to understand how important the science of sound is to bringing viewers into theaters.

Now we confront perhaps the most important scientific advance in motion pictures since the arrival of sound: computer graphics. Progress in CGI has been astounding, from its first clunky appearance in films like *The Last Starfighter* to ever greater sophistication. Where does it go from here, from today's technology that we mistakenly believe to be so advanced? Where once we replaced subtitles with the spoken word, we are now at the point of replacing live actors with their digital equivalent. CGI is already the norm for large crowd scenes. No longer does a cinematic spectacle require thousands of extras. We don't pay them anymore; we render them.

And tomorrow? How soon will we reach the point where live actors are no longer required at all? Where the uncanny valley no longer exists, and it becomes impossible to tell an actual human from its digital equivalent? Why hire a new actress for a role when you can insert Marilyn Monroe? Or for that matter, Lillian Gish? Why hire Daniel Day-Lewis to portray Lincoln when you can generate a composite of the actual Abraham Lincoln from historic photos? And then have him say and do whatever you, the filmmaker, desire?

Right now CGI is vital for creating believable aliens and alien worlds. What happens—and it will happen very soon—when it can be employed to recreate this world, in any time or place, and populate it with seemingly real but in actuality entirely artificial people?

Then you add in real 3-D, which will be the theatrical equivalent of virtual reality. The walls and ceiling and floor of the theater vanish, to be replaced on all sides by a computer-generated world. Think Star Trek's holodeck, only larger and more refined with much greater depth. You are no longer watching a movie: you are within it. That too will happen sooner that most people think. And when it does, once again the audience will find itself persuaded to scream and duck.

Your Dealer and Mine

As far back as I can remember, drugs have always been advertised on TV. I'm talking as far back as the '50s and '60s. Everything seemed so much simpler back then. Television itself, the ailments described, and the drugs required to treat them. Alka-Seltzer (hi, Speedy!). Pepto-Bismol. Aspirin.

As society has grown more complex, so has television. And so have the medications advertised thereon. As for the ailments themselves, you have to be a combination physician/biochemist to even begin to understand them. And the names for today's medications: where do they get these names? It's as if someone blew up a Scrabble set and just combined the surviving tiles. Merlacept. Canarex. Xinofler (for some inexplicable reason, pharmaceutical companies are especially enamored of drugs that begin with the letter "X." Xanax doubles down on this).

Actually, none of those first three are actual drugs (I hope). I just made them up to give you some idea of the linguistic contortions drug manufacturers seemed to go through when naming their products. In tandem with the number of drugs advertised on TV, the commercials created to market them have similarly evolved, and not necessarily in a good way. When it comes to illness, of any kind, I want and appreciate a straightforward pitch. Got diarrhea? Take Imodium. Sore throat? Try our cough drops. Instead, we get this:

The Setting: a beautiful, tranquil, impossibly scenic beach. Preferably California or Oregon. A perfectly healthy-looking couple (wait—isn't this supposed to be an ad for medicine, which implies some kind of sickness?) are strolling on the sand, the sun illuminating their (age notwithstanding) blemish-free faces. Depending on their ages, a couple of children may be playing at the water's edge. Or maybe a dog, cavorting along the surf line (you never see a cat in these commercials; cats are too smart to participate, and have too much pride). Occasionally the couple glance lovingly at one another. *Real* lovingly, if it's an ad for an ED drug (you didn't see *those* in the '50s). Then, after the main plug for the drug, you hear a soothing voice in the background, usually a woman, while the commercial's

director does his absolute best to employ stunning visuals to distract you from what she is saying.

"Certain side effects may occur while taking Xtushi. You may experience chills, fever, muscle aches, the shakes, excessive bleeding, explosive diarrhea, an uncontrollable urge to dance to 'Uptown Funk,' or an occasional loss of sight, hearing, the ability to think clearly, walk in a straight line, or breathe. More serious side effects can include an inability to drive, walk, sleep, or vote for Donald Trump for President of the United States.

"Women who are pregnant should not take Xtushi due to the possibility of giving birth prematurely, forever retaining your pregnancy weight gain, a risk of birth defects including but not limited to giving birth to a child with no limbs, no neck, a head that swivels uncontrollably like that of the girl in *The Exorcist*, one who might vote for a Trump offspring for President of the United States, or a rising desire to kill your husband, the latter condition which may or may not already exist and therefore be exacerbated.

"Men should be wary of taking Xtushi because it may cause drowsiness when watching important sporting events, enhance the chance of getting your wife or girlfriend or some ho you met on the street pregnant, stimulate you to buy that sports car you always wanted but could never afford thereby increasing your risk of divorce, or cause the loss of whatever hair you have remaining which is inevitably a lot less than that of the guy in the commercial advertising Xtushi. Also, your dick may fall off. In rare instances, death may occur."

And lastly, in that same gentle, clear, soothing voice, "Ask your doctor about using Xtushi."

Ask my doctor? Then what the hell do I need a doctor for? Clearly Xtushi is the greatest thing for my particular condition since the Balm of Gilead. Also, if I have a specific medical condition that is as difficult for me to pronounce as the drug that promises to treat it, shouldn't my doctor know about it? If he or she doesn't, then I don't need the advertised drug half as much as I need a new doctor.

Me: "Hey doc, have you heard about this drug Xtushi for my flagrant elbow problem?"

Doctor: "Why, no, I haven't. Is it something new?"

Me (voice rising): "How the hell should I know? Who's the physician here!?! What am I paying you for?"

If You Shoot the Breeze, Are You Murdering the Weather?

It is said that these days you need to be your own plumber, your own electrician, your own computer expert. But your own doctor? They say that nobody knows your body better than you. Well, I don't know my own body nearly that well. It's an alien world full of bone, blood, muscle, hair, lymph, organs, nerves, nails, and if any of it starts misbehaving, I want a doctor who can not only explain what's wrong with me, but who knows how to treat it and with the proper medications. I don't want to have to rely on a television commercial to make it all "easy" for him.

But I sure miss Speedy.

Farewell to the 17th Century: Class is in Session

Public schools in the United States have been operating more or less the same way since the first one, the Boston Latin school, opened in 1635. Back when students used to walk to school. Everyone remembers a favorite grandpa who used to regale the grandkids with tales of how he had to walk ten miles to class every day through a blinding blizzard (only efficacious if you plan on a career in meteorology) and then ten miles home on 100-degree afternoons—sometimes even on the same day.

Okay, so maybe gramps exaggerated a smidgen here and there. But the only difference today is that most kids are dropped off at school by their parents, or ride a school bus.

It's all such a waste.

Parents who have to drive their children to school and pick them up again sacrifice valuable time. School districts required to provide bus service spend thousands of dollars that could be better put to use paying for infrastructure and staff. Which leads to the question—just how much does supplying loaner tablets or computers to students cost versus the current arrangement?

I originally contemplated our antique educational system some decades ago, when alternatives to the present inefficient setup started to become practical. Essentially, school hasn't changed since 1635. Surely we can do better now.

For example, if you have twenty teachers in a large school teaching the same course (English, say) and one teacher is clearly head and shoulders better than the other nineteen, you are automatically depriving 95% of the students taking English the best available education in that subject. If students take that class at home from that best instructor, via tablet/computer, they then receive the best possible instruction in the relevant subject. Secondary teachers (as many as the school district deems necessary) are then made available online to interact with students and answer questions. This frees the top instructor from having to spend time

in class responding to queries and the interactive-answer teachers from having to prepare and deliver lectures.

This allows students to receive better instruction as well as the opportunity for more personal interaction with a teacher. Advanced students will research and find answers to their questions on their own while students struggling with a subject will have access to far more time with an instructor. Remember how in class the good students always answered the teacher's questions while their uncertain and less secure friends sat in the back and kept quiet for fear of saying something "stupid"? When a student is one-on-one with an instructor and no giggling classmates are present, that fear goes away. Those students who need more attention and help receive it while the brighter students are free to go their own way and learn far more than they ever would in a crowded class.

In my stories (*Montezuma Strip*) I proposed that kids physically attend "school" two days a week. Not for academics, but to enhance and develop social interaction (which is why I called them socis ("sewshes"). Socis would be where kids interact with one another, whether through sports, mutual hobbies of interest, expeditions out into the wider world: zoos, museums, universities, factories, banks—if they still exist in physical form—"real life." With children only attending a site once or twice a week, the need for expensive physical plant paid for by taxpayers would be greatly reduced.

An experimental study needs to be done on the cost of providing every student in a district who cannot afford one on their own with a tablet/computer and basic internet service. I bet it works out cheaper than having to provide every 15–20 kids with a live teacher for every class plus the cost of commuting them to a physical location. I don't think there's any question that children would do better academically. Instead of wasting time being driven or having to trudge to and from school, they can be at home learning. Class hours can be set according to every individual student's needs. Early risers can start at 6 AM (okay, kids like that don't exist, but still…). It has been shown over and over that to do their best, children need their sleep. Imagine starting school at the same time as currently, but without having to rise an hour or so earlier just to get there.

So you say: kids will just ignore their lessons and goof off. Not as long as there are tests (and there are algorithms that can ensure against cheating). Relaxed at home, without fear of having to run to the next class

or answer questions in front of one's peers, every student will do better. And physical bullying will be a relic of the past.

Some school district, somewhere, ought to give it a try. I think we can do better with today's technology than we did using the same methods we used in 1635.

Architecture for Hoomans

I'm a big fan of certain architecture. I don't think much of the work of Walter Gropius and the Bauhaus group, and a lot of what passes for modern architectural design has all the heart and warmth of Ikea bookshelving. I feel better about Frank Lloyd Wright, but you could have put a trailer at the spectacular site of Falling Water and it would still make for a beautiful picture. I love the swooping designs of Frank Gehry, and I'm truly going to miss the wild yet functional work of the late Zaha Hadid.

Which leaves me to wonder why everyday structures always seem to work better on paper, or these days within CAD designs, than they do in real life. I think this happens when architects get carried away by a vision, or become too enamored of their own perceived talent. Then you end up with something like the US post office on Miller Valley Road.

If any structure should be designed with functionality in mind, it's hard to imagine anything more basic than a post office. Now admittedly, when the Miller Valley location was chosen, designed, and built, it was not possible to foresee the growth that would occur in Prescott. But even taking that into account, after driving for years into that location I still find myself wondering what was in the architect's mind as he or she was designing it.

The main problem with such designs is that what looks good on paper does not necessarily translate to usage in real life. For example, it is rare to see an architectural rendering that includes surrounding structures and streets that have actual vehicles on them. Not to mention people. Crossing from one line of parking spaces over to the post office itself requires more attention on the part of pedestrian traffic than any other short walkway in Prescott, because drivers are either in a rush to leave or in a hurry to park.

The danger is compounded by the need for drivers to look every direction simultaneously, a physical impossibility. I've seen hundreds (not dozens; hundreds) of near fender-benders barely avoided as two drivers attempt to back out of their opposing parking spaces at the same time, only to be saved by a shout from a pedestrian or an alert third driver. It's

a nerve-wracking experience, one that must be particularly unsettling for older drivers.

Then there is the entrance, which was apparently designed for cars from Hobbiton. Watching a double cab dually try to maneuver into the parking area without ripping off a fender ranks with the most suspense-filled film at the multiplex. Watching a full-sized pickup struggling to angle into the drive-through mail drop-off is nearly as exciting.

I suppose my favorite architectural blunder involves the exit that dumps many departing drivers directly into the left-turn lane onto Miller Valley. This not only backs up traffic into the parking area, it results in a surfeit of colorful language voiced by drivers coming down Schemmer Drive who wish to turn right onto Miller Valley, only to find their access blocked by those leaving the post office who block the right-turn lane while waiting for the light to change. This snafu is especially fun during the Christmas season, when it backs up traffic into the parking lot so severely that people cannot even back out of their parking spaces. Meanwhile, a vast section of available parking directly behind the post office is fenced off and inaccessible to patrons.

Did the architect who envisioned this setup realize what kind of traffic issues the design was going to produce? Plainly not.

For years I posed this question to the folks at the P.O.: why not take out one tree and extend the parking lot into a right-turn (onto Miller Valley Road) only exit? This would enormously facilitate exiting the area and eliminate much of the blockage on Schemmer. The inevitable reply is: "We can't get the money." So the next time you're trying to exit the parking lot and find traffic backed up, have a look at that potential unrealized exit.

The post office is an example of narrow-vision architecture. I am just as exercised by potentially useful architecture that sits unused. In this case I refer to the aged three-story building at the end of North Cortez. Its ground floor was recently home to a restaurant or two, now closed, and it sits abandoned and forlorn. For forty years I've found myself wondering if old, original brick lies beneath the thick layer of white stucco. What remains of the interior? The upper floors must have wonderful views, to Thumb Butte to the west and maybe even to the San Franciscos to the North. If the building is structurally sound, what a perfect location for a boutique hotel—or even better, senior citizen housing.

Any architects listening?

Rise of the YGPs

Television's *The Original Amateur Hour* started on radio and debuted on television in 1948. I doubt I remember the earliest shows (I would have been two years old at the time) but I certainly remember the show from the early '50s. Even though it was sometimes known, after its TV host, as *Ted Mack's Amateur Hour*, for most of its long run it was only a half hour long. Mack moved the show along at a no-nonsense clip, running briskly through an endless and often interchangeable roster of singers, jugglers, tap dancers, magicians, and dog trainers. Most were at best competent amateurs, the kind you seeing entertaining at store openings, weddings, and bar mitzvahs. Occasionally someone actually memorable would appear. A very young Ann-Margret, for example. But for the most part the performers, while energetic and bright-eyed and hopeful, were eminently forgettable—largely because Mack had to primarily draw upon local talent.

That has changed.

Now we have *Dancing With the Stars, The X Factor, World of Dance*, individual country iterations of "…Got Talent," and many more. Between the omnipresence of television and the rise of the internet, a world of opportunity has opened for performers from obscure locations who heretofore would never have had the chance to showcase their abilities. A few, such as Spain's wonderful Christina Ramos, have all but made a career out of going from one such show to another.

In the days of *The Original Amateur Hour* these talented individuals would likely never have had the chance to appear before a real audience, much less go viral on the Net to showcase their abilities to millions. Perhaps most notable among these are the YGPs—the young girl prodigies.

They seem to be everywhere. Just when you think you've heard everything, along comes an Angelina Jordan winning *Norway's Got Talent* by singing Billie Holiday—at age seven. Nobody sings Billie Holiday at age seven. Her phrasing is unique and mature. Yet here is a Scandinavian seven-year-old mesmerizing listeners by sounding like a

thirty-year-old whiskey-soaked torch singer. Now a mature fourteen, Jordan has recorded over a hundred covers in addition to her own original material. I wonder what Ted Mack would have made of her, at age nine, covering the Screaming Jay Hawkins version of "I Put a Spell on You."

The angelic Amira Willighagen wins *Holland's Got Talent* at age nine singing "O Mio Babbino Caro." How else would a self-taught (by watching YouTube videos of opera singers) attract world-wide notice? Unlikely her parents could have afforded to ship her off to New York to appear in a talent contest. For that matter, in the absence of the internet she might never have learned how to sing at all, and the world would be a poorer place for it. Now she lives in South Africa, is fifteen, has three albums to her credit, and appears regularly in recitals around the world.

Her schoolmates looked down on nine-year old Courtney Hadwin's prancing and screaming. So did many adults. Not the sort of thing for a proper English schoolgirl to engage in. Much better to save a halfway decent voice for the choir, for psalms and madrigals. The same kind of quiet ridicule also greeted the young Janis Joplin, an earlier singer to whom Hadwin has often been compared.

Thanks to amateur shows like *The Voice Kids UK* and more recently *America's Got Talent*, Hadwin has gone from street busking to the release of a forthcoming album, writing her own material, and transmogrifying songs like Lil' Nas X's country/hip-hop song "Old Town Road" into a rock ballad. Without the exposure supplied by "amateur hour" TV shows, chances are Hadwin would still be singing on the streets for lunch money.

The reach of the internet has allowed us not only to access talent that would forever have remained unknown to most but to provide that talent with the kind of exposure that is capable of lifting individuals out of poverty as well as obscurity. In Russia, a specialized talent show called *You Are Super* features only young performers who were orphans or otherwise suffered difficult childhoods. Singing "Dernier Danse" (in French), fourteen-year-old Diana Ankudinova blew the judges away and subsequently won the show's Grand Prix. If it would have been near-impossible for the winner of a Dutch or Norwegian amateur show to gain recognition outside their home countries, imagine the odds placed on an unknown girl from Eastern Russia. I compare Ankudinova to a young Yma Sumac. Have a look at her performances of "Rechenka" (haunting Russian folk song) and "Wicked Game" (Chris Isaak) on YouTube. Her

life story is what these amateur shows should be about: the opportunity for obscure performers to become known and for otherwise hidden talents to flourish that would otherwise never have been brought to light.

Television birthed such discoveries, but it is in combination with the world wide web that they have been effortlessly brought to our notice and into our own homes for our enjoyment. Science promotes art.

Mona Lisa Simpson

It's been about a year now since I saw da Vinci's *Mona Lisa*. From something of a distance. Oh, I was close enough, I suppose. The trick is to go well to the left or the right of the mob that surges in front of it. You don't see the painting from straight-on, but you can get much closer by looking from the side. That is the only way you can even approach *La Gioconda*. Nobody wants to take a picture of Mona at an angle. All that matters to the horde is that it is essentially impossible to take a decent selfie with Lisa if you are shooting from an angle.

So the paradox is that the people who actually have an interest in the painting—as history, as art, as one symbol of Western civilization—must settle for the poorest viewing position. The more you wish to appreciate Leonardo's work, the farther away from a perpendicular viewing line you have to stand. I suppose those who are the most interested in the Mona as art end up seeing the side of the frame with only a sliver of mottled paint in front of it.

Meanwhile, other Leonardos that I find more accomplished and of more interest repose elsewhere in the museum. Only the discerning linger to gaze appreciatively at them. The majority of visitors give them a passing glance, perhaps pause if they happen to note the name on the identifying plaque, and hurry on. The Louvre is a vast treasure house of great art, and one mustn't be late for lunch.

Though it is a great painting and in some ways represents the epitome of Leonardo's art, nobody takes a selfie with Leonardo's *John the Baptist*. Not even with *La Belle Ferronnière*, a much more accomplished portrait of a young woman than that of *La Gioconda*.

The issue is not just with the *Mona Lisa*. In a different section of the museum a pair of Vermeers hang side-by-side. To see two Vermeers in one place is extraordinary. To look on as visitors pause before *Girl With a Pearl Earring* to take a selfie and then move on while virtually ignoring *The Astronomer* is… disheartening.

The why of these highly selective decisions is obvious. These visitors are only marginally, or not at all, interested in the art. It is the selfie that is

important. I only use the paintings in the Louvre as an example. It's the same everywhere people travel. Noted monuments, dinosaur footprints, meals in restaurants, fields of flowers, spectacular beaches—to all too many people none of these are as important as the selfies taken in front of them. Sure, travelers take pictures of the subjects, but it is the selfie that has become the king of casual photography. A picture of the Grand Canyon has no meaning unless you have at least one photo of yourself standing in front of it. The canyon itself needs no validation, as opposed to innumerable visitors who do.

Selfies, before the name became a meme, always conveyed a particular kind of social status. Here we are, Mr. and Mrs. Yamashita, having beignets and chicory coffee at the Café du Monde in New Orleans. Proof for the folks back home in Kyoto. Not that the beignets and coffee are that good, or even that visiting the café is particularly important. What matters and what requires visual confirmation is that Mr. and Mrs. could afford to take the relevant vacation.

With the rise of the internet it is much worse now. I think of selfies as photographic graffiti. Something about we humans requires not only that we record proof of our presence wherever we go, but that we inflict that proof on the rest of humankind whether it wants to see such images or not. There are people making a living doing this. You are not a travel influencer if you can't prove you've been someplace. I'm waiting for the first influencer to work exclusively out of their apartment in New York using only their imagination, a suitable camera, and a green screen.

Maybe I shouldn't be so hard on a newish craze that has been adopted by youth. Had cameras and the 'net been around hundreds of years ago, I suspect folks would have embraced the technology with equal verve.

"Hey Caesar—move a little to the right! I can't get all the Gaulish corpses in the frame with you!" Or "That's Joan of Arc burning at the stake behind me! You sure I'm in the shot?" That sort of memorialization.

But while we're busy putting ourselves in the picture, we do not spend sufficient time admiring the paintings. Or the sculpture, or the field of battle, or an episode from history. Via selfie we may acquire the recognition of others, but we lose the opportunity to gain something more valuable for ourselves. We become a tiny bit more widely known even as our souls grow shallower.

For all the self-improvement we acquire taking selfies, we might as well selfie ourselves in front of a cutout of Lisa Simpson as in front of the *Mona Lisa*.

Symphony + Metal = Symphonic Metal

Not everyone is familiar with the genre of music known as symphonic metal. Certainly it is far less well known in the US than in Europe or even in South America. I can't vouch for South America, but in Europe the tradition of classical music survives far more widely and is far more deeply ingrained in the young than it is in the US. Children are raised with it and taught to *enjoy* it. Not here in the States, where classical music courses in schools are usually something to endure rather than appreciate (even if such courses are optimistically called "music appreciation").

It was not always that way. In the '30s and '40s, radio brought great music into the homes of people who had never been to, and likely would never attend, a classical music concert. Conductors like Leopold Stokowski and Arturo Toscanini were household names. Only Leonard Bernstein, much later, managed to achieve similar broad popular acclaim.

Meanwhile in Europe, largely beginning in the '90s, some bands looking for a new direction strove to merge the classical tradition with heavy metal. The advancement of recording electronics allowed bands to incorporate not just performances by live orchestras but more importantly recordings of same into their work. This last was critical because bands could neither afford to bring along entire orchestras on tour with them, nor afford the number of extra musicians. Decades ago the band Procol Harum recorded an album with the Edmonton Symphony Orchestra: they could hardly bring the entire orchestra on tour with them. But recorded orchestral components—choirs, instrumentalists, etc.—could easily be utilized via modern recording and mixing techniques for use even in small venues.

Within Temptation was one of the first bands to popularize this new musical hybrid. They were joined by bands like Apocalyptica, Haggard, and others soon followed. Perhaps the two most notable practitioners of symphonic metal these days are Nightwish and Epica. Both feature dynamic female lead singers. Notably, in contrast to other variants of metal (thrash, garage, grunge, etc.), symphonic metal has welcomed women not only as performers but as lead singers.

Of these, Floor Jansen of Nightwish is unquestionably the most recognized. Dutch, 6'1", and usually performing in 4" heels, Jansen is a Valkyriesque presence on the stage. Having been in previous bands long enough to learn what works for her and what does not, she is fully aware of the effect she has on an audience, and utilizes it to great advantage. The fact that she has an astounding and astoundingly versatile voice completes the picture. The best description I have read of her singing is that she is the Swiss Army knife of vocalists, able to render anything from an operatic soprano to heavy metal growling.

Much of the rest of Nightwish has performed together for more than twenty years. This kind of continuity leads to a perfection of performance in which everyone knows what everyone else can do, when they are expected to do it, and how it should be done. This is not some kids' band trying to slap songs together in a garage. Their work, like that of Epica, is as polished as any classical composition. It is also a lot more exciting and listenable, and of a recognizable lineage dating back to the great composers of yore, than is the bulk of what passes for classical music today (the work of Jennifer Higdon and Philip Glass being personal exceptions). These days, composers of similar bent write for film, not for orchestral performances. In recent years, think of the sweeping yet intricate film scores of John Williams, James Horner, Basil Poledouris, Hans Zimmer, and Michael Giacchino.

Quite simply, much symphonic metal is cinematic in scope. Close your eyes and listen to the music and you can easily visualize epics of fantasy and science-fiction. Of course, if you close your eyes you will miss the spectacular performances of Floor Jansen of Nightwish and Simone Simons of Epica. That is indubitably one area where symphonic metal has it all over traditional symphonic music. I do not expect to see Philip Glass dancing on stage during the performance of one of his pieces (nor would I especially want to—pace, Mr. Glass).

Nightwish has recorded over 100 songs, many of which are viewable in performance on YouTube and elsewhere. Epica is similarly represented. And as mentioned, there are other bands happily and grandly crashing and slamming their way through the genre. I don't know about Bach and Brahms, but I think Beethoven and Mozart would've loved the stuff.

How Microsoft Got Started, and Other Adult Fairy Tales

In 1997 an extraordinarily bright lady by the name of Michele Kraus thought it would be a nice idea to try and develop a new video game. Headquartered in (surprise!) Palo Alto, California, she began by putting together a crew of clever young programmers, conjured up the name Magic, Inc., and then sought for source and sauce for a story for the game. For reasons lost to history, she settled on me, away down in the wilds of central Arizona. The result was a ground-breaking (maybe too ground-breaking) game that was never quite finished and so never quite released. We were doing motion capture before *Jurassic Park*. We were going to call it *The Matrix*, but some film company had already copyrighted the name for an as-yet unreleased movie that no one would ever hear of. We ended up calling the game *The Marrexx*.

Every few weeks I would fly up to Palo Alto, settle myself into a hotel around the corner from the company's rented offices, and dive into work on developing the game. At night our crew, led by Michele, would retire to some nearby restaurant for dinner, mental cool-down, and our fearless leader's guess-who-that-is live show identifying other diners. Il Fornaio seemed to be Silicon Valley's equivalent of Hollywood's Spago, where in between mouthfuls of lasagna and related pastas Michele would point local celebs out to us. They were, unsurprisingly, not actors.

"See that guy? The one in the lederhosen and sandals? He invented 'Sim City.' He's worth half a billion now."

Pfft... half a billion. This was in the early days, when half a billion meant something.

One day Michele approached me and said, "I've got an invite for two to CES. You want to come along? We'll make contacts, try to spark interest in the game, reach for some financing."

"Sure, you bet!" I replied. I knew what the Las Vegas CES (Consumer Electronics Show) was, but I had certainly never been to one. And in the absence of the internet, I couldn't research it, either.

For those who have never been to a CES, it's kind of like Prescott's farmers' market, only featuring different chips. Every electronics or electronics-related company in the world attends CES to promote their products, be they already in production or forthcoming. It's the forthcoming promotions that are the most interesting. From this year's CES, think Hyundai's electrically powered flying car/taxi and Samsung's roll-up-into-the-ceiling TVs. Products we may never actually see, much less be able to buy, but boy, are they fascinating.

Remember now, this is 1997. The stone age where consumer electronics are concerned.

Perambulating through the show, Michele seems to know everyone. I don't know anyone, and half the time I'm not sure what she is discussing with these gentlemen (they were nearly always gentle*men*). But I smile and nod stupidly, doing my best to fake comprehension of much of what I'm overhearing.

"Oh, Alan, this is (redacted). He's vice-president of Intel."

Okay. Intel I knew. So I listened, and nodded, and smiled, and then this very personable chap turns to me and says, "You know the story of how Microsoft got its start?"

Uh, no. Couldn't fake that one. "I'd like to."

Mr. (redacted) settles in. "IBM was developing the first home computer operating system. They had hardware, but no software. So they put out a call for a brand-new software system that would be used on all IBM small computers. They received twelve responses—companies and individuals. One of them, one of the brightest guys in the industry, had developed this terrific operating system. Far better than anything else available at that time.

"The day came for the developers to make formal presentations. When it came time for Mr. Brilliance to make his, it turns out he sent his wife to present in his stead because he 'was busy with something else.' Well, that's not how you treat a bunch of busy suits from a company like IBM. They picked Microsoft's DOS operating system instead."

The moral of this industry tale should be obvious to anyone. If you are going to pitch an idea—for a movie, a TV show, a new product, a new soap, or a wedding venue for your Aunt Maggie's giggly daughter—do it yourself. Because if those listening to the pitch don't think you have confidence in it, then they certainly won't.

If You Shoot the Breeze, Are You Murdering the Weather?

That was the coolest thing I remember about CES 1997. The second coolest thing was this slick black laptop computer backpack/carry bag that was embroidered with the CES logo. Nowadays you could carry a dozen or so iPads in it. Or fifty iPhones. I hung onto it for a long time, and finally gave it away.

Don't skip meetings, do always be on the lookout for free swag. Even if it will likely be obsolete in a year or two. Because that is what consumer electronics are all about anymore.

Art Theft, Thieves Bereft

Art thievery has been with us since Aunt Oog surreptitiously swiped cousin Frag's necklace composed of rough-hewn river rocks chipped into the shape of dead mammoths. But sometimes I wonder if those who steal important works of art have excellent taste, or are simply stupid.

Case in point: twenty-three years ago, Gustav Klimt's *Portrait of a Lady* was swiped from the Ricci-Oddi Modern Art Gallery in Piacenza, Italy. This caused no end of local anguish because the collection in the Ricci-Oddi is not exactly on a par with that of the Louvre or the Met, and the museum already had to deal with the problem of being named Ricci-Oddi, which sounds like a character from an Italian science-fiction movie.

Herr Klimt not only had a very distinctive style, his work is considered among the masterpieces of fin de siècle Viennese art. It is instantly recognizable even by those with only a casual interest in painting. Is the piece in question valuable? Inestimably so. Is such a work saleable without heavily documented provenance? You would have an easier time filling up a bag of volcanic pumice and trying to pass it off as moon rocks.

Why steal something of great value you cannot sell? It may be that the filchers of this particular painting got cold feet once the aforementioned logic finally penetrated whatever lobes of protein they used as brains. So they stashed the painting in a sack in a wall under the museum, where after twenty-three years it was found by an inquisitive gardener.

Instances of invaluable art being stolen only for the thieves to abruptly realize there is no way they can sell their booty occur with surprising, and stupefying, frequency. In 1911, Picasso's *Le Pigeon aux petits pois* was stolen from a modern art museum in Paris, only for the thief to realize what he had taken and subsequently dump the painting. It was never recovered.

Vermeer's *The Concert* was taken from the Isabella Stewart Gardner Museum in Boston in 1990. There are thirty-four authenticated Vermeers in the entire world. I would almost prefer to think that the theft of *The Concert* was one of passion rather than for profit, and that the painting is sitting safely somewhere on the wall of a wealthy but corrupt art

If You Shoot the Breeze, Are You Murdering the Weather? 229

aficionado. Should you happen to come across it and report its location to the authorities, you would be in for a nice reward, since the work is valued at $200 million. It disturbs me to think that, like Picasso's *Le Pigeon*, the unsellable Vermeer may have ended up in a trash dump somewhere.

An icon of modern civilization and art is Edvard Munch's *The Scream*, which is splashed across everything from T-shirts to coffee mugs. Museum-quality prints are readily available from multiple sources. This widespread availability does not seem to make it any less irresistible to thieves, since the painting has been stolen from museums not once but twice (1994, 2004).

Most depressing of all, we have the theft of seven important paintings from the Rotterdam Kunsthal museum. To keep them concealed from the authorities, one of the Romanian thieves left the paintings with his mother, who first hid them in an abandoned house, then buried them in a cemetery, and when she heard that the police were looking for them, eventually did what few actual thieves do with such plunder, even if it is unsaleable. She burned them.

The thieves who stole Henry Moore's bronze sculpture *Reclining Figure* in 2009 had higher temperatures in mind; namely, having the massive work cut up to be melted down. Two tons of bronze in a sculpture appraised at roughly $4 million destroyed to realize perhaps a few hundred dollars as scrap. Fortunately, photos now exist of every major and many minor artwork scattered in museums around the world, so if twits like the Moore thieves persist in their labors, nothing will disappear forever.

Almost forgot. In 1911 (what was it about 1911?), a trio of Italian art thieves purloined the *Mona Lisa* (yes, that *Mona Lisa*) from the Louvre and made a clean getaway with their prize. After some time had passed, the purportedly brilliant ringleader tried to sell it to an art dealer in Florence. The notion that an art dealer in Florence would fail to recognize perhaps the most famous painting in the world and therefore not notify the police truly makes one marvel at the lack of mental acuity in such individuals. Or at their chutzpah.

Famous artworks are better protected today, but none, not even the greatest of the Masters, is wholly safe. So keep a tight lock and a close watch on your comic book collection. Someday the Louvre may come calling.

That Sinking Feeling

Talk of rising sea levels is in the news a lot these days. Melting of the Greenland ice sheet accelerating. Record storms in the North Pacific. The Pine Island glacier in Antarctica cracking up. Climate change denialists cracking up. I had the disheartening experience of seeing what this means in person nearly twenty years ago, in a place few people ever visit. When I went there in October of 2001, I was officially the 12th fly-in tourist of the year (although yachties do visit more frequently): Tuvalu is officially the least-visited country in the world. Which is a shame: it's the real South Pacific.

The island nation of Tuvalu consists of nine very small, very flat islands and atolls. Total land mass is about ten square miles. Area-wise, this makes Tuvalu the fourth smallest country on the planet. Put another way, the land mass of the country is about one-tenth that of Washington DC. The highest point of land is fifteen feet above sea level. Many of the coconut palms are taller.

But that won't save them. Or Tuvalu.

The immediate problem is not land loss. In fact, a recent study indicated that despite measurable sea rise, Tuvalu had actually gained about 3% in land area in the period 1971–2014. This was likely due to several factors such as shifting patterns of sand deposition and the rearrangement of gravel deposits. So if Tuvalu actually gained in area, then whence the threat?

One of the problems with discussing climate change is that, as with most science, the details are not as simple as presented by the media. Greenland, for example, is likely to also grow in land area as it loses its enormous ice cap. The melting will cause sea level rise, but at the same time the land mass that is Greenland is likely to rebound due to the loss of weight.

In Tuvalu, as in other low-lying island countries like Kiribati (which is pronounced "Keer-i-bass," just so you know, since most folks get it way wrong… and Tuvalu is pronounced "Tu-VAH-low") and the Tuamotus of French Polynesia and the Indian Ocean country of Maldives (not "the"

Maldives... just Maldives) and others is the immediate problem caused by sea level rise involves the land not sinking beneath the waves but something less visible and more insidious: salt infiltration.

The inhabitants of most small island nations get their drinking and irrigation water from a thin lens of fresh water that accumulates above denser, saltier water. The only way for such water to be naturally replenished is through precipitation. Lesser amounts of rainfall are also collected in basins and cisterns. Sucking too much water out of such lenses not only reduces the amount available for use, it also increases the likelihood that salt water will seep into the area vacated by fresh.

Therein lies the danger for small, low-lying island nations. It is not even so much that the supply of drinking water will disappear. Those cisterns and collection basins can help mitigate the loss, and where installed, small desalinization facilities can provide at least a minimal supply of drinking water. Newly developed water producing systems can even draw water right out of desert air.

The problem is that rising sea levels allow salt water to penetrate deep into the soil. Even the hardy coconut palm will eventually succumb to salt intrusion. The less resilient plants on which people living a subsistence existence depend, such as taro, will quickly be killed by a higher percentage of salt in the groundwater. Without plants such as coconut palms and wilsonia to hold the soil, repeated storms will eventually wash it all away.

I saw this for myself one day as the local fisheries officer, Semese Alefaio, and I were out diving the expansive Funafuti lagoon. As we passed one barren chunk of weathered coral rock on the encircling atoll, he told me that not long ago it had been a lush little islet, complete with palms and thick ground cover. Salt water intrusion had killed all the plant life and the most recent big storm had taken away all the soil, leaving behind nothing but the underlying bare coral limestone. I gazed at the other nearby surrounding islets as we motored past, and tried to imagine a similar fate for them. The image was not pleasant.

I believe there is an old movie titled *Death Comes from Below*. That's the increasingly ominous situation in the South Pacific and elsewhere, where rising sea levels infuse already fragile land with ever more salt. Meanwhile, Fiji exports millions of gallons of fresh water every year. You can buy bottled Fiji water at any local supermarket. The argument is that

Fiji, an island nation that includes many high islands, is making use of a resource that would otherwise flow unimpeded into the sea. True enough, I suppose, but I can't help but think there might be better ways to utilize it.

Meanwhile, with foreign help and anticipating the need to eventually evacuate its population, the nation of Kiribati has bought high land in Fiji. Just in case.

Critical Mess

Toilet paper—what we regard as modern toilet paper—was invented by the American Joseph Gayetty in 1857.

There. That's out of the way.

The current recurring dearth of toilet paper in stores seems to suggest that society is on the brink of collapse. In today's news I saw that a truck crashed on a freeway in Texas, dumping its entire load of—toilet paper. I fully expected to see follow-up scenes of folks leaping barriers at the risk of their lives to score an armful of Angel Soft three-packs, with commentary by breathless TV reporters ("Oh, the humanity!). There have been fights in supermarkets between people competing for the last rolls of t-paper. Just saw a report on one involving three women in Australia. Diapers I can maybe understand. But toilet paper?

I checked with Wikipedia and yes, civilization did exist before 1857. Thrived, depending on where you happened to live at the time.

I received a solid lesson in the recent history of toilet paper from my wife of forty-five years. JoAnn was raised on a small farm outside the town of Moran, in west-central Texas. Her family did not have indoor plumbing until she was fourteen. I realize that this bit of information may stun those of you under 30, but it is a fact that much of what we now take for granted did not exist within the borders of the United States prior to 1857—flat-screen TVs, cell phones, the internet, Facebook, skateboards, and toilet paper—and that not all persons born after that date gained automatic access to such goods.

My wife's family utilized a two-holer outhouse for applicable business. When said structure was torn down, we had the wood salvaged, heat-treated, and fully disinfected. It now panels the walls of our guest bathroom. The double-hole platform itself is not up yet, but the other wood is a small way of reminding visitors that not so very long ago, indoor plumbing was not an everyday thing. Additionally, it's difficult to imagine anything more appropriate, décor-wise.

In lieu of toilet paper the Sears-Roebuck catalog was a popular national substitute. You remember Sears-Roebuck: the company that had

a head-start with what we now call internet shopping. Sears could have owned the internet, but to its managers the 'net was just a fad, soon to fade away. Sears is just about gone, but t-paper is still with us. When you can find it.

So how do we solve the current toilet paper shortage? Common sense and anti-hoarding aside, you might consider purchasing and installing a fancy Japanese toilet. These have heated seats, clean you with warm water, and then air-dry the relevant geography. Think your local drive-through car wash, only on a smaller scale and without any need to tip an attendant. Though you still need to put yourself in neutral.

You can of course use toilet paper with a Japanese toilet, and the same t-paper shortage panic currently exists in the land of the Rising Sun, but if you can afford a top-of-the-line Toto, you don't need to worry.

In many middle-eastern countries, a regular toilet comes equipped with a shatafa. This is an attachment consisting of a narrow hose that terminates in a small shower head, the kind you find everywhere in European bathrooms and increasingly here in the States. Someone had the bright idea to eliminate the need for either a bidet or a fancy toilet by simply attached a shatafa to the existing water line feed to the toilet. Employ the shatafa to clean yourself, use a small paper or cotton towel to dry off, and hey presto: no need for scarce t-paper.

You don't encounter a great deal of toilet paper in China because it tends to jam up older pipes. It has nothing to do with culture.

Or as JoAnn pointed out, "Haven't people ever heard of washing machines?" Costco and other stores are stocked with bundles of small, cheap hand towels and washrags. Use one, toss it into a pail designated for the purpose, and then clean them in your washer. But we were all born into a disposable society, so no one thinks of re-using things in such a manner. We're wasteful, we are.

While we're on the subject of waste, the newest Japanese toilets use less than four liters of water per flush compared to the thirteen required by traditional western toilets.

You would think that statistic would prompt the installation of a fair number of Japanese johns here in Arizona, but I don't know anyone who has one. We would, but we live in an old house. There's no electrical outlet near our master bathroom throne, and we're not about to rip up

If You Shoot the Breeze, Are You Murdering the Weather?

historic tile work to install one. But I think of it often when ensconced in that place where thinking comes easily.

When the Sears catalog was out of pages and magazines were not handy, JoAnn's family had recourse to corncobs. Think of that the next time you're tempted to bitch about a shortage of ultra-soft four-ply.

CV Baby, You're Driving Me Crazy

I know you're sick (no pun intended) of hearing about the coronavirus. *I'm* sick of hearing about the coronavirus. The government is sick of hearing about the coronavirus (or is that the sick government?). And yet, herewith a few sick (sorry... quick) thoughts on the matter. Plus one genuine awkwardness involving the disease that only we here in Yavapai County have to deal with.

First, some perspective. Worldwide, seasonal flu kills about 646,000 people every year. That is likely an understatement because exact reportage from places like Burkina Faso (much of which looks a lot like parts of Arizona) and Borneo (which does not look at all like Arizona) is lacking. Also, local governments, depending on their degree of autocracy and the state of the bowels of their current despot, have a vested interest in not accurately reporting deaths from disease. Because nobody is in a rush to invest in places where potential workers are dropping like flies.

We're so frantic and worried and paranoid about the coronavirus that we have a tendency to forget our history It is estimated that worldwide, the great influenza pandemic of 1918 killed upwards of fifty million people. That's fifty *million*: not fifty thousand. And again, that statistic relies on reportage that was far less accurate that it is today.

Remember the Black Plague? (I don't mean personally). Nowadays it's sometimes fodder for comedians. Doubtless because it occurred so far in our past. It is believe that pandemic killed sixty percent of Europe's population. If such a plague/pandemic struck Europe today, it would mean roughly 450 million dead. Nor do the mortality totals of the influenza of 1918 nor the Black Plague nor the coronavirus take into account the permanent damage to their health suffered by millions of survivors.

So when the airlines bitch about the loss of passenger traffic, or the cruise lines (most of which are not registered in the US but rely heavily on American travelers) complain that they don't qualify for relief from the US government, I think of history and tend not to throw too much sympathy their way.

If You Shoot the Breeze, Are You Murdering the Weather? 237

Now, about that awkwardness I mentioned earlier.

The human mind works in mysterious ways. I'm saying that those neural pathways sometimes lead to some peculiar destinations. Currently, the prime example has to do with a perfectly innocent (and, I am told, tasty) libation called Corona beer. Said brew has nothing whatsoever to do with the virus. Everyone with half an ounce (or maybe twelve ounces) of brainpower knows that the beer has nada to do with the disease. But small portions of our brains (larger portions in some unfortunate folks) make weird associations simply via the similarities of certain words. So yes, there are those who even though they know better hear "corona" and think "deadly virus" instead of beer. Which is harmless, except that when shopping they may well, consciously or subconsciously, just decide to avoid purchasing that particular brew and reach for another instead.

What is really screwy is that while that is an effect people might expect, the actual sales of Corona beer in the US are *up* five percent.

I can't explain that. While you would hope that people are intelligent enough to reject the notion that there is any connection between the beer and the virus, what explains folks buying more of the Corona-labeled brand? This would be excellent fodder for psychologists, except that beer sales in general during the pandemic are up *forty-two* percent. Which means that Corona may actually be losing market share/sales due to the virus.

I dunno. Where human impulse is concerned, sometimes my powers of cognition fail me.

I relate these sudsy minutiae to show how the human mind can work even in ways we do not want it to. Which brings me to that other, localized awkwardness.

Folks who have trouble with, or simply desire to avoid multisyllabic words, will choose to refer to the disease not as "the coronavirus," but simply as "Covid-19." Or still more conveniently, as "CV." My problem is that when I hear somebody say "CV," I don't think of the coronavirus.

I think of Chino Valley.

I know that nearly any local saying CV these days is likely referencing the virus. But I can't help it. I keep hearing "Chino Valley." Fortunately, the national media has not picked up on this, or the poor residents of Prescott's northern neighbor would find themselves deluged with a pandemic of another kind: reporters from national newspapers and TV

looking for a "local human interest" story (without regard to what the local humans might think). And masks won't help with that... though social distancing might. So let's keep that particular abbreviation to ourselves, and if interviewed nationally, always say "coronavirus" or "Covid-19" and not "CV." Lest Chino Valley residents be subjected to the same sort of goofy detrimental word association as Corona beer.

Or maybe it's just my mind that works that way, and I need to go have a drink of something with seriously different initials.

Planet of the Unrepurposers

Day after day, we find ourselves bombarded with announcements, declarations, exhortations (and sometimes exorcisms) prodding us to recycle. Pretty much everyone I know dutifully complies, or uneasily says that they do. Since *5enses* frequently deals with art and science, we see the word repurposing a lot. This is the word that artists utilize when making "art" out of junk so that they don't have to use the word "recycle." Because in most folks' minds, "recycling" conjures up images of garbage, of things we throw away, and for an artist struggling to sell their junk art, "repurposing" provides a less objectionable moniker.

Far be it from me to chastise the creative for their choice of certain labels, though. It is just that I have yet to see a contemporary repurposed piece of art to which my initial gut reaction is not "hey—that's a pile of rubbish!" I understand that art is in the eye of the beholder. I'm just not so sure that it should once also have been in the nose of the beholder.

I guess it is better to have old cans, cardboard, glass, office supplies, paper clips, clipped hair, tree clippings, beautified baby diapers, and abandoned cars slapped with paint placed in museums and art shows than simply thrown out. If nothing else, this provides a useful service by freeing up valuable space in landfills. In fact, if we are really serious about recycling, it should be the law that a certain amount of money ought to be freed up for individual citizens to spend on art—so long as it's "repurposed" art. Think of it: itinerant, impecunious artists would gain an income, there would be less rubbish altogether which would speed up trash collection, and a general aesthetic edification would be inflicted on a reluctant public. A win all around.

Given the prices that some of the repurposed art I see bring, I am always surprised that our noble and hard-working refuse collectors do not all double as commercial artists. C'mon, guys—you know you can do as well as half the stuff you see in museums of contemporary art. As long as your wives are going to drag you to such venues because "it's educational," you might as well snap some pictures of samples, go home, and get to work in the garage.

I personally think that Prescott, a community proud of its artistic heritage and leanings, should sponsor a contest once a year open strictly to refuse collectors from around the world who have made it a point to repurpose a small portion of the crap they are forced to handle every day. Think of the national publicity!

By golly, if Sweetwater, Texas (a charming little community on the interstate to nowhere, now subsumed in a jungle of wind generators) can derive national notoriety out of annually massacring hundreds of innocent, vermin-eating reptiles, then how much more upscale would it be to throw a yearly bash celebrating the artistic accomplishments of men and women creating art out of the debris (excepting that hoarded by your Uncle Fred, who never throws anything out) they deal with daily? I tell you, the *New York Times* would send its art editor out to cover the event. Guaranteed.

Better for the environment, too. Not just because it keeps garbage out of landfills but also off the necks and legs of small animals and birds that don't know any better, and out of the stomachs of sea turtles. A floating plastic bag looks just like one of the turtles' favorite foods: jellyfish. And surely there is a clever tinkerer out there who can figure out a way to do something with the tens of thousands of pairs of cheap flip-flops that litter beaches from California to the Comoros. Glue them all together to form a single pair of gigantic, multihued floppers. Call it "The Essence of Future Past" or something equally pretentious. Win prizes, impress your friends.

Having dumped, I hope with some small eloquence, on pretend artists and non-recyclers alike, I'll offer a suggestion of my own. Why can't we reuse the hundreds of thousands of pill bottles that are discarded every year? Surely there's a quick, cheap way to disinfect them without compromising the integrity of the plastic. Each bottle already has the name and relevant information of the recipient on it. Save the pharmacist time looking up details. Take in your tough plastic Rx bottles and have them refilled. Every modern pharmacist has an electronic record of how many refills a customer is due, so pasting over or trying to change a label wouldn't work.

Failing that, cut out the bottom of each bottle, glue 'em together, and make a cockroach run. Fun for the whole family.

And if the kids get tired of it or your spouse threatens to leave you unless you get rid of the creepy thing, you can always enter it in an art show. Sometimes the roaches win.

Of Note

I love classical music. Blame my mother. Also Walt Disney.

We had a baby Steinway grand. To a small child, this monster of an instrument that occupied a good portion of the living room in the house where I grew up was a source of both wonderment and awe. Wonderment, when my mother would sit down to play the entirety of Gershwin's *Rhapsody in Blue* from memory. Awe at the cascading, dramatic sounds it could produce. I used to just sit on the floor nearby and listen.

When I reached my early teens, my mother insisted I take piano lessons. I had two or three, but lost interest when I discovered I could not play Rachmaninoff's 2^{nd} piano concerto by the third lesson. Wish I'd had the maturity to stick with the program. What I really wanted was a drum set. Might as well have asked for bagpipes.

Then there was Disney's *Fantasia*. Seeing it for the first time at a very young age, I was bemused by Bach's *Toccata and Fugue*, delighted by the interpretation (however fanciful) of Beethoven's sixth symphony, mildly amused at Ponticelli's *Dance of the Hours*, enchanted by Tchaikovsky's *Nutcracker* suite, awed by Dukas' *Sorcerer's Apprentice*, and terrified out of my young mind by Mussorgsky's *Night on Bald Mountain*. Disney added a nondescript animation of the *Ave Maria* to the end of the film because he was afraid that the Mussorgsky might be too scarifying a conclusion to the picture. He was right.

The first LP (hey, vinyl is back!) I ever bought was of Stravinsky's *Rite of Spring*. Because, *Fantasia*'s dinosaurs (pace, Igor). The dynamism, the stabbing chords of that piece never left me. Which was why, when I took Musical Appreciation in high school, I was bored to tears with Schubert and even Schumann. But I continued to haunt a used record store in west Hollywood, eagerly sifting through the racks of LPs for more Stravinsky, and every new discovery (Wagner, Shostakovich, more Beethoven). When CD technology arrived I was able to introduce myself to composers who never get played live at least in this country. Bantock, Büttner, Braga Santos, Tournemire, Pierné, Podešva—the list is extensive.

Then Havergal Brian's *Gothic* symphony arrived, in the form of a Marco Polo CD. It was a shock to my senses. The rare performance of the full symphony, utilizing a thousand performers, in London's Albert Hall in 2011 remains the greatest concert experience of my life—and that of many other classical music lovers. There is an excellent recording of the performance on the Hyperion label. If you search on YouTube, you'll find the brief excerpts of the final rehearsal that I managed to shoot before an usher shut me down. I believe it is the only video footage extant of that memorable rehearsal. And the BBC did not video record the performance because they ran out of money, or so I was told.

Meanwhile, I've continued to hear music in my head. As a member of the Havergal Brian Society once chided me at a Society meeting in London, "We *all* hear music in our *head*. What matters is writing it down." He was tipsy at the time, but quite correct. As I tell want-to-be writers, many people have good ideas. It's writing them down that turns them into authors.

Time progresses. So does technology. Just as there now exists excellent writing software so, I found, there is also music composition software. Though it would help a great deal if I could play an instrument (didgeridoo and taiko don't count), I thought I ought to give it a try. Science learns from failures. So do writers, composers, painters, etc. After much effort, I produced a three-minute prelude for orchestra. The result sounded, to me at least, like—music. A few other folks thought likewise. I wrote another piece. Then I wrote a symphony, or tried to. Twenty-five minutes of orchestral playing, anyway. I may not be good, but neither am I discouraged.

My favorite band is the Finnish symphonic metal ensemble Nightwish. I wrote a short orchestral impression (not portrait) of each member of the band. After undergoing still additional tech contortions, since Facebook does not allow you to post musical excerpts directly, I found something of a work-around and managed to get all six movements of my Nightwish suite posted to my Facebook page. You can judge them for yourself by going to www.facebook.com/alandeanfoster.

I have no idea where or whether these efforts will lead to anything besides personal satisfaction. I continue to write books (and this little column). But if a 73-year-old writer of fiction can do it, anyone can. Regardless, I'll keep trying.

If You Shoot the Breeze, Are You Murdering the Weather?

Blame those dinosaurs in *Fantasia*. And Chernobog. And my mother, who stood by patiently while I struggled with a stick to conduct those old 78s of Beethoven's Fifth without breaking anything (much) in my room.

Science?

I consider myself a considerate person. Polite and controlled. Diplomatic in discussion, tactful in argument. When debating current issues that affect us all it is a particularly useful way to respond. Especially in a state awash in everything from derringers to small thermonuclear devices. Hey, everybody needs home protection. Most of us simply disagree on the degree.

I grew up in a family dominated by businessfolk. My parents were straight middle-class. Mom was a homemaker, Dad worked nine to five and brought home a paycheck. As far as I know there were no technologists in the lineage. No researchers, no scientists mad or even mildly dyspeptic. Far less were there any artists, musicians, or writers. Yet from as far back as I can remember (some might slyly say since time immemorial) I have always loved science. More than that, I have had the greatest respect for it and for what it has been able to achieve for the human species (when not developing more efficient ways for us to off our fellow man).

Now I find myself living in a time when science is not only characteristically important, but life-saving. Having royally screwed things up, as humans are wont to do on occasion, due to a small group of hungry folks deciding to chow down on bushmeat, we find the entire human herd under relentless assault by an enemy that does not listen to reason, does not care about our lives, loves, or desires, does not respond to threats, argument, persuasion, promises of riches, or being hit by a rock, is not fazed by knives, bullets, gas, rockets, or nuclear bombs. Well, maybe the latter, but you know what they say about the cure being worse than the disease.

I am speaking of our new companion, the coronavirus. Covid-19. It jumps from person to person, it makes young people sick and hits them with afflictions that may not materialize for years, it kills old people without mercy, and it slays even the fittest. Perhaps most insidious of all, it has a tendency to mutate. It even attacks politicians, which is maybe why something is getting done about it. It often seems we are helpless to fight back against an enemy we cannot see, taste, feel, or hear. We are weaponless. Almost.

If You Shoot the Breeze, Are You Murdering the Weather?

We have science.

It is science that identified the threat. Science that tells us how to best defend ourselves against it, avoid it when possible, and hopefully fairly soon now, give us a vaccine to protect ourselves against it. To that end money is being spent and resources marshalled. This world-wide, species-wide project faces only one real stumbling block.

Us.

Or more properly, a disturbed minority of us. Because for some reason there are folks who do not believe in science. Science, not politicians or therapists, tells us the best ways to beat back the virus are to wear face masks when out and about or in a crowd, social distance six feet (not a hundred, not a thousand), and god forbid, wash our hands frequently. As one commentator pointed out, our fathers and grandfathers were asked to storm the beaches at Normandy in the face of tank traps, barbed wire, concealed machine gun fire, and artillery bombardment.

Yet some people object to wearing a cloth mask?

Why? Because they believe in "individual freedom," But this is not about individual freedom. You want individual freedom, go live in a cave or on an uninhabited island in the middle of the Pacific. Failing that, you live in a society. As such, you have responsibilities to your fellow members of that society.

What is it with people who do not believe in science? Are these the same folks chatting with their friends on cellphones? Science. Do any of them watch satellite TV? Science. Drive a car? Fly in a plane? Flush a toilet? (All that stuff about hydrology and gravity, you know). It's all science. We live in a world that science has made. Science did not gift us with coronavirus. Or AIDS, or ebola, or typhus, malaria, trypanosomiasis, cancer, and a whole farrago of diseases I probably can't pronounce or spell. But science helps us fight back.

So when I see people dissing science by claiming to invoke individual freedom, or anti-vaxxers putting their own children at risk because of their "beliefs" (do they ever ask the children about this?), I shake my head in despair and wonderment. The lives of all of us, every day, is infused with science, yet there are still all too many who choose to ignore it. Not all of it. Just those aspects with which they personally disagree.

Okay. It's a free country. But it's a funny thing about science. You don't get to pick and choose which bits you like and which you do not.

When Pigs Fly

With Tesla, Elon Musk has been putting computer chips in cars for roughly a decade. Today it was revealed that he has put one in a pig. Without going into details, the chip basically reads the pig's brain waves and broadcasts them wirelessly to a receiver. There they are downloaded for viewing. We can now see what a pig is thinking, even if we cannot yet interpret it.

It's a good thing Elon utilized a pig. Had the chip been implanted in a cat or dog, animal activists would have been up in arms. Even though a pig was used, it's hard for folks who just finished bacon and eggs for breakfast to protest at the idea of a pig being employed for the benefit of science. It just doesn't raise the emotions the way a plate of dog and eggs would. Also, I'm not sure I want to know what my cats are thinking. They're predators, after all.

Elon may be a little mad, but history shows us that brilliant people often are. There is always method to his madness. Science-fiction has been giving us stories centered around brain-computer interfacing for some time now. The idea being that once we can develop such an interface, a user will be able to tell a chipped machine what we want simply by thinking about it. Instead of yelling for a partner to make toast, we'll simply think "toast," the necessary device will pick up the brain-broadcast request, and make toast.

Tesla already sells cars that respond to verbal commands. Additionally, if one hits the signal lever to change lanes, the car complies and then straightens out in the new lane—provided no other vehicle is occupying that lane. This is very useful since the car has 360° vision and I don't.

Now imagine that *you* are chipped and the car is appropriately equipped to receive your thoughts. The physical turn signal disappears because all you have to do is think "change into left lane." Beyond that we'll move to commands that are now done tactilely or verbally. "Raise temperature—tune to KFAC—slow to sixty-five," and so on.

This won't stop (or necessarily begin) with cars. The driving force behind human-computer interfacing is to add QoL (Quality of Life) to

patients with severe neurological impairments, like Lou Gehrig's Disease. If a sufferer can think "turn on the TV" without having to struggle to reach for a physical remote, that's a huge benefit right there to a lot of physically impaired people.

Stretch the tech a little. You're a paraplegic in bed. You think "bring me a glass of water." The thought is picked up by your beside robot, which departs and returns, bringing with it the needed water. Straw, sir? Had enough? In fact, to voice the verbal command "I've had enough," or just "stop," you'd first have to un-mouth the straw. With an interface, you could just think the request.

This technology is coming, and faster than most people think. It is a reason why certain aspects of contemporary science-fiction film have always troubled me. Have you ever noticed that whether it's an X-wing fighter from *Star Wars*, or the command deck of the starship *Enterprise*, or the cockpit of the Earth-Moon shuttle in *2001: A Space Odyssey*, ship controls always consist of pressing buttons, with the occasional use of voice commands?

Here we have ships that can travel faster-than-light, hand-held communications devices that let us talk to aliens, robots equipped with serious artificial intelligence, artificial gravity—but everyone is still typing and pushing buttons. I suppose we have to cut Hollywood something of a break here because watching a cockpit or command deck full of people just thinking would make for some pretty dull cinema. But I would dearly love to see it on screen, even if just once. Because that is how people on a future spaceship will interface with it and give it commands. By thinking at it through the special chips imbedded in their brains. Or if a less intrusive method is preferred, via some sort of mesh arrangement that fits comfortably over one's head. Think medieval snood, only with chips instead of gems.

Filtering will be a major concern. Thinking back (no chip involved here) to the example of the toast, assuming the toaster is not preloaded, what if the husband wants whole wheat and the wife wants an English muffin? What's a poor interfacing home robot to do? Such situations might actually inspire people to be more polite to one another lest via their mental requests they lock up expensive machinery.

For the next step, we can imagine two-way interfacing. Think (assuming you are equipped with the right chip and that you've paid your

monthly fee) "I want to see the film *Gunga Din*." No TV, no movie screen—the film unspools, as it were, right inside your brain. Music would be even easier.

Imagine the boost to creativity. In the late 1940s, the SF writer Katherine MacClean wrote a story where people simply thought new music, and it became available. No paper, no external computer involved. True, it's a long step from reading the brain waves of a pig to composing music simply by thinking about it—but it was only a couple of hundred years from the sailing ship to the 787. Two hundred years from now, a lot of the tools we use today will be obsolete.

Thinking about work will take on an entirely new meaning. And folks like me will no longer need a keyboard. Or a computer.

Toast, yes.

The Decepticons

It was the ice cream that finally did it.

Product packaging is both an art and a science. The same could be said of playing blackjack in Las Vegas. The difference is that you have a better chance of coming out a winner at the table in Vegas. By playing the table, or in this case the shelves, at your local supermarket or drugstore, you're already a loser. The difference is that in Vegas you lose fast. Little time for remorse. At your supermarket, you lose slowly. Verrrry slowly. Your favorite brands hope you don't even notice. Apparently we don't, because with very few exceptions we accept these periodic abuses as if they are inevitable. We cringe silently as we pay for our own maltreatment. We love our favorite products and in return, from their manufacturers we receive nothing but contempt and indifference.

That pint of ice cream that pushed me over the edge? It's not a pint: it's 14 ounces. Don't believe me? Check it out the next time you go shopping. Häagen-Dazs started this downsizing in 2009. Some brands are still a full 16 ounces. Graeter's, for example, which is my favorite store-bought ice cream in the Prescott area (although far too few of the company's flavors are carried locally—where's my coconut chocolate chip?). But in the ice cream section, 14-ounce cups are still shelved right next to the 16-ounces. When I buy a pint of ice cream, I don't want to have to check every label to make sure it's a pint.

As I said, this deconstruction of American packaging occurs over time, so the producers hope you won't notice. I can hardly think of a single product that has not been adversely affected. Breakfast cereal? The boxes have stayed the same size, but hey—is that less actual cereal in the box? The only way to know is to have an old box of the same stuff so you can do a side-by-side comparison, and who does that? What's the point, anyway? The manufacturer is not going to pay attention. There hasn't been a public uprising where throngs of rioters assault General Mills. So the packaging "specialists," artisans of deception that they are, keep getting away with it.

Remember when you used to buy soda in quarts? For some time now it has been liters. But this is America, and we don't much like the (far more sensible) metric system. So how and why have soda producers succeeded in selling us on liters of Coke, or Pepsi, or (if you have taste) RC? Does anybody really remember when or why this changeover took place?

The explanation is simple. A liter is 0.946 of a quart. You think you are still buying a quart, but you're buying less. Not a whole lot less. Like I said, the deception is as gradual as it is insidious. Nor is it restricted to food.

When was the last time you opened a bottle of pills (medicine, dietary supplement, vitamins—it doesn't matter) and found the bottle filled to the top? Or even in the geographic vicinity of the top? According to the innocent manufacturer, that gaping Grand Canyon-size vacant space is due to "some settling in transit." Sure it is. I packed a bottle of vitamins full to the brim and shook the hell out of it. There was some very modest settling, sure, but nothing like opening a bottle and finding it half full. A nuclear blast couldn't have settled those little suckers any more. Same excuse is given for cereal.

Among the worst offenders are powdered products, where the "some settling in transit" excuse is king. This offense varies among manufacturers. I've bought some supplement powders where the container is literally half empty. "Settling in transit" my sugar substitute!

Another favorite offender is toilet paper. One of our bathrooms has a t-paper holder that eliminates the center roller. It's just two spring-loaded clips, one on each side of the holder. Worked perfectly fine for decades. Then one day when I went to install a new roll, it just fell through. Was too narrow for the clips. In-depth scientific study (accompanied by suitably non-scientific language) revealed that while the roll was the same length as before and contained the same number of sheets (do consumers really count the number of sheets on a roll of toilet paper when comparison shopping?), it was now narrower. So, less paper, but looks the same, and if you use the standard fits-on-a-roller holder, you'd likely never notice the change.

Face it. We're suckers. We put up with these insults every time we shop. All I can say is, check the actual weight on the cereal you buy, stick to full pints of ice cream, and if a product is in a transparent bottle or tube, check the fill level.

Honestly, sometimes I do think we live in a third-world country. Except there, in small city or country markets, if you try this sort of brazen subterfuge, the other vendors will fall on you and chase you out of the souk, or bazaar, or street market, howling with outrage. Because they have honor.

The Buzz

It seems that folks are pretty agitated right now. Opinions sharply divided, neighbor quarreling with neighbor, even battling over something as silly as signs (my favorite sign says "Ice Cream Sold Here"). Might be a good time for everyone to take a step or two back and spend a few minutes contemplating the marvelous part of the world in which we are all fortunate enough to live (maybe minus the signs). If Nature can do it on a regular basis, why can't we?

Take bees. Arguably our most beneficial insect. They provide us with honey that is not only nutritious and tasteful but therapeutic. They pollinate our fruit and vegetable farms, giving us food. They pollinate flowers, giving us beauty. And yet for many people they have somehow acquired a reputation for being argumentative. Yes, they sting, but only when seriously provoked. Something useful to remember during election season. Bees always work together for the general good of the hive. One reason why they're called "social" insects. Nobody rails at them and calls them communist insects. Bees don't worry about being labeled by other species.

About ten years ago they colonized our well house. Starting from nothing they built an enormous, thriving hive. Not unlike the folks who founded this country. They made use of their natural environment (without destroying it) and constructed a compact, highly successful little civilization. They're all immigrant stock, too. Our honeybees were imported from Eurasia. I enjoyed watching them at work on the blossoms around our house. We've been here for forty years and in all that time I was stung only once. My fault. Can't say the same for local politicos.

One time, they colonized the main house and we had to have them put down. It was a painful but necessary move. Their buzzing was keeping us awake, and they posed a danger to our dogs. But the colonization of the well house was another matter. It was well away from the main structure and posed no threat to our animals. Except... the combs they constructed outside the smaller building blocked the doorway.

I could walk right up to the hive, filled with thousands of busy workers, and they completely ignored me. But if I opened the door it

would break off some of the comb, and they were likely to react the same as if someone broke into our house. So we had them moved by a beekeeper.

Ten years later they were back and the same situation redeveloped. Combs hanging outside, filled with honey and larvae. This time we engaged some folks from Skull Valley. Tom and Michele Veatch of the Prescott Beekeepers came out and spent the better part of an afternoon moving the bees. This involved cutting the combs from the well house roof overhang and placing them in wood slots that then fit neatly into a wooden box; a hand-built new hive.

Understandably, the bees were a bit upset. Even though it was to their ultimate benefit, making them understand was not possible (when was the last time *you* were forcibly relocated?). So they swarmed a bit, and some of them got a bit pissy, as Tom and Michele said. But there was no ferocious attack. These weren't Africanized bees (I prefer the term "uncivilized"). Watching Tom use a flat-bladed tool to scrape hundreds of live bees off a comb and into a box was fascinating. Michele and I monitored the process from maybe thirty feet away. Even though there were bees all around, they never bothered us.

When the sticky job was finally complete, Tom loaded the now newly populated hive into the rear of his truck. The back of the pickup was uncovered. "They'll stay with the hive," Tom assured me. As indeed they did, all the way back to Skull Valley, where they are now comfortably ensconced in their new location.

Subsequently, our flowers have been visited by other bees, and not just honeybees. At least half a dozen different species have come to visit. Arizona is bee-rich. I watch them when I can, usually when I take a break from work. They're having a long season, not unlike our politicians. Also unlike our politicians, they're not interested in stinging and raising welts and injecting venom. They just go about their business: building their hives, raising their young, making honey, getting ready for winter, and trying to stay healthy while avoiding the Varroa mite. The Varroa is to honeybees what Covid-19 is to us.

I'd say that we could learn a lesson from our local honeybees, but somebody would probably call me a radical socialist for making the analogy. Honey is bees' Social Security, and nobody seems to object to honey. But I still think it's a good lesson to learn. Maybe if we were a

little more like honeybees, sharing the work and the honey, we'd stop yelling at each other for a while. Even the drones get their share, but just a fair share. If the drones monopolized all the honey, you wouldn't have much of a civilization, and the hive would die.

I don't want to see our hive die. I don't want to see it become Africanized, uncivilized, striking out violently and blindly at every perceived threat. Doesn't make for a happy hive.

Taking a few moments to watch the bees and enjoy the flowers. Winter will be here soon enough.

The Mouse and Me

Every craftsman expects to be paid for their work. House painters, wallpaper hangers, plumbers, electricians, stonemasons, cake decorators, fine artists, musicians, and yes, authors. When a writer signs on to do a "work for hire," sometimes the contract is for a one-time flat fee, and sometimes it includes an advance against royalties. When the advance has earned out, then the writer receives royalties. It has been thus in the publishing industry for a very long time: a relatively straightforward and time-honored business relationship that pleased everyone.

There was rarely a problem when mergers occurred between two publishers because everyone understood the arrangement. Then something strange happened. The creators of content (writers, artists, musicians) suddenly found themselves party to vast mergers that swallowed up not just another publisher but entire other corporations. Most notable of these was The Walt Disney Corporation's recent acquisition of Twentieth Century Fox and then Lucasfilm.

Some of you may know that I ghost-wrote the book version of the very first *Star Wars* film, and also the first sequel novel, *Splinter of the Mind's Eye*. I also wrote the book versions of the first three *Alien* films. I always received regular royalty reports from the original publishers. Then Fox and Lucasfilm were swallowed by Disney and a funny thing happened: my literary agency stopped receiving royalties.

They no longer even received royalty reports.

When a writer is dealing directly with a publisher it's fairly easy to track such things. When a gargantuan entertainment conglomerate that bestrides the land like an all-consuming colossus arrives, small things tend to fall through the cracks. Even writers and their modest concerns.

That's what happened to me. And subsequently to the writers' organization to which I have belonged since the beginning of my career (SFWA—the Science Fiction and Fantasy Writers of America) going public with the situation, also to a growing number of other writers.

It took my agency about a year just to find out who had the rights to (and income from) the three *Alien* books. Previously, an agent or writer

could simply call a publisher and ask. It was a little easier to find out who controlled the rights to the two *Star Wars* books. Subsequently—well, you get brushed off. You, your agency, your writers' organization, the writers' organization's lawyers. To a corporation the size of WDC, you're just creative dandruff. Unless....

Unless you go public. Which is what we finally did. Now, suddenly, there is communication between my representatives and the WDC. It's funny what the light of day and a little publicity can do. We'll see if the brush-off continues or if a resolution to what is at base a simple matter eventuates. Disney is claiming that in purchasing Fox and Lucasfilm they only acquired the rights to properties and not the obligations joined to them. It's an interesting approach.

Anyone out there paying off a mortgage? Why? You clearly own the house... just sell it to someone else and explain that the mortgage doesn't go with it: then buy it back free and clear. It's the same concept.

It's a pain to have to deal with something like this, but my representatives and I finally decided we could no longer simply let it slide. Because, money aside, the more you let giant corporations get away with such things, the more they will continue to do so.

Here's how I presented my original complaint to the WDC. Pretty straightforward, I think. I addressed it personally to Disney's most venerable representative:

Dear Mickey;

We have a lot in common, you and I. We share a birthday: November 18. My dad's nickname was Mickey. There's more.

When you purchased Lucasfilm you acquired the rights to some books I wrote. *Star Wars*, the novelization of the very first film. *Splinter of the Mind's Eye*, the first sequel novel. You owe me royalties on these books. You stopped paying them.

When you purchased Twentieth-Century Fox, you eventually acquired the rights to other books I had written. The novelizations of *Alien*, *Aliens*, and *Alien³*. You've never paid royalties on any of these, or even issued royalty statements for them.

All these books are all still very much in print. They still earn money. For you. When one company buys another, they acquire its liabilities as well as its assets. You're certainly reaping the benefits of the assets. I'd very much like my miniscule (though it's not small to me) share.

If You Shoot the Breeze, Are You Murdering the Weather?

You want me to sign an NDA (non-disclosure agreement) before even talking. I've signed a lot of NDAs in my fifty-year career. Never once did anyone ever ask me to sign one prior to negotiations. For the obvious reason that once you sign, you can no longer talk about the matter at hand. Every one of my representatives in this matter, with many, many decades of experience in such business, echo my bewilderment.

You continue to ignore requests from my agents. You continue to ignore queries from SFWA, the Science Fiction and Fantasy Writers of America. You continue to ignore my legal representatives. I know this is what gargantuan corporations often do. Ignore requests and inquiries hoping the petitioner will simply go away. Or possibly die. But I'm still here, and I am still entitled to what you owe me. Including not to be ignored, just because I'm only one lone writer. How many other writers and artists out there are you similarly ignoring?

My wife has serious medical issues, and in 2016 I was diagnosed with an aggressive variety of cancer. We could use the money. Not charity: just what I'm owed. I've always loved Disney. The films, the parks, growing up with the Disneyland TV show. I don't think Unca Walt would approve of how you are currently treating me. Maybe someone in the right position just hasn't received the word, though after all these months of ignored requests and queries that's hard to countenance. Or as a guy named Bob Iger said: "The way you do anything is the way you do everything."

I'm not feeling it.

Metal Can be Funny

Yes, metal can be funny. Can even make you laugh out loud while not taking itself too seriously. But you do have to pay attention and...

Oh, wait. Not *that* kind of metal. I'm referring to the musical kind. The genre known as heavy metal—or more concisely, just metal. Music as typified by such progenitors as Metallica, Iron Maiden, Rammstein, Evanescence, and these days by bands like Apocalyptica, Sonata Arctica, Amon Amarth, Sabaton, Stratovarius, HammerFall, and many more. Far too many to name. And of course, Nightwish. Calling Nightwish a metal band is like labeling Beethoven a songwriter, though they can go as hard as anyone.

In fact, there are so many practitioners of Metal and so many bands that there are specific publications dedicated to the genre, like *Metal Hammer* (metal band names tend to be takeoffs on High Fantasy tropes). Confusingly, the illustrated magazine *Heavy Metal* was about comics and graphic novels, and was the English language version of the French magazine *Metal hurlant*.

When any creative subgenre, be it of fiction, music, painting, or sculpture gets popular, satire and parody inevitably follow. The best satire builds upon its subject matter instead of simply making fun of it. Think the political sketches on *Saturday Night Live*. The skits skewer their subjects while also becoming political commentary in their own right.

Metal music parody is no different. Any group can make fun of the genre by dressing up and throwing out thunderous riffs. Borderline metal group Spinal Tap naturally comes immediately to mind. Or going back much further and branded as pop-rock, the Monkees. What was intended to be little more than a TV joke ended up producing some very good music. Performing musical satire while simultaneously making good music is much more difficult than it sounds. With regard to classical music one thinks of the Hoffnung Music Festival, or for Americans, Victor Borge.

Ever heard of Pirate Metal? It's exactly what it purports to be: metal produced and played around a pirate theme. Its foremost proponents are

the Scottish band Alestorm (even the name is a satire on the genre). I highly (perhaps I should say heartily) recommend their video "Drink." Also "Keelhauled," "Shipwrecked," "Fannybaws," and—well, one that's not reproduceable in a family paper. With some sharp instrumental playing and wackadoodle singing, this band will have you in stitches while simultaneously appreciating their musical abilities. Nothing is sacred and the only thing they hold back on is their actual capacity to imbibe all manner of recreational stimulants.

I am told this is actually how Scotland is and the Scots are, but having been there a couple of times myself I remain dubious. Perhaps it all takes place behind closed doors only, and me without a ticket.

Currently we have Gloryhammer, which has a creative connection with Alestorm (there is more incest in the metal genre than in six generations of mittel-European royalty). Scifi Metal instead of Pirate Metal. Once again, driving power metal with excellent musicianship in the service of songs like "Legendary Enchanted Jetpack," "Power of the Dragon Laserfire" (I am not making these up), "The Unicorn Invasion of Dundee" (these are Scots, remember), and the immortal "The Epic Rage of Furious Thunder"—about as metal a song title as anyone could come up with. The lyrics are commensurate with the titles, but if those are all cheese, the music is not. Inspiration is where you find it.

I could go on, but we'll end with the band "Nanowar of Steel." Which in actuality is an Italian parody band doing satirical music in the style of northern European metal groups. The lyrics to their songs are hilarious, the music is great, and the musicians are inspired. I recommend "Norwegian Regaetton," which may change your perception of Caribbean music forever, "The Call of Cthulhu," which is something other than what Lovecraft had in mind, "And Then I Noticed that She was a Gargoyle," which is kind of the obverse of the TV show "The Bachelor." In any event, there is the recent "Valhallelujah." If you don't have a favorite Christmas song, even if where Christmas is concerned you are deeply and severely humbugged, I suggest you watch the video for this one. There is a great central riff, some moving gospel, and a concluding suggestion for Christmas gifts as well as the anxiety that attends them. Furthermore, their founder, Edoardo Carlesi, is a noted polyglot and astrophysicist. So if "Valhallelujah" is not your liking, you can try his 2013 paper "The imprints of quintessence dark energy on the cosmic web and galaxy clusters."

These groups are not a vaccine, but they do inoculate against taking everything too seriously. Also, unlike anything from Pfizer or Moderna, you can sing along with them.

Refrigeration Relativity

As I am writing this we are cleaning up here in Prescott after some 4–5 inches of snow, with the weather folk insisting there is a good deal more to come. I have a friend in upstate New York who would refer to that amount of snow as a flurry, but for central Arizona it's a good evening's fall. A friend was telling me how cold it was (it presently is just above freezing) and especially, how dark it was this morning.

Lemme tell you about cold and dark.

A few years back, I was invited to speak in Utqiagvik (formerly Barrow), Alaska. NPR had a policy of inviting a science writer up every year to speak to the local schoolkids, and the guy in charge of the local public radio station (KBRW, natch) had the bright idea of changing things up a bit by inviting a science-fiction writer. Being a fan of my writing, he extended the invitation to me. I jumped at it.

"Provided," I wrote back, "I can come up in the dead of winter. Mid-December, say."

Now, I understand why some folks might think this a peculiar stipulation. But I had never experienced Arctic winter, and here was my chance.

Utqiagvik (just pronounce the syllables separately) is the northernmost town on the North American continent. Located on the shore of the Chukchi Sea, it is home to a major (and with climate change, expanding) US climatology research station. Also the world's northernmost Mexican restaurant. I flew Phoenix-Seattle-Anchorage, with a stop in Fairbanks and then onwards to Utqiagvik.

My ticket being for seat 1A on the final two legs I was impressed and pleased by the resources at NPR's disposal. Boarding was my first clue that the Far North handles things differently. The plane was a Boeing 737-400C. I didn't think about the "C" until I boarded. I was indeed in the first row—bearing in mind that the front half of the plane was for cargo. I was actually seated behind the wing.

We landed in total darkness sometime around midday. The terminal was not the first-class at Heathrow, but all I was concerned about was the

one piece of luggage I had brought with me. Having already had a look outside via one of the terminal's triple-pane windows, the last thing I wanted was to spend a week in town with just the clothes on my back.

I spoke to the kids, most of whom were local Inuit, on several occasions. They were quiet and respectful in a way that would probably shock a lot of educators hereabouts. The rest of the time I was free to wander around town on my own. Utqiagvik had twenty-six miles of road—all of which dead-ended somewhere out in the tundra. You can't drive to the place from anywhere else.

Turns out they were having a heat wave, with the daytime highs reaching into the 20s and scarcely going below zero at night. Given this balmy weather, on one free afternoon I set out to explore the farther reaches of the town. Away from the bright lights (Circle K, the couple of motels, that Mexican restaurant) it quickly grew quiet on the night-time dark snow-covered streets. *Very* quiet. For some reason I was the only one out walking. Everyone was in town or at the research station Doing Something, so I didn't hear as much as a single vehicle. It wasn't *that* cold, and you couldn't get lost, so why was I the only...?

Uh, Arizona dude? Polar bears.

I had been warned about that, and had forgotten. I hastily made my way back to my motel, managing not to run, not managing to keep from constantly looking over my shoulder. Baby polar bears are cute and cuddly. Adult polar bears are homicidal.

Having survived both being eaten and my stupidity, I thoroughly enjoyed the rest of my visit, and I hope I didn't bore the kids too much. On the day before I was to fly out I was asked if there was anything I wanted to do.

"I'd like to see a polar bear," I naturally replied.

Equipped with snow machines and a couple of rifle-toting guides, we zoomed out of town in search of the elusive massive predator. After many hours of banging around on gravel that was barely snow-covered, I'd had enough, and said so. One of my guides called in our intended return, only to be told that there was a whole family of polar bears about. All of whom were trying to rummage through the dumpster out back of Arctic Pizza.

I could have settled back in nice, toasty surroundings and enjoyed a pizza while watching the bears. Never did see one.

But I did see a snowy owl perched in Arctic twilight atop a huge satellite dish at a mothballed US Air Force long-range radar station. Probably less common than seeing a polar bear.

Oh, the cold? You know it's cold when the temperature inside the freezer at the Circle K is twenty degrees warmer than the outside temperature, and the local ladies are doing their shopping in flip-flops—albeit with socks. And yes, there is such a thing as a dry cold. By the end of the week I was walking the block from my motel to the Mexican restaurant clad only in jeans and a flannel shirt over a long-sleeve T-shirt (okay, so it was a short walk).

But even though the street was brightly lit, and there was occasionally someone about, I never stopped watching for polar bears. You never know when they'll tire of pizza.

Algorithm for the Deceased

Except in zombie films, we know we cannot raise the dead. But technology is making it increasingly easy for even talented amateurs to restore to some of the deceased a semblance of life. I'm not talking about modern CGI, where an entire individual is recreated utilizing computer graphics. I am referring to the use of advanced colorization techniques and AI to reanimate the appearance and in some cases the movements of the long-departed.

This is a trend that began by using computers to colorize old black-and-white films. The first efforts were, at best, muddy and consisting of fuzzy imagery that looked like it had been colored with crayons. The necessary tech improved rapidly. Colors became more natural and the images sharper. Following film the technique was applied to classic television shows, so that now we can watch episodes of *I Love Lucy* and revel in the sight of Lucille Ball's red hair without flinching. Whether you agree with the practice or not it has to be admitted that color adds sprightliness and immediacy to the old broadcasts. I suspect that before too long the technology required will become cheap and easy enough to use so that you can do it on your home computer, enabling you to render in color that favorite obscure TV show from your childhood (well, from the childhoods of folks my age, anyway).

I do not know at what point or place in time it occurred to someone that a similar technique could be equally as well applied to still as well as moving images. Adding color to still photographs by means of hand coloring has been with us almost since the invention of photography, proving that many people wanted images in color from the beginning. It's one reason why folks continued to sit for portrait paintings long after photography provided a more accurate rendering of reality.

I appreciate the aesthetic of b&w photography as much as anyone, but eliminating color does not always enhance life. It's a different art form, much as silent film differs from sound. But from the standpoint of bringing people to life, b&w—and especially early black-and-white—has a number of unavoidable drawbacks.

If You Shoot the Breeze, Are You Murdering the Weather?

First off, well—dead people turn gray. No getting around that one. No matter how you try to rationalize the time and tech, sitters in 19th-century photos always appear just a little demised. Then there is the usual stiffness, the formality of their poses. This was largely, but not always, because it was considered appropriate to act formal when sitting for a formal portrait. Our ancestors, famous and otherwise, nearly always appeared downright stoic when having their pictures taken. And they rarely smile. Not only because they're sitting for "formal" portraits, but because many had—bad teeth.

The ritual of having to sit motionless for a painted portrait carried over into photography. Not to mention that sitters had no choice in the matter if they wanted the result to be sharp. Long exposure times meant that the subject simply could not move if the photographer was to capture a clear image.

But what if newer, advanced colorization techniques could be combined with those of artificial intelligence to not only bring forth natural color from old b&w photos, but movement as well? As the writer Arthur C. Clarke said, "Any sufficiently advanced technology is indistinguishable from magic." That is what we have now: a process becoming more and more indistinguishable from magic.

Consider George Washington. The president sat for many painted portraits, as befits the man and his station. Except—the man is just as valid as the station. What if we could not only view Washington in natural color, but see him blink? See his eyes move? Maybe even see him—smile? We have no photographs to work with, but what if a similar technique could be applied to paintings of the man? And to his successors?

Have a look: https://www.youtube.com/watch?v=hjfy-ZxKqCk

Our predecessors did not appear exactly like us, of course. All those fading black-and-white images and accoutrements like the antique makeup and jewelry and clothing. Too often we rarely find them attractive, the men as well as the women. But add a little color, a little movement, perhaps even let an algorithm play with a hair style, and you have this: https://www.youtube.com/watch?v=ac82cak413U&t=455s

I'll match Maude Adams against any of today's cosmetically enhanced beauties. And with color and a smile doesn't Sarah Bernhardt look just a little like Elizabeth Taylor?

Why restrict ourselves chronologically? Paintings of the Roman emperors are scarce. But the ancient Romans insisted on accurate representations of their appearance in sculpture, so…: https://www.youtube.com/watch?v=dz90uauo9nI

Hi, Julius.

And as a final example of what this increasingly sophisticated tech can do, how about bringing to life a few more famous paintings, of those dead for centuries. Some famous, some virtually unknown: https://www.youtube.com/watch?v=3eRghDauJsg&t=234s

What is amazing about this technology is that it is in its infancy. In less than ten years I expect Washington to stand up and speak, Caesar to move in three dimensions, and famous beauties to be available to substitute on your communications device for Siri and Alexa—not just verbally, but in person. In a hundred years…

In a hundred years we'll be able to invite them all around for a party.

Wither Weather?

This is my one hundredth column for *Perceivings*. That's a lot of disquisition. So for this month's column I thought to do something related to the number 100. My initial idea was to write about the hundred-dollar bill, but that seemed churlish given that a lot of people right now are experiencing a shortage of that particular denomination. Times are tough for many folks, and one thing they do not need is to be reminded of what they don't have.

What *does* everybody have? What commonality circulates around the number 100? This being Arizona, often the first thing that comes to mind for residents as well as visitors is—the temperature. Every radio and television weather broadcast seems to have a contest offering prizes for the individual who can pick the first day—and sometimes the exact time of day—the temperature in Phoenix, or Yuma, or Tucson, will hit a hundred degrees Fahrenheit.

It's a good thing the Founding Fathers didn't listen to Benjamin Franklin, or we would somehow have to struggle along without these contests. Franklin wanted the nascent United States to adopt the much more sensible metric system. In Celsius, a hundred degrees Fahrenheit is 37.77 degrees. This is plainly an insufficiently catchy number on which to base a weather contest. Similarly, a hundred degrees Celsius is 212 degrees Fahrenheit, at which point goofy weather contests become untenable. Also our species and pretty much everything else.

I reckon I have seen tens of thousands of television weathercasts. In these days of fast internet connections and wristwatches that are smarter than their wearers, the weather forecast is available instantly nearly everywhere in the world. Such forecasting has transformed farming in Africa and fishing in the Pacific. But we still have our television weather segments to break up the actual news and force us to wait for the sports. Green screens and remote controls notwithstanding, these weathercasts represent a link with the television past. Presentations are sufficiently traditional that there is actually very little to differentiate a TV weather forecast of today from those in the early days of the medium.

Still, some things don't change. For example, in hopes of gaining viewers many station managers experiencing low ratings tend to favor attractive women to present the weather. They may have advanced degrees in meteorology or competing in beauty pageants, and I do not need to explain which one will get you on the air faster. Having both is a rare combination. Failing that, there is a noticeable correlation between the ability to speak rapidly and the higher up one rises in national weather presentations on the major networks. The principal weather folk on all the national US channels talk so fast that they might as well be explaining binary code instead of the cold front currently passing through Dubuque.

In contrast, weather presenters in other countries aim for comprehension instead of speed. I enjoy watching the weather on the BBC not only because the presentation is sedate (although even the Brits seem to be shoveling it at us faster and faster these days, just like Americans), but because the Beeb gives us the weather for the entire planet. There's a bit of a guilty pleasure in enjoying the weather in Arizona while Shanghai is bracing for a typhoon. Tracking the seasonal monsoon in India brings those of us in Arizona a bit closer to the other side of the world.

There are a few things about the traditional TV weathercast that still bother me, though. Why is it that when I *really* need to see the forecast for Prescott and the weather map is on screen, the presenter always seems to be standing in front of Prescott? And that map… the names of the cities are writ so large it is impossible even for those of us who have lived in this state a long time to locate our communities. Take Casa Grande. On the weather maps, you can scarcely tell by looking at the longish name whether the city lies in the western or eastern portion of the state, much less pinpoint its exact location. In addition to the city names, why can't weather maps put in little stars or something to indicate *exactly* where a city is situated? Somehow I think the relevant expensive software could handle that.

At least we don't live in a vast metropolitan area like greater Phoenix. Presumably the folks who dwell in the Valley of the Sun have some idea where their homes are located when the city weather map appears. Is it really necessary to show the same temperature (maybe a degree difference now and then) between Gilbert and Chandler, downtown Phoenix and Glendale? All those similar, often identical forecasts just crowd the map.

If You Shoot the Breeze, Are You Murdering the Weather?

Lastly, I have to plead with the station weather folk. Please, please, when you're showing weather rolling through Arizona, could you maybe run through the weather's progress at a speed slower than supersonic? As it is, within seconds an incoming, developing storm has traveled on the map from Yuma to Window Rock. Then you repeat it. At the same ridiculous speed. Over and over. Maybe you stop the video once. Twice, if the viewer is lucky. Honestly, while you are talking couldn't you slow down the video so we can actually see where and when the rain or snow is going to materialize?

Unlike the inevitable follow-up plug for the chili festival in Apache Junction, that would actually be useful, weather-wise.

Printed in the USA
CPSIA information can be obtained
at www.ICGtesting.com
LVHW051334031223
765482LV00008B/235